Edvard Munch.
A Poem of Life, Love and Death

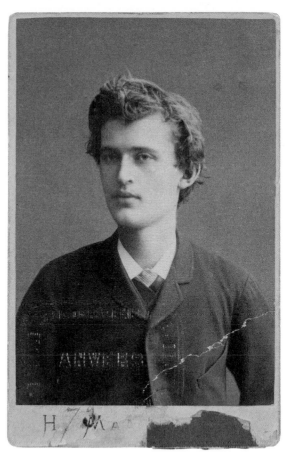

Carte-de-visite photograph of Edvard Munch used on his admission card to the Universal Exhibition in Antwerp, 1885. Unknown photographer. Munchmuseet Archives

Foreword

Nearly 80 years after Edvard Munch's death, people from all over the world continue to be captivated, intrigued and powerfully affected by his work. The huge number of visitors to exhibitions of his works at museums in every part of the world show us that he still has a great deal to teach us.

As a young artist, Munch followed the currents of change and innovation into the heart of Europe and, as two of the essays in this book remind us, enjoyed his first artistic success and notoriety on the continent. His many visits to Paris between 1885–1908 were formative both for his technique and aesthetics and for widening his circle of artistic friends. We are therefore particularly delighted to celebrate Munch with an extensive solo exhibition at Musée d'Orsay, which is so closely associated with artists of the same historical era and generation as him.

The first time our institutions collaborated was back in 1991, with the major large-scale show *Munch et la France*. On both occasions the experience of working with Musée d'Orsay has been extraordinary. I would like to thank our hugely professional and friendly colleagues for a wonderful collaboration.

This English-language book is a redesigned and slightly abbreviated edition of the comprehensive French catalogue published on the occasion of the exhibition *Edvard Munch. Un poème d'amour, de vie et de mort*.

My sincere thanks to Musée d'Orsay's chief curator Claire Bernardi (now director of Musée de l'Orangerie) and documentary research officer Estelle Bégué, as well as writers Patricia G. Berman, Hilde Bøe, Ingrid Junillon, Trine Otte Bak Nielsen, Øystein Ustvedt and Pierre Wat for their contributions. I would also like to thank my great colleagues at MUNCH for their contributions to realising the exhibition and the publication.

The composite portrait of Edvard Munch in this volume shows the artist in his philosophical and scientific milieu; the places and geographic locations that shaped the man and his art; a rare glimpse of Munch's lesser-known attempts at creative writing; and the historical evolution of his monumental *Frieze of Life* series and the world-famous *Scream*.

I would also like to extend my warmest thanks to our sponsors, who are so crucial to financing our broad programme of exhibitions and publications: INPEX Idemitsu Norge AS, Canica, VIKING, AkerBP, Deloitte, Multiconsult and Polestar. Their contributions are vital to enable us to promote and exhibit the work of Munch, both in Norway and abroad. I am also extremely grateful to my counterpart at Musée d'Orsay, Dr Christophe Leribault, President of Musées d'Orsay et de l'Orangerie. Our dialogue and collaboration have led to fresh perspectives for all of us on the life and work of this still fascinating artist.

Stein Olav Henrichsen
Director, MUNCH

Foreword

The reception of the work of the Norwegian painter Edvard Munch (1863–1944) quickly crystallised around the single image of *The Scream*, an elevation to iconic status that turned this motif into a kind of screen concealing the body of work that made it possible and gives it meaning. The exhibition at Musée d'Orsay and this accompanying catalogue seek to demonstrate the scale of Munch's artistic work by exploring his career – 60 years of creation – in its full time span and complexity.

Munch's image occupies a singular place in modern art. It has its roots in the 19th century but is fully integrated into the 20th. In reality all of Munch's work, from the 1880s to his death, was animated by a vision with a powerful Symbolist dimension. In accordance with its curators' intent, this exhibition does not set up an opposition between fin-de-siècle Symbolism and the Expressionism seen as securing Munch's place within modern art, but instead offers a global reading of the artist's work which places the main emphasis on its great consistency. In this regard, the notion of the cycle is key to an understanding of Munch's art. Fascinated by the concept of metabolism, the artist often expressed the idea that humanity and nature are indissolubly united in the cycle of life, death and rebirth. This idea also affected the construction of his works and enables us to highlight his unique creative process, which led him to produce many variants of the same motif. He created many different versions of the same subject, moving fluidly from one medium to the next. So we are invited to revisit a body of work that is profoundly consistent, even obsessional, and at the same time constantly renewed in the strict sense of the word.

The exhibition was made possible by an extraordinary partnership with MUNCH in Oslo. It could never have happened without the exceptional loan of more than 60 masterpieces from the museum's impressive monographic collection, comprising the artist's bequest of his works to the City of Oslo. We are profoundly grateful to the museum's director Stein Olav Henrichsen, to Jon-Ove Steihaug and all the teams who so generously gave us full access to their resources, at a time when circumstances made the development of this project particularly complicated. In addition to difficulties of the pandemic that we have all experienced, the collections then had to be moved prior to the opening of the magnificent new museum building on the Oslo waterfront.

We should also like to express our most sincere thanks to the public and private institutions that so generously lent their works for this exhibition, and in particular to Nasjonalmuseet in Oslo and KODE in Bergen.

We must also thank the authors of this catalogue, all international experts on Munch, whose fascinating contributions invite us to look at the artist's work with new eyes.

This ambitious, demanding project could never have come to fruition without the active involvement of all the teams at Musée d'Orsay, who played a vital role in making it a reality. Our warmest thanks go to you

all, and to the curators Claire Bernardi, formerly chief curator at the Musée d'Orsay and now director of Musée de l'Orangerie, in collaboration with Estelle Bégué, documentary research officer.

Last, though by no means least, we recognise the enthusiastic and generous support given to this project by our French and Norwegian sponsors: Natixis, Yara, Art Mentor Foundation Lucerne, Nexity and Ponticelli.

Christophe Leribault
President, Musées d'Orsay et de l'Orangerie

Contents

Essays

Creating an Oeuvre: Munch's Story of Himself 12
Claire Bernardi

Munch's Haunts and Social Circles 20
Øystein Ustvedt

The Sinuous Line of Life 44
Pierre Wat

A Scream Through Nature 58
Trine Otte Bak Nielsen

Munch and the Symbolist Theatre 70
Ingrid Junillon

Munch's Aula and the Theatre of *The Sun* 86
Patricia G. Berman

The Literary Munch 100
Hilde Bøe

Artworks exhibited at the Musée d'Orsay
Introductory texts by Estelle Bégué

From the Intimate to the Symbolic 114

The Frieze of Life 130

Reuse and Mutation of the Motif 170

Munch and the Grand Decorations 192

Mise-en-scène and Introspection 210

Reference

Chronology 242
List of Artworks exhibited at the Musée d'Orsay 246
Selected Bibliography 250
Photo Credits 255

Essays

Creating an Oeuvre: Munch's Story of Himself

Claire Bernardi
Director
Musée de l'Orangerie, Paris

In my art I have sought to explain to myself life and its meaning – I have also intended to help others to understand their own lives – I have always worked best with my paintings around me – I arranged them together and felt that some of the pictures were connected to each other in content – When they were positioned together there immediately arose a resonance between them. [...] it became a symphony.[1]

Edvard Munch is not the painter of one work, as is sometimes said, and nor is his art a manifestation of impulsive Expressionism. Throughout his artistic life he was driven by the same concern to explain his works and help others to understand them by highlighting the syntax and compositional aspects that they share and which bind them together. This can doubtless be seen as reflecting a desire to influence the reception of his work, but we must also recognise it as the expression of the profoundly Symbolist idea of resonance between works, of art in dialogue with itself, in the manner of a musical symphony. If we follow Munch's artistic itinerary we can see that he guides the reading of his works through the development of a discourse, a language, and turns their presentation into a narrative. Becoming something like the curator of his own exhibitions, he invents his own staging devices, highlights the thread that connects the works to each other and emphasises the idea of 'newness in sameness' by giving his work a cyclical rhythm. His conduct of his artistic career takes on the dimensions of a story. Recent studies have revealed Munch's aspect as a businessman,[2] his active role in mounting his exhibitions[3] and his concern for the posthumous reception of his works, which he developed in the later decades of his career.[4] We can infer similar intent in his strategic approach to showing his work and bequeathing it to posterity. At every stage in the life of his oeuvre, he noted the response of the public, and indeed tried to control it.[5]

Story and Staging

The early public showings of Munch's work in the 1890s proved central to his thinking and to the definition of his artistic programme, revealing that, in order to make his images more understandable, he needed to relate them to each other, as they were hard to decode in isolation. With each new show he modified the organisation of his paintings and the titles of the different sections, developing his ideas as he went. So there is no one *Frieze of Life* – as he eventually entitled this group of works so central to his artistic world – but rather several series of paintings, each with its own visual narrative.[6] There are 10–12 known presentations of the frieze from the years 1893–1918, with changing titles and different content, major differences of style and arrangements varying from one exhibition to the next. The number of paintings shown each time varies from six to 22, and no single work is present in every group.[7] Mai Britt Guleng, who has analysed the evolution of the frieze, has compared it to syntactical analysis, which seems a fruitful direction to explore.

The six paintings that Munch showed in Berlin in 1893, with the title *Study for a Series Called 'Love'*, all focus on a theme that was central to his life at the time, in a kind of metonymy of the future project. But he very soon set about developing this project and creating a coherent whole. For his 1893 exhibition in Copenhagen, after the early deinstallation of the show that had proved scandalous in Berlin, Munch asked his friend the Danish painter Johan Rode to identify the works that had proved particularly controversial and which the German press had described as manifesting insanity and a 'hasty' style. Crucially, he told Rode about his new strategy: the recent events had led him to rethink how to show his paintings, and how to create an oeuvre: 'So what I'm going to do now will be different. I have to strive for greater coherence.'[8]

His exhibition at the Berlin Secession of 1902, entitled *Presentation of a Sequence of Pictures from Life* was the outcome of a process. Munch had devised a far more complete installation, emphasising the link between the works – the term 'frieze' was also used on this occasion.[9] The 22 paintings were split into four groups and hung high on the wall in a canvas passe-partout. While the themes of love and angst had appeared in earlier series, death was introduced in this exhibition. Most importantly, this was the first presentation of *Metabolism: Life and Death* (p. 147), a painting that served as a link between the beginning and end of the series and which was given its title by Munch himself.

An exhibition of 1903 in Leipzig was almost identical to the Secession show. At Munch's request, a series of photographs were taken (p. 16), enabling us to see how the exhibition was arranged and which works were selected. The request itself is interesting in its intention to record this historical moment and also to pass it down to posterity. At this time Munch's interest in photography and its uses led him to take it up himself. The design of the exhibition clearly seeks to make connections between the works on show, with the paintings once again hung in a passe-partout, with prints of the reworked motifs hung below.

After several other exhibitions in different forms, the show of 1918 at the Blomqvist gallery in Kristiania was particularly unusual. In it Munch showed 20 paintings from the years 1890–1918, revealing major stylistic differences. In the frieze, hung high on the wall, most of the works featured a beach with trees. *Metabolism* had been reworked and the bush and embryo covered over, with Adam and Eve shown in a wood.

At the time of this exhibition Munch was actively considering how to exhibit this major work. In the years 1910–16 he made a series of drawings, reworking the motifs of the frieze explicitly as a decorative cycle rather than as a set of individual works.[10] This approach is notably reflected in a drawing found in Munch's archives, which shows a plan for hanging the frieze. The scenes are bound together by a setting of wall panels decorated with trees with falling leaves.

Although there is no explicit causal link between the different series of paintings and no correlation between events is established, an evolution from one exhibition to the next reveals an overall structure, while the general atmosphere suggests that humanity is carried along by certain

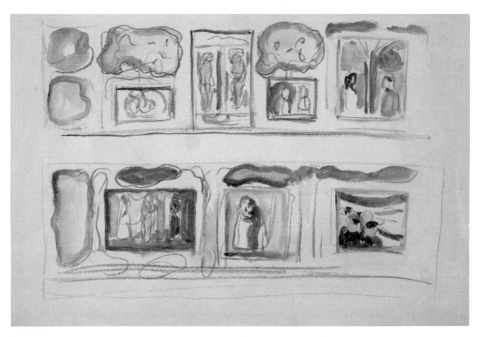

Outline sketch for *The Frieze of Life* **including** *Metabolism:*
Life and Death, *The Kiss,* *Anxiety* **and other works** 1917–24
Watercolour and blue crayon, 431 × 628 mm
Munchmuseet, Oslo

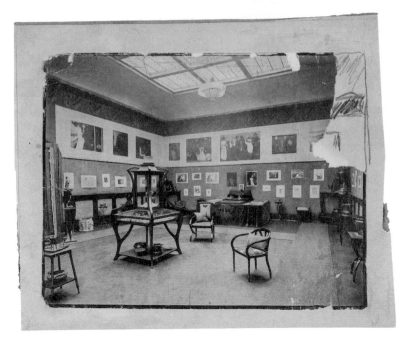

Edvard Munch's exhibition at P.H. Beyer & Sohn's gallery in Leipzig, 1903
Unknown photographer. Munchmuseet Archives

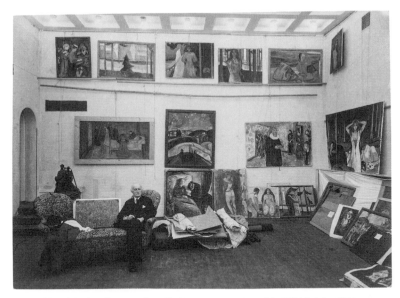

Edvard Munch in the winter studio at Ekely, on the occasion of his 75th birthday, 1938
Photo: Ragnvald Væring. Munchmuseet Archives

dominant forces. It is precisely here that we see the importance Munch gave to the text. In parallel to the visual narrative, the titles of the works listed in the catalogues provide a condensed table of the contents of the exhibitions. They form a kind of second narrative, a sequence of events with a subject and an atmosphere, and their sequential list of works lays the foundations for the viewer's 'reading' of the frieze. Coherence gradually emerges, as Munch, in quest of a commission, explains in a leaflet published in 1919, *Livs-frisen* (The Frieze of Life): 'The Frieze is intended as a number of decorative pictures, which together would represent an image of life. The sinuous shoreline weaves through them all, beyond it is the ocean, which is in constant motion, and beneath the treetops multifarious life unfolds with all of its joys and sorrows. The Frieze is intended as a poem about life, about love and about death.'[11]

A Strategy for Control of the Exhibition

Some have suggested that Munch had an exhibition strategy. This idea clashes with art history orthodoxy – the image of an isolated, accursed artist, living only to create and refusing to engage in any commercial activity, which was promoted from the start of his career.[12] In recent years Patricia Berman has countered this cliché, revealing the 'business of being Munch'[13] and the help he received from his network.

Munch's painting emerged in the midst of a series of scandals, starting with the monographic exhibition of spring 1889 (at the students' association in Kristiania), which brought together some one hundred works, which he organised himself and for which he charged an entrance fee. Shortly after this, in 1892, the organising committee of the Verein Berliner Künstler, then hosting an exhibition by Munch, voted to shut it down, bringing the artist a great deal of press publicity. In his correspondence with his aunt,[14] he does not appear at all alarmed by the ongoing scandal and indeed seems to find it amusing. In reality it brought him instant, widespread fame in Germany.

Crucially we can see that Munch very quickly began putting on solo shows, at a time when this was unusual, and refused to take part in many collective exhibitions. From 1902 he focused on his own exhibitions and made his living from selling tickets rather than pictures. He did make some exceptions for shows that enabled him to enhance his fame, continuing to exhibit at the Salon des Indépendants, due to the importance of the French art scene, and also participated in international exhibitions, notably Cologne in 1912 (where he did, however, have an entire room to himself), San Francisco and the Armory Show, New York, in 1913.[15] Similarly, in quickly abandoning his contracts with his dealers (Paul Cassirer for prints and the Commeter gallery for paintings), Munch was clearly seeking to control the sale of his works.

Should this strategic dimension be seen as a reflection of commercial concerns? Without ruling this motive out, Munch might also and perhaps primarily have been seeking to retain control over the exhibition and reception of his works, and so to preserve their meaning. He created miniature 'portable exhibitions' that facilitated the promotion

of his art. He also made catalogues of works for sale, in the form of albums of black and white photographs to be shown to potential buyers, which indicates that he sold the works individually. On several occasions he also organised exhibitions with the manifest aim of influencing public opinion and getting his art accepted in all its singularity. His exhibitions outside Norway brought him international recognition, which ensured his success when he returned to his home country for good in 1909. In another move to exert control, around 1911 and with the help of Jens Thiis – an early supporter of his work, who took over as head of Nasjonalgalleriet in Kristiania in March 1908 – he mounted a travelling exhibition with the aim of presenting his designs for the Aula (festival hall) at the University, a commission to be decided through a competition, in order to influence public opinion and, by extension, the jury.[16]

This exhibition strategy was also intended to enhance Munch's visibility and to maintain a position that had been hard to acquire. Tina Yarborough reveals the way that he relocated his exhibitions after WWI in order to preserve his place in the Norwegian art market, while distancing himself from an aesthetic too closely associated with Germanic art.[17] However, we should not place too much emphasis on this 'turn', given the artist's rapid 'return' to the motifs of *The Frieze of Life* in the 1920s. After an interruption due to his work on the Aula decorations, he returned to work on the frieze in 1915, culminating in a new exhibition in 1918, in which older versions were shown alongside more modern reworkings. Munch announced this exhibition himself in the press, by publishing an article entitled 'Livs-frisen' in the daily newspaper *Tidens Tegn* on 15 October, the day of the opening. This was the first formal use of the title. In the spring of 1919, in the booklet *Livs-frisen*, he responded to negative criticism and explained the approach behind the cycle.

Working for Posterity

Was this effort to control the exhibition and reception of his works a reflection of Munch's goal-orientated desire to gradually construct a body of work? This idea would seem to be undermined by his constant reworking of the same motifs, themes and indeed works, to the point where it might seem that he was sometimes going backwards. But the motive that drove him to construct his own story and to tell it himself can perhaps be found in the idea – ever present in his mind – of being part of a genealogy of modern art and the grand narrative of art history. Munch reveals a paradoxical tendency towards a certain anachronism, in the form of a (very Nietzschean) call for creation through self-generation, and at the same time wanting to be part of a history, a narrative, by holding monographic exhibitions, or actively contributing to the development of catalogues raisonnés and even biographies.

In recent years many publications and exhibitions have focused on Munch's later work, and highlighted a noticeable change to his aesthetics in the early 20th century. A great contrast has been identified between his more luminous, brightly coloured and lyrical works, and his art of the 1890s. Some have even suggested a kind of dichotomy between two periods of

his art. And yet at the same time it has been noted that, in the 1920s and 1930s, Munch deliberately adopted what has been called a 'retrospective attitude'.[18] In this period he painted new versions of the motifs of *The Frieze of Life* (for example *The Dance of Life*, and *Ashes* [p. 35], which he painted at Nasjonalgalleriet in Oslo, using an earlier version of the work as his model). At the same time he reworked old writings, diaries and notes to publish the booklet *Livs-frisens tilblivelse* (The Origins of *The Frieze of Life*) in 1929.

Reinhold Heller has considered the way that Munch acted as the guardian of his own art for future generations, analysing two photographs taken late in his life, in December 1938 at Ekely, to mark his 75th birthday (p. 16).[19] In them he poses as the protector of a global, self-generating body of work, which he plans to bequeath as a whole with the meaning he gives it. Munch then becomes the curator of the work he has created, seeking to ensure its preservation at a time when his paintings were being taken down in German museums and his position in the history of art was under threat.

This portrayal of Munch as the collector and legator of his work finds its most important expression in the will he wrote on 18 April 1940, nine days after the German invasion of Norway, leaving his collection to the City of Oslo with the aim of establishing a Munch museum. At this time, as ever, he posed with the works of *The Frieze of Life*.

1 Note N 46, 1930–34. Munchmuseet.
2 Berman 2017–18.
3 Guleng 2013.
4 Heller 2017, pp. 35–47.
5 Yarborough 2006.
6 On this, see Pierre Wat's essay 'The Sinuous Line of Life' in this book.
7 Guleng 2013.
8 Letter to Johan Rode PN 20, 8 February 1893. Munchmuseet. See also Guleng 2008–09, p. 227.
9 For a reconstruction, see Guleng 2013, p. 132.
10 Guleng 2013, p. 138.
11 Munch 1919.
12 Notably by Julius Meier-Graefe in his essay in Przybyszewski 1894 and by Curt Glaser in his biography of 1922 (see Glaser 1922 and Glaser 2008).
13 Berman 2017–18.
14 Letter to Karen Bjølstad N 785, 12 November 1892. Munchmuseet. Cited in Woll 2008 and in exh. cat. Oslo 2008–09, pp. 85–103.
15 See the Chronology in this book.
16 On this, see essays by Patricia G. Berman and Estelle Bégué in this book.
17 Yarborough 2006, p. 67.
18 Steihaug 2013, p. 13.
19 Heller 2017, pp. 35–47.

Munch's Haunts
and Social Circles

Øystein Ustvedt
Curator
Nasjonalmuseet, Oslo

One of the very last artworks Edvard Munch created in the course of his long life was a tiny lithograph, a portrait of a friend from his early years in the critical 1880s: Hans Jæger. Munch was over 80 while working on it over Christmas 1943, and Jæger was long dead. The picture was also a repetition of another lithograph made almost 40 years previously, itself a piece based on a painting made in 1889 (p. 119). Why Munch kept coming back to this motif several times, right up to the end of his life, we can only speculate, but Jæger was obviously important to him.

What's more certain is that the lithograph reveals some crucial aspects of the way Munch conceived his images. Firstly, it shows the significance of Kristiania's cultural circles in the 1880s and Munch's close connections with radical authors and intellectuals of the time. It reveals an interest in graphic art, and for new pictorial media and techniques. The repetition of motifs and themes is also characteristic. It's something Munch often did, revisiting older motifs at different stages of his life. In addition, the lithograph shows that Munch was also interested in traditional pictorial genres. It was with his experimental figurative compositions, stripped-down in form, that he captured attention and became the world-famous artist that he is today, but throughout his entire career he also worked with portraiture, scenes of everyday life and landscapes. However, there's a different reason why Hans Jæger's portrait is specifically highlighted here. It's because Jæger was hugely inspiring to Munch's artistic approach and ambition. Jæger encouraged his friends and fellow bohemians to be sincere and truthful, and to make use of themselves and material from their own lives and immediate surroundings in their work.[1]

In this essay we will take a closer look at all this, beginning with some of the most important places and artistic circles in which Munch moved; places and circles that made an unusually powerful impression on his artistic practice. Yes, he is often portrayed as a shy, reserved individual; as a lifelong bachelor; as an odd, childless loner. But the mound of correspondence Munch left behind gives a different and much more outgoing, socially connected impression. It shows that he had, and kept in regular touch with, a wide network of contacts: family, friends and colleagues, patrons, assistants and collectors. The material also explains how he was tightly bound to particular locations and cities, which he regularly returned to and featured in his works. Above all, it tells of a socially approachable artist who fully lived his surroundings and his life; an artist who was fascinating, engaging, and appreciated by many people.

1880s Kristiania

Munch became an artist early on. Before he had even reached 17, he was declaring that he wanted to be a painter.[2] But he received no extensive higher education, for various reasons. Largely because he lived in a country that had no further education for artists, and because he came from a middle-class family which couldn't afford to send him off on a longer course of study abroad. However, as we will see, the lack of education meant that he very early became involved in a milieu that was nurturing an anti-academic attitude and which defined itself in opposition to the

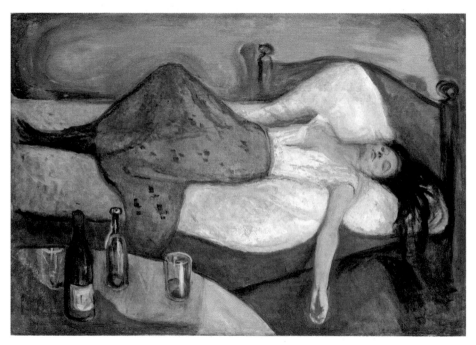

The Day After 1894
Oil on canvas, 115 × 152 cm
Nasjonalmuseet, Oslo

art establishment. They insisted on depicting truth over beauty, and on bringing out each artist's particular, subjective qualities.

At the beginning of the 1880s, Kristiania (today Oslo) was a relatively small and fairly provincial city on the fringes of Europe, but it was changing rapidly. With the end of the Napoleonic Wars and the Treaty of Kiel in 1814, Norway was transferred from Danish ownership to a looser union with Sweden. During this brief interim the nation established a constitution and parliament, while in the years that followed Kristiania was able to build a university and a palace, and eventually founded its own national gallery. These political circumstances gave rise to a strong will to national independence throughout the 19th century, a process that culminated in secession from Sweden in 1905. The idea of a homegrown art academy was continually on the table, but the plans were postponed. After a few preparatory years at the city's Royal College of Drawing, the goal of most people with artistic ambitions was to get out and study at one of the leading art academies of the time, in cities such as Dresden, Düsseldorf, Munich, and later Berlin and Paris.

In the visual arts, a number of prominent artists had made a name for themselves and were eager to develop their own independent Norwegian art tradition, led by Johan Christian Dahl, Adolph Tidemand and Hans Gude, among others. By the beginning of the 1880s, however, a new generation was emerging. They had worked their way through romanticism and historicism, and were moving in the direction of predominantly sober, naturalistic realism. The wind was blowing towards painting *en plein air*, steered by Paris's avant-garde art world which was now considered the artistic cutting edge. During the 1880s, Paris was the yardstick used by anyone who wanted to keep up with what was happening in modern art. But unlike before, the younger artists now began moving back to Norway after completing their education, or settled down there for longer periods.

In this way, painters such as Christian Krohg, Erik Werenskiold and Frits Thaulow became important precursors for Munch and his fellow students. Via these painters and certain well-informed art critics, they were able to gain advance knowledge of what was going on, despite never having set foot in Munich or Paris. A strongly growing economy and a blossoming cultural scene gave rise to a vibrant art community in the new capital, manifested in two new art institutions: Nasjonalgalleriet and Høstutstillingen (the Autumn Exhibition). The latter was an annual, artist-run exhibition, established in 1882 as a direct rival to the more conservative Christiania Kunstforening. The opposition between the two venues stirred up debates, disputes and violent exchanges. Munch came of age, in other words, amid an art world that was lively, full of tensions, and well positioned internationally.

Three Milieux, Four Phases

Munch didn't lack for either talent or supporters. On the contrary, at the College of Drawing he was one of the head teacher's favourites, and among the students he was hailed as the most promising. In the absence of a

proper education, it was three particular milieux which came to wield the most influence during these early years. First and foremost, of course, was his family background: his upbringing in a bourgeois middle class family headed by a deeply religious father who was a doctor, and an aunt who took over the running of the household after his mother's death (she died of tuberculosis when the artist-to-be was just five). Honour, ambition and a sense of duty ran in the family, especially on his father's side, which included a noted portrait painter and one of the country's foremost academics (the historian P.A. Munch).

Next was Kristiania's youthful art scene at the beginning of the 1880s, which blatantly promoted realism as an ideal form, and which was interested in the current fad for open-air painting. Some of them set up a studio together where they received tutoring and guidance from their slightly older colleagues. Impressionism was on the agenda, even though few of them had either seen an impressionist canvas or fully understood what it involved.

Equally important in Munch's development in these years, however, was that he entered a milieu which stood in pronounced opposition to the current bourgeois culture and the establishment; a critical, anti-cultured bohemian scene – the Kristiania Bohemians – which congregated around the tables of the Grand Café on the main street, Karl Johan. Here the talk was all free love, seeing through society's double standards and depicting reality unfiltered. Truth and reality were paramount, and artists had to write about themselves and their own lives. This was advocated, above all, by Hans Jæger, a writer and activist who served as one of the scene's most vocal and controversial leaders.[3]

Out of all this, Munch built up an exceptional artistry which, from very early on, was usually considered to have developed over three or four different phases. First, a period of realism and Impressionism in the early 1880s; then the decisive Symbolist period through the 1890s, when he created the majority of his most famous works, wrote texts and began making prints; and then a clear artistic change of direction in the early 1900s. That was when he was first taken seriously as a modern master and recognised as an Expressionist pioneer. This last phase extends for almost the next 40 years, even taking into account certain striking changes that appear in his work around 1930, as a result of an eye infection.

Beyond Realism

Munch's first independently produced pictures display a wide range of interests, but mostly landscapes, street scenes, portraits and everyday life. These pictures have, for the most part, a grounding in the artist's immediate, quotidian surroundings. Painting outdoors, directly in front of the subject, was the favoured method of the young artists, preferably with slightly coarse brushwork, which corresponded to a subjective or personal involvement. The choice of a prosaic motif and the absence of any idealisation was typical of this realist approach. A growing idea at the time was to depict what one actually saw, direct and unvarnished, but at the same time in an independent or individual style. This was a general move

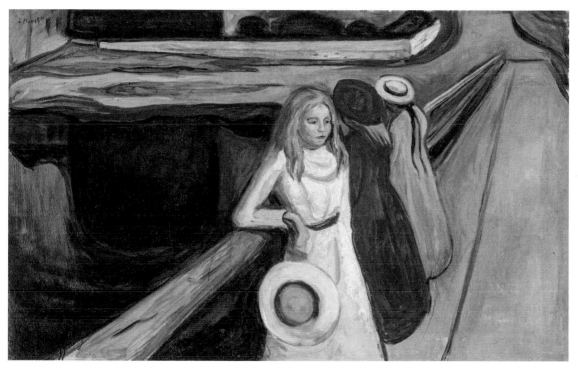

The Girls on the Bridge 1901
Oil on canvas, 84 × 129.5 cm
Hamburger Kunsthalle, Hamburg

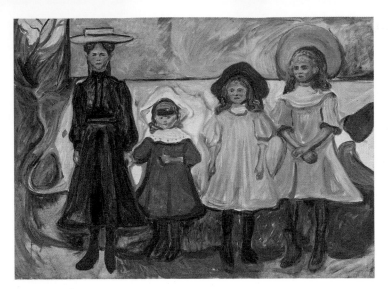

Four Girls in Åsgårdstrand 1903
Oil on canvas, 106 × 145 cm
Munchmuseet, Oslo

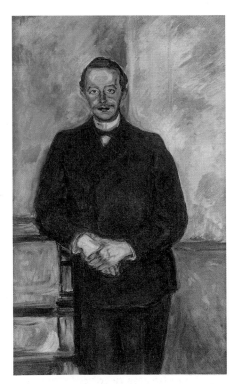

Max Linde in Sailing Outfit 1904
Oil on canvas, 133 × 81 cm
Munchmuseet, Oslo (Rolf Stenersen Collection)

away from academic rules and regulations, allowing them to concentrate on getting down what they could actually see. Munch's anti-academic attitude can clearly be seen in the way, for example, he never bothered about making copies of works by the old masters, nor did he make preliminary studies or cartoons in preparation for his studio compositions.

In Munch, this 'painterly realism' is most visible in his early street scenes from various locations around Kristiania, with contemporary people clothed in the fashions of the day; and in his portraits, in which we are brought very close up to the subject. Many of them are in a similar style to the works of Thaulow and Krohg. They acted as important champions, while representing slightly different points of view. Thaulow emphasised the value of art for its own sake: anything could be a subject as long as it was well painted. Krohg was more of a figurative painter and, in contrast, stood for a more empathic and socially engaged art. But both of them ended up supporting the new ideal of participating in their own time, or of painting images of their own time: *il faut être de son temps*. They made Émile Zola's words – 'Art is a corner of creation seen through a temperament' – their own.

In 1886 Munch was included for the fourth time in the Autumn Exhibition, which by that time had become an important annual event in Kristiania. But this time he attracted some serious attention and became a name many people took notice of. A large painting, modestly entitled *Study*, was roundly commented upon and criticised. Was the painting a masterpiece or a total failure? The coarse texture and the unfinished quality of the motif caused many reactions, and some even wrote it off as an incomplete artwork. Instead, the work was interpreted as a calculated provocation from a young, self-aware artist bound up with the notorious Kristiania Bohemians. Since then, *The Sick Child* (1885–86) has become known as Munch's big breakthrough, a characteristic *succès de scandale*, but it was also a painting that went on to anticipate a central theme in his art – sickness and death – as well as some of his later routes away from painterly realism. He himself regularly returned to this work, mentioned it in his writings, painted several later versions and made variations on the theme in different graphic forms. Today the picture's rough execution is more usually interpreted by placing greater emphasis on its emotional involvement; about the feelings that it stirs up: a sense of loss, serious illness and premature death.

The Female

Around the same time Munch turned to another subject that he would often come back to: representations of the female, shown in different settings and at different stages of life. The embryonic version of this running theme can be seen in his early portraits and depictions of young women doing everyday tasks, but also in his many pictures of his slightly younger sister Inger. For a while, she was practically his muse. But in those days it should also be noted that the first versions of iconic masterpieces such as *The Day After*, *Puberty* and *Madonna* were being made. The first iterations of these were soon lost, and we only know them today from their later, mid-1890s versions. They remain some of Munch's most powerful and intimate

depictions of women. They too deal with everyday scenarios, but here we are drawn deep into the sphere of intimacy, in a way that transcends the more controlled representational work. There is something confrontational and effusive about the way the motifs are painted, and they are suffused with deep emotional and psychological empathy.

Puberty and *Madonna*, especially, seem to be based on a willingness to sympathise with the female figure and scene depicted; an ability to focus on a condition that he himself, as a man, could not fully experience in any real sense. In the former, a naked girl is shown sitting on the edge of a bed, her arms covering her budding genitals, her eyes wide open. The shallow picture plane, with the figure pulled into the foreground, makes it seem as if she is leaning towards us. Behind her, the light casts a long shadow, but it appears to have more to do with the girl's mental state than a realistic portrayal of the lighting conditions. In *Madonna*, a young, attractive, naked woman is shown in what could be seen as the throes of lovemaking. It's as if she is caught in the middle of an orgasm, or even at the moment of conception. It's not difficult to understand why many people at the time found such images provocative and offensive, even pornographic. One motivating impulse behind the picture was Munch's own first serious love affairs, as well as the Kristiania Bohemians' obsession with free love, the relationship between the sexes, and female sexuality.

As in the portraits and urban scenes, it's reasonable to suppose that these early figurative paintings grew out of real-life observations and experiences. He witnessed premature illness and death first hand with his own sister Sophie, who died of tuberculosis in 1877, but also from accompanying his father on medical visits to private homes. The family lived in cramped proximity, and at home he observed his sisters' growth from children to women. And the bohemian scene offered up extravagant lifestyles, the trials of love, and the fact that women too had their own sexuality.

Åsgårdstrand

In his work, Munch developed an early affinity with particular places and environments. In the summer holidays throughout the 1880s, the Munch family often rented a house on the coast approximately 100 km south of Oslo, and this area – in and around the village of Åsgårdstrand – came to hold great significance. From 1889 onwards, Munch spent nearly every single summer here, and made all kinds of work inspired by the local surroundings. In 1898 he bought a sailor's cottage just outside the village centre, which today is known as Munch's House, a well-preserved museum.[4] For many years, this would be his favourite spot: '...the only nice house I have ever lived in'.[5] His attachment to individuals whom he knew well, and to places he was drawn to, were blended together in several paintings such as the 1889 portraits *Hans Jæger* and *Summer Night: Inger on the Beach* (p. 121). With its peaceful, atmospheric midsummer evening light, contemplative composition and 'painterly realism', the latter caused a stir when it was shown at the Autumn Exhibition in 1889. Jæger's portrait, on the other hand, met with more hostility and scepticism. It was included

in Munch's first large scale solo exhibition and showed a recognisable representation of a person many considered deeply immoral and a revolutionary enemy of the people. Solo exhibitions of this kind were very unusual at the time, and the portrait of Jæger undoubtedly helped to raise awareness of the event.

Inspired by Gustav Courbet's and Edouard Manet's famously self-reliant solo manifestations, Munch succeeded in attracting considerable attention. Later, these kinds of solo exhibitions became one of his preferred ways of showing his work. In the beginning he didn't sell much, but one advantage of showing in this way was that you could charge an entry fee, which for a long time was an important source of revenue. Such exhibitions, however, meant that the individual artworks could be seen more in relation to each other, and this would become a key tenet for Munch: that many of his paintings 'belonged together' or worked well shown side by side. Munch's pictures and his 'painterly realism' appear to have had a persuasive effect in 1889; that autumn he finally received the state travel grant which he had applied for several times. Thus, he was able to embark on his first major study tour abroad.[6]

Paris and Berlin

A longer stay in France, in Paris and on the Mediterranean coast, forms the prelude to the next big phase in Munch's art, a period which began to unfold in earnest over several of the ensuing years in Berlin. Many of Munch's best-known works come out of this period. As well as painting, he writes sketches and drafts of literary texts, and begins working with prints. His affiliations with various bohemian scenes continue, especially in Berlin, where, early on, Munch falls in with a group of writers, musicians, artists and intellectuals known as the 'Piglet Circle'. It's Swedish dramatist August Strindberg who renames their local drinking hole on Unter den Linden 'The Black Piglet'.[7] In 1895 Munch portrayed himself as a bohemian artist in the painting *Self-Portrait with Cigarette* (p. 124), lit dramatically from below, as if on a stage, with a burning cigarette in his painting hand, trembling with nerves and placed strategically in front of his heart. Munch regularly returned to representations of himself and the role of the artist as a theme. In many contexts, he emphasised that the task required sacrifice, pain and self-denial, a clear feature in works such as the woodcut *Blossom of Pain* (1898, p. 222) and in comments like: 'All art must be born in your heart's blood – art is your heart's blood.'[8]

The works from this first Berlin period are characterised by increased simplification, emphasising flattened shapes, curving lines and an exploration of the medium of paint itself. Open, washed-out areas and flowing paint are allowed to stand out in alternation with impasto, restless strokes and flat, saturated colour fields. Munch is seriously developing a rapid, sketch-like way of working, without caring too much about filling in details or treating the surface of the canvas with an even finish. This is the point when he really emerges as the master of the unfinished artwork. And it is primarily this rough, slapdash method of painting that leads to his first Berlin exhibition ending up as a veritable scandal. In Paris, typically, he

never applied to take part in the still-prestigious Salon, but rather identified with the many radical outsider scenes and the *refusés*. Instead, the Salon des Indépendants, established in 1884, became his preferred place in Paris, as well as certain progressive private galleries and art dealers.

But it was in Berlin that Munch first established himself as an artist to be reckoned with outside his homeland. It started with a remarkable incident. His first exhibition in the city, arranged by the Verein Berliner Künstler (Association of Berlin Artists) in 1892, provoked violent reactions. It was reviewed in extremely negative terms, held up as an outrage and a disgrace. Some accused the association's management of poor judgement for having accepted the show in the first place, and demanded their resignation. The matter caused a split within the artist-led society, which by a small majority decided to close the exhibition down after just one week. The rift became a landmark event in German cultural life, and laid the ground for the breakaway protest group the Berliner Secession, a new institution that promoted avant-garde, radical modern art. 'The Munch affair' was a challenge to people's entire understanding of what art was. The exhibition became a characteristic *succès de scandale*, which paved the way for Munch's powerful German breakthrough.

Literary Writings

At that time, Munch enjoyed close friendships with musicians, writers and intellectuals: Strindberg, Dagny Juel, Stanislaw Przybyszewski, Julius Meier-Graefe. Many among the Piglet Circle were already publicly known as radical authors, or so they later became. Munch, too, wrote many texts in those years, mostly in a flowing, free-associative style that followed Hans Jæger's injunction to 'write one's own life'. To what extent Munch harboured literary ambitions is debatable, but in general the 1890s were on the wane as a literary and Symbolist period. This period has also given us the nearest thing we have to an artistic manifesto in his own hand. Here is an extract:

> I was going to do something – begin [working on]
> something. It would grip
> others as I was gripped now
> I would depict two [persons] in
> the most hallowed seconds of their lives – [...]
> In the instant one is no longer oneself –
> but merely one of the thousand
> generations – that
> propagates the next generation. [...]
> And the public will sense
> the sanctity of this – and they will
> take off their hats as in a church. [...]
> There must be no more painting of interiors,
> and people reading and women knitting.
> There must be living people who breathe
> and feel, suffer and love.[9]

Here, his objectives and the way ahead seem fully formed and clearly expressed; to move beyond the prosaic representation of reality and create a more subjective and emotional art, or make work that largely dealt with people's inner feelings and existential life experiences. In this way Munch was in accord with another of his generation's young authors from Norway who would later become well known in Europe: Knut Hamsun. In 1890 Hamsun drew attention in Kristiania with his ambitions for a literary form that would transcend the social issues of the day and to a greater extent depict material 'from the unconscious life of the soul'.[10]

Otherwise, it's in Berlin's radical outsider scene, the Piglet Circle especially, that we find the germ of a deeper and more analytically-minded interest in Munch's work. In 1894 his fellow bohemian Przybyszewski edited what would be the first book on Munch, featuring four essays, each trying to understand the phenomenon. Przybyszewski himself contributed the foreword and the most important text. He believed that in Munch's paintings could be found examples of a new form of expression which was about showing spiritual phenomena via external events – a new 'psychic naturalism'.[11]

Melancholy

Most of Munch's best-known motifs appeared in this period, or achieved their final form, including *Puberty*, *Madonna*, *Melancholy*, *The Kiss*, *Vampire*, *Summer Night's Dream (The Voice)*, *The Dance of Life* and *The Scream*. The emphasis on emotion and mood, however, also characterises his landscapes and portraits, which are frequently filled with the pale light of the Nordic summer night. The way the painting *Melancholy* developed is typical of his approach, but also of the way Munch was now able to utilise material from his own life – his experiences and surroundings – as a starting point for many of his works, ideally combined with motifs that had a historical resonance. Like the portrait *Summer Night: Inger on the Beach*, *Melancholy* (p. 137) is based on a painted figure in profile located in the foreground, sitting outdoors by the sea. A curving coastline has been placed in the background – a motif that eventually became a recurring feature in Munch's work. But whereas the portrait of his sister is made with an emphasis on lyrical tone and brooding atmosphere, *Melancholy* has more of the quality of condensed symbolism. The handling of the subject is rough and stylised; the sky's wavelike shapes, especially, create the sensation of movement, intensity and rhythm. Shapes and colours are brought together in a psychologically loaded unity.

The figure of 'melancholy' was itself a popular archetype, traditionally associated with representations of the Seven Deadly Sins, but revitalised in more recent times in sculptor Auguste Rodin's visions of Hell. In Munch, the motif was removed from its biblical connotations and linked instead with an inner, spiritual condition. The melancholic was now a human being full of feelings of disempowerment towards their circumstances and the realities of life. The motif also came out of an actual situation among his circle of friends: Jappe Nilssen's unhappy love affair with Oda Krohg, both of whom were part of the Kristiania Bohemians. The painting is a good

example of how Munch was now able to deploy familiar motifs while imbuing them with new forms and meanings.

The Frieze of Life

Many of these key motifs would go on to be included in a large-scale project which Munch initially called *Study for a Series: 'Love'* and *Images of Life*. The project was later given its final title: *The Frieze of Life*.[12] The concept of this kind of sequence of paintings hanging together in a frieze took shape during the 1890s and was exhibited in its totality in two large exhibitions, one in Leipzig in 1903, and one the following year in Berlin. The selection of pictures could vary, but certain motifs – such as *The Scream*, *Madonna*, *The Kiss*, *Vampire* and *Melancholy* – remained. Some years later, Munch published a piece of writing in which he justified his motivation for linking them together in this way:

> The frieze is conceived as a sequence of decorative images, which, collected together, are meant to give a picture of life. Throughout it runs the curving shoreline, out there lies the sea, which is in constant motion, and beneath the treetops, there are so many different varieties of life, with all its joys and miseries.[13]

The works stand alone in their own right, but when viewed together they can also come across as a kind of narrative comprising a sequence of events. From a blossoming love affair and erotic awakening to the portrayal of intimacy, desire and devotion. Subsequently it shifts into argument, ambivalence and conflict, and finally breakup, separation and death. Some of the monumental compositions with allegorical qualities stand out as central: *Metabolism: Life and Death* (p. 147) and *The Dance of Life* (p. 79). The theme is the cycle of life, either through the different stages of a woman's lifetime or via the concept of metabolism: substances and materials that are created, evolve and pass away. The range and depth of the subject matter make this something new in the history of art. Love and desire had of course been portrayed and interpreted many times previously, but these were usually rooted in biblical or mythological stories. The paintings in *The Frieze of Life* toned this down, although traces and remnants of these are referenced in Munch's use of titles, motifs and symbols. He was not the only one to address the condition of love in such an open and direct manner. On the other hand, of all the artists of his time, he was perhaps the only one who approached it in such depth, and on such a large scale.

Painter-Printmaker

Around the mid-1890s, Munch began working as a print artist, which would become a main occupation in this period. He had already come a long way with what he had taught himself, but by working with several of the leading master-printers of the day in Berlin and Paris, he quickly became familiar with a wide range of techniques and methods. He first used copper plates, then lithographs and woodcuts which could be overprinted with colours. Lithography, in particular, proved useful with its technical flexibility, ease

of reproduction and the possibility of creating 'paint-like' effects. At the end of the 19th century this was a totally new medium, mainly used for reproductions and associated with automation and commercial business – posters and advertisements.

Munch was one of the first to make extensive use of lithography for artistic purposes. The woodcut, for its part, represented the oldest and most elementary way of creating an art multiple. The wooden board invited the artist to work with sharp contrasts, bold lines and many other kinds of mark-making, and to use stencils or other strongly stylised types of images. By experimenting with these techniques, wrestling with their unique properties and visual qualities, Munch expanded the possibilities of this medium. For example, errors, mis-strokes and manufacturers' faults could be incorporated into the visual scene, and in a manner that made the actual making of the image crucial. Instead of being discarded, the knots in the wooden boards and the jagged edges of the lithographic stone could be used as an important element in the printed image. In his woodcuts, he later developed his own 'jigsaw' technique. By sawing up the wood into separate pieces, which could be individually coloured and put back together again like a jigsaw puzzle, he gave himself the option of printing identical motifs with different colour combinations.

Munch transferred many of his most famous and popular works to print versions, without them ending up looking like reproductions. The motifs, in fact, developed in new ways in accordance with the reduced dimensions, the peculiarities of the technique, and the properties of the paper underlay. In some cases he experimented further by colouring the individual impressions after printing, thereby creating a new genre: the hand-coloured print. In this way, for instance, features such as red and blue brushstrokes could be added as a special feature to the lithographic version of *Madonna* (p. 159).[11]

The time Munch spent working on lithographs and woodcuts was a period of obsession and innovation. His motivation for working with prints was mostly, perhaps, economic at first, but clearly over time he developed an innate sense of what was special about these techniques, for the creative processes themselves, and for the possibilities inherent in being able to duplicate an image and make different versions of the same picture. In addition, the print medium opened up a vital factor for Munch, which was being able to attend closely to all the different stages in the process of making a picture.

His printmaking lasted throughout his whole life. When, at the end of his life, Munch once again chose Hans Jæger as the subject of a lithograph, he had more than 700 printed motifs behind him and was long established as one of the leading 'painter-printmakers' of the 20th century.

Girls on the Bridge

During the 1890s, Munch developed his own form of landscape painting, often located in the area around Åsgårdstrand. The golden Nordic midsummer light, with full moon over mirror-calm waters, became a running theme in addition to the curving beach. On some occasions,

such landscapes came to serve as a backdrop for representations of human conditions or dramas – or, as it sometimes seemed, the other way round. In other works the relationship between the group of figures and the landscape was more evenly weighted, as in his most popular and most frequently reproduced motif: *The Girls on the Bridge* (p. 25).

The surroundings here are easily recognisable as a part of Åsgårdstrand looking towards the sea. Dressed in different colours, the three girls are shown as individuals within a group. They peer down into the water, as if they are deep in an intimate conversation. What are they talking about? The picture's enigmatic aspect is enhanced by the way the girls appear to be partly childlike, partly on the cusp of adulthood. In this way, their placement on the bridge is significant: in other words, they are standing on the threshold of different places and states. The bridge is also a familiar motif which is repeated in several of Munch's works. It is often a place where fundamental experiences and relationships between the individual and the mass are enacted. But in *Girls on the Bridge*, there also arises a meta-perspective in the way the motif is composed. We stand looking at them standing and looking.

Munch never started a family, nor did he have children, but around this time portraits and other representations of children in different settings and doing various chores increasingly seem to be an obvious area of interest. Many paintings and drawings display both sympathy for and understanding of children's particular mental disposition, whether in individual portraits or shown playing in water or standing on the edge of a mysterious, frightening forest. In *Four Girls in Åsgårdstrand* (p. 26), they are seen from the front, standing side by side, holding each other's hands as if they are slightly unsure of the situation. As a group they represent the different states and stages of childhood, from small child to teenager and young adult.

An Artistic Renewal?

In the early part of the new century, Munch went in new directions. After several turbulent years of constant travelling, with shorter stays in Norway, he settled down once more in Berlin and lived in Germany for a longer period beginning in autumn 1902. By this time he had already come through a lengthy, difficult relationship with Tulla Larsen, which was now over. However, he carried on with the wayward, bohemian way of life which had become the norm, and which only became more pronounced.

In many surviving letters from the time, friends and other correspondents express deep concern for his lifestyle and his mental state. This reaches a peak in 1908 with a nervous breakdown, followed by a period of half a year's convalescence at the clinic of Dr Daniel Jacobson in Copenhagen. At the same time as all of this, Munch achieves enormous artistic success. Big exhibitions are staged both at home in Norway and all over northern Europe. He begins selling well; upcoming collectors start showing their interest; and he begins to work with the most avant-garde dealers and galleries of the time, such as Paul Cassirer in Berlin and Galerie Commeter in Hamburg. In 1908 he is awarded the Order of St Olav, an

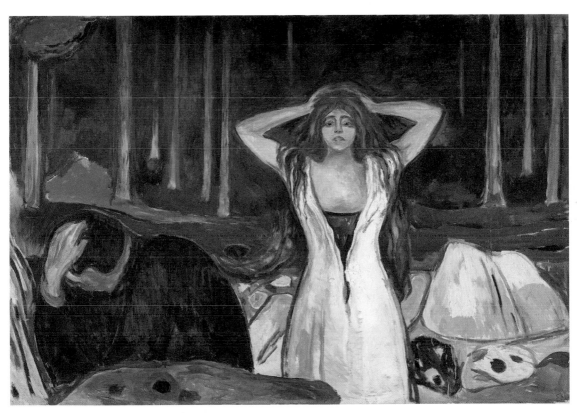

Ashes 1925
Oil on canvas, 139 × 200.5 cm
Munchmuseet, Oslo

honour bestowed by the royal family of Norway for 'extraordinary services to Norway and humanity'. Munch accordingly replaces his social circle, coming increasingly in contact with a milieu of wealthy, educated society figures. Many of them become important collectors and supporters.

Around 1900, the eye doctor and art collector Max Linde (p. 26) from Lübeck begins to buy Munch's works. Thus begins a long chain of events which eventually included a large collection, a commission (unfinished), a print portfolio and a book. Linde also introduces him to other people of importance, among them the lawyer Gustav Schiefler, who eventually initiates what will be the first catalogue raisonné of Munch's printed works. In Weimar, magazine editor and diplomat Harry Graf Kessler hooks him up with the architect Henry Van de Velde, the head of the Nietzsche archive Elisabeth Förster-Nietzsche, the banker Ernest Thiel and others from the so-called Neues Weimar scene. And in Berlin, theatre director/producer Max Reinhardt commissions Munch to design sets for a production of Henrik Ibsen's *Ghosts*, and later to decorate the foyer of his newly built theatre in the city.

These changes in Munch's life and art can clearly be seen in his many portraits. Close family members, colleagues and bohemians are now replaced by scientists, doctors, captains of industry and other representatives of society's progressive elite. In Munch's paintings they are presented as outgoing, self-assured personalities playing an active part in society and modern times. Whether it's the Norwegian consul Christen Sandberg, Harry Graf Kessler or Max Linde, there is no mistaking their body language: they firmly occupy the picture space and speak openly and directly to the viewer. The way they strut with broad legs planted solidly on the floor signals virility, self-confidence and significance.

But in the way they are handled, the paintings are often very different and, seen as a whole, they come across almost as variations on the same theme; from very simple and sparse pictures based on thin, smeared layers of paint, to cascades of impasto strokes and frenzied activity on the canvas. Something similar can be seen in Munch's landscape paintings, where the mood-saturated twilight of the Nordic midsummer night is exchanged for blinding daylight or glorious sunrise, or with images of open countryside covered in snow. In contrast to his earlier work, human activity appears much more prominently in many of his current landscapes. They are much more about gardens, parks or cultivated land, or the landscape is linked to labour in woods and forests.

Munch is generally heading in a direction that is lighter, more powerful and more vividly coloured. These changes are seen in both his style and in his choice of subjects. Healthy, naked male bodies emerge as a central motif, and dignified workers in the snow, builders and street labourers. The soft, curving brushwork which so dominated his work in the 1890s is now replaced with a more systematic, patterned sense of organisation based around distinct vertical and horizontal lines and movements. The colours become clearer, the lighting stronger and the brushstrokes broader. The overriding impression is powerful, monumental. We can detect a movement away from the introspective examinations of

spiritual conditions and drama-laden relationships and towards a more outward-looking, life-affirming vitalism. This overwhelming new direction reaches its apotheosis with Munch's substantial décor for Oslo University's new festival hall (the Aula), a work that was begun in 1909 and completed in 1916, with the glorious, glowing, gigantic sun as its central motif.

The changes are very apparent and can also be seen in larger figurative compositions on themes of love, desire and interpersonal relations. But now the motifs are presented with mythological or historical references, as in *Cupid and Psyche* (p. 39) and *The Death of Marat* (p. 216). The story of Charlotte Corday's murder of the journalist and revolutionary leader Jean-Paul Marat in a bathtub during the French Revolution, immortalised in Jacques-Louis David's painting of 1793, is used to create an allegory of a dramatic love affair. In the painting the dialogue is between lying down and standing, active and passive, and is reinforced by an eyecatchingly powerful interplay of colour and brushwork. Blaring orange-yellow and green are surrounded by scrawls of bright colour arranged in a systematic pattern of squares.

Explanations

The fundamental reasons for these changes in Munch's art in the early part of the 1900s have been much discussed.[15] They have traditionally been linked with alterations in his way of life that began with his breakdown of 1908, his hospitalisation and subsequent return to Norway. Others have placed greater emphasis on the previous years' summers in Warnemünde in 1907–08 as a decisive factor.[16] This theory has formerly been justified by Munch's interest in Friedrich Nietzsche and his close contact with the aforementioned Neues Weimar scene.[17] Nietzsche's philosophy emphasised physicality, creativity and vitality, and humanity's instinctive will to life and will to power. However, it's worth noting that the changes came about over time and have much in common with new attitudes beginning to prevail more generally in the era's avant-garde or progressive artistic movements.

Of the Scandinavian artists, one of Munch's closest colleagues – Jens Ferdinand Willumsen from Denmark – was one of the earliest to develop a similar style with strong colours and stylised forms. It was also around this time that artists using bright light and colour such as Vincent van Gogh, Paul Gauguin and Paul Cézanne were identified and promoted as important pioneers. In the years around 1905, Henri Matisse and his Fauvist circle gained attention for their wild, untamed use of strong colours. And in Germany, a younger group of artists picked up the gauntlet and started what we now know as German Expressionism. In this light, it can make more sense to view Munch's new direction in the light of the innovations and changing face of modern art at the beginning of the 20th century, rather than as the result of particular events or personal circumstances.

Breakthrough

In Europe, Munch became a celebrated progressive modern artist at that time, especially in Germany, culminating in 1912 with a comprehensive

retrospective at Cologne's Sonderbund Exhibition. The purpose of this exhibition was to demonstrate the development of modern art and establish a contemporary canon. A wide range of Munch's works were allocated a prominent place and hung in their own room, so that he came across as a boundary-breaking pioneer in line with the likes of Van Gogh, Cézanne or Gauguin. Of all the featured artists still living, only Pablo Picasso was accorded the same recognition. Here, the seed was sown for the idea of Munch as a father figure of Expressionism.

Throughout the 1920s, this institutional acceptance was followed by many retrospective shows, first in Zürich, Bern and Basel, then Mannheim, and finally at none other than Berlin's Nationalgalerie in 1927. More than 200 paintings were assembled and shown in Berlin's public art museum, which at the time included the most advanced modern art salon in Europe: the Galerie der Lebenden in the Crown Prince's Palace.

Into the Sun

In the period following his breakdown and spell in hospital in 1908–09, Munch made changes to his lifestyle. First and foremost, he went back to Norway, pretty much for good, but he also calmed down, toned down his nocturnal carousing, and spent more time at home, as a more settled resident. At first he found a place to live in the southern coastal town of Kragerø, among the sizeable farm buildings known as Skrubben. A little later he rented or purchased several other properties further into the Oslo fjord, at Hvitsten, Ås and Moss. In 1916 he bought Ekely, a large property on the outskirts of the capital, which would remain his permanent home for the rest of his life. One of the reasons for securing these fairly extensive residences was undoubtedly the huge project that he had sought and fought for from the moment he arrived back in Norway, and eventually attained in 1912: to decorate the Aula of the University of Oslo.

Munch had been hoping for this kind of decorative project for a long time, if only to be able to finally realise his *Frieze of Life* on a large scale. The requirements for the Aula building, however, were something else, with motifs connected to history, the passing-on of knowledge, genealogy and motherhood, all to be set in an open and 'timeless' Norwegian mountain and coastal landscape. Here, the new, vitalist influence was given possibly its most blatant expression, in a shining, chromatic sunrise as the focal centrepoint on the hall's end wall.

Munch was keen to do more work of this kind, but apart from the so-called Reinhardt Frieze (1906–07), which was taken down a few years after its completion, and a smaller, privately financed frieze for the Freia chocolate factory in Oslo in 1922, the Aula would be the only decoration he would carry out on such a large scale.

Ekely

Ekely was Munch's final large home. He worked here until his death in 1944, and the pictures that came out of it reflected much of the surroundings and the life that went on there. The property had been developed by a gardener and the surrounding area had an agricultural quality with open

Cupid and Psyche 1907
Oil on canvas, 119.5 × 99 cm
Munchmuseet, Oslo

farmland. Farmers and horses at work, swelling fruit, gaudy flowers and ancient elms, vegetables and building work. Now, as before, Munch didn't bother to seek out a distinctive landscape or a particular handful of motifs, taking his imagery instead from his immediate surroundings. During this time he practically became a 'garden painter' reminiscent of Claude Monet at Giverny or Emil Nolde at Seebüll, but he also continued to experiment, explore and revise. Several outdoor studios were built on the estate so that he could work in large formats under open skies. And if he was not happy with one of his paintings, or if one of them went wrong or became too difficult, the canvas could be left outdoors for a long time, as a kind of punishment, exposed to the wind and rain. This so-called 'horse cure' meant that the work was affected by the environment and chance effects which many artists today find interesting. But in particular, Munch became interested in revisiting his old motifs, rethinking and reworking them. At Ekely he created new versions and variations of many of his major early works, such as *The Sick Child*, *Vampire*, *The Kiss*, *Ashes*, *The Dance of Life* and *Girls on the Bridge*. And in the basement, he installed equipment and printing presses for making graphic works in which these motifs and others were churned out in countless different editions.

The Ekely period falls between two world wars and takes in the darkest period in European history. Munch increasingly retreated from the world in these years, but despite this his works do bear witness to some of what was happening at the time. They display a growing interest in everyday working life, in things that take root and grow, and for edifying subjects connected to fertility, lust for life and earthly human achievements. People at work, or groups of labourers on their way to or from the workplace, was one particular theme that became more important in his work. Alternatively they are portrayed standing in the foreground in snow, resting on their shovels, as if they have just taken a break from their work in order to be painted. Munch had in mind a 'workers frieze', a new monumental decoration that might become part of Oslo's new city hall which was being planned at the time. However, the decision-making process for this project was delayed, and time eventually ran out for the ageing artist.[18]

Painter and Model

The various depictions of the relationship between men and women, over many years, were followed by a host of paintings and drawings examining the relationship between the artist and his model. At Ekely, Munch worked for a long time mostly with the same models and was happy to collaborate with slender young women such as Annie Fjeldbu, Hildur Christenen and Birgit Prestøe, all of whom can be easily identified in several works. These paintings are added to his lengthy sequence of female depictions, only now it's as if the earlier ambivalence, the struggle between attraction and repulsion, desire and impotence, is toned down or shown in a different light. Munch kept up his studies of the female nude, but these seemed to be about sexual urges restrained. Many of the works also contain aspects of self-revelation. In some of them, an elderly male figure enters the frame;

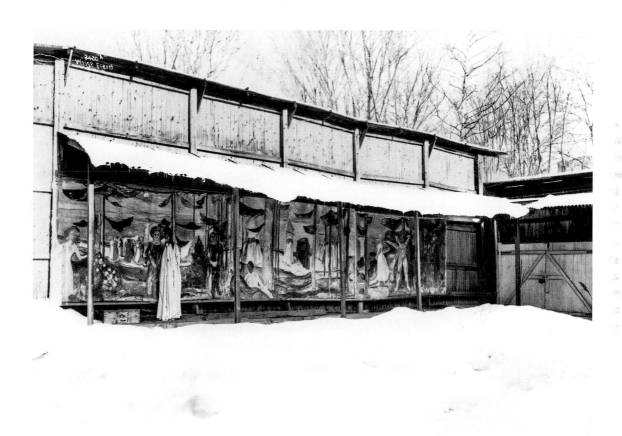

Munch's open-air studio at Ekely, 1937
Photo: Anders B. Wilse

his desire for the young female body is shown almost as a caricature. The surviving source material seems to indicate that the models were well treated, and that there was nothing in the relationship between the artist and his models to suggest that anything sexual occurred – at least, not directly.

Self-Images

From his student days right through the whole of his career, Munch examined, located and cast himself in many of his own works. His many self-portraits comprise a body of work in themselves, and with them he joined the legion of artists who, over the centuries, have cultivated the self-portrait as an important element of the artistic oeuvre. In common with two of his favourites, Rembrandt and Goya, Munch painted himself at all kinds of stages of life and in all sorts of situations, and with different types of identity. We encounter him as a young, ambitious artist; a revolutionary outsider and bohemian; in a state of extreme disquiet, as if burning in Hell; or in abject loneliness. But he could equally portray himself as healthy and vital, with brushes held aloft in a symbol of potency and virility or basking in the sun at the heart of his creative space outside the yellow villa at Ekely. And when, in 1902, he bought his first camera, self-portraits quickly became the main thing he wanted to take. And he kept at it.

Some of the most fascinating and moving paintings of this type, though, arrived right at the end of his life. In these, he pictures a reclusive old man who is confronting old age and approaching death with eyes wide open. Munch paints himself as a crepuscular ghost in this big villa, or else simply stands there, upright and facing the viewer, between a stopped clock and a bed that is waiting to receive his body when he takes his last breath. Given all this, the reason why he chose to return to the old portrait of his friend, Hans Jæger, and create one last lithograph of precisely that image, is ripe for speculation. But in it, there unquestionably lies a sense of recognition and affirmation. Perhaps it's easiest to interpret it as a tribute to a man who, more explicitly than anyone else, believed in the commandment that one's artistic work must stand up for truth, and life as it is lived.

1 The Kristiania Bohemians' first commandment, 'Thou Shalt Write [from] Thine Own Life', published in *Impressionisten* no. 8, 1889. The text is often attributed to Hans Jæger but has also been read as a parody of Jæger's commandments.

2 Sketchbook T 2913, 1879–82. Munchmuseet.

3 The Bohemian movement's name is embedded in Hans Jæger's novel *Fra Kristiania-Bohêmen* (From the Kristiania Bohemians), which was first published in 1885, only to be rapidly banned for its unsavoury content. Jæger was sentenced to a fine and a spell in prison for blasphemy and infringement of public morals, thanks to the book.

4 https://vestfoldmuseene.no/munchs-hus/

5 Letter to Sigurd Høst N 3246, 26 September 1933. Munchmuseet.

6 In the summer of 1885 Munch visited Antwerp and Paris.

7 For an analysis of the Piglet Circle, see Fialek 2007.

8 Note N 29, 1890–92. Munchmuseet.

9 Note N 289, 1889–90. Munchmuseet. Hamsun's position on literature was laid out in the article 'Fra det ubevisste sjeleliv' (From the Unconscious Life of the Soul), first published in 1890 in *Samtiden* magazine. In it he advocates, among other things, for greater attention to be paid to characters' inner spiritual states in contemporary writing.

11 Przybyszewski 1894. For a discussion of the book, see Gluchowska 2013.

12 Munch 1918–19. For a summary of *The Frieze of Life* and related pictorial series by Munch, see Guleng 2013.

13 Munch 1918–19.

14 According to Magne Bruteig, Munch hand-coloured at least 123 of his images in his graphic works, often in several variations, so that in total there were probably around 300–400 of this type of work. They were frequently made as special gifts for friends and contacts, but it seems likely that Munch also made many of them for his own pleasure, with no other objective. This idea is suggested in Bruteig & Zondag 2022, pp. 31 ff.

15 The topic has been discussed by many art historians in the past. For an overview, see Berman 2008b.

16 Sørensen 2006, p. 23.

17 Slagstad 2008b; Rognerud 2011.

18 See Estelle Bégué's text 'Munch and the Grand Decorations' in this book.

The Sinuous
Line of Life

Pierre Wat
Professor of Art History
Université Panthéon-Sorbonne,
Paris

You cannot step into the same river twice. All things spread and then shrink, come close, and then move away.
– Heraclitus

The true birth which is called death.
– Edvard Munch

Cyclical Time

In the work of Edvard Munch, people and things are captured in a state of impermanence, a moment seized in unfolding time. All things, all people, are undoubtedly shown in their present state, but this state can only be grasped when restored to its place in a chain, a kind of gap between past and future, shaped by its origins and destiny alike. The girl in *Puberty* (p. 126) is a perfect example of this. Half-child, half-woman, caught between protectively turning inward and unfurling like a butterfly emerging from the chrysalis, she is an example of the between-person, the person in time, so central to the work of Munch.

Munch chose the title *Metabolism* (p. 147) for his depiction of the biblical motif of Adam and Eve. In this painting, which was to become an important element in his *Frieze of Life* project, he portrays a naked man and woman, facing each other on either side of a tree. In an early state of the painting, the tree – which at this point was a bush – contained an unborn child, emphasising the symbolism of genesis and the union of humankind and nature in the primordial Eden. The scene acquires its full meaning when seen in its carved frame, the top section of which shows a city, while the bottom section, functioning as a predella, shows two skulls, one human, one animal. This vision of Genesis is at once a beginning (the child yet to be born) and an end (the skulls). The title (remembering that 'metabolism' refers to all the chemical reactions that take place within a living being and keep it alive) highlights the circulation and exchanges operating between the two extremes, which together are a manifestation of life. The erotic attraction between the two figures, despite the Tree of Knowledge that stands between them, is a materialisation of the fluids that flow through Munch's painting and give it life. In the compositionally similar but less explicitly biblical painting of the same period, *Eye in Eye* (p. 46), a young couple are seen looking into each other's eyes on either side of a tree. Here, rather than acting as a barrier, the natural element (the tree) appears to be the vector of the erotic energy linking these two desiring figures. As the title *Metabolism* suggests, Munch paints nature like a body through which humours and energies circulate, a nature shaped by time and experienced as active flow.

The fact that Munch so often painted the sea, and more importantly the way that he painted it, gives form to this vision of the world as the fecund, living, animated connection between opposing forces. So many drawings and paintings are traversed by the same sinuous line, reminiscent of the leading edge of a wave at the precise moment when it is caught

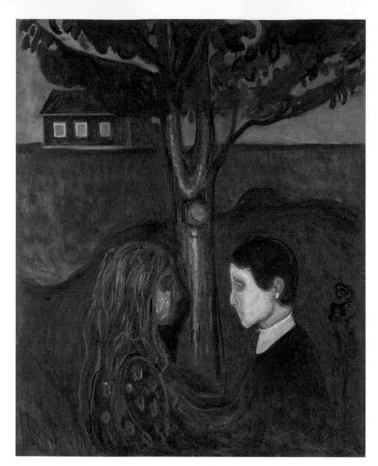

Eye in Eye 1899–1900
Oil on canvas, 136 × 110 cm
Munchmuseet, Oslo

between the force driving it forward and the force that will pull it back, so that it undulates before disappearing, perhaps to return more strongly. To put it another way, so many works are traversed by a sinuous line in which contradictory energies acquire material form, encountering and countering each other in an endlessly repeated cycle. A wave advances and retreats; it is pushed by its past, pulled by its future.

Edvard Munch sees this sinuous line as the image of life itself. Here is what he says about *The Frieze of Life*: 'The Frieze is intended as a sequence of decorative pictures, which together would represent an image of life. The sinuous shoreline weaves through them all, beyond it, in perpetual motion, is the ocean, and beneath the treetops multifarious life unfolds with all of its joys and sorrows.'[1] Sinuosity, perpetual motion and the depiction of multiform life, with joys and sorrows as its antagonistic poles, all combine in a dynamic, temporal and cyclical conception of life as perpetual animation, given material form in a line that is sinuous because it is influenced to an equal extent by two opposing forces, like an eternally renewed beginning.

This line is not confined to the ocean. It reappears in *Melancholy* (p. 137), *Train Smoke* (1900, Munchmuseet), *The Island* (1900–01, private collection), *Summer Night by the Beach* (1902–03, private collection), in the blood red clouds and main figure of *The Scream* and in many other works. Every line is sinuous, that's how the world's metabolism works, caught between joys and sorrows, between high and low tides. The rhythm of this coming and going has a cyclical pattern, like that of the girl's body when she enters puberty.

If we take Munch's wave as a manifestation of time that is at once continuous and cyclical, we can understand the importance he gives to bathers as a motif. Bathers appear in dozens of works and are shown engaging with the sea's waves as with the flow of time. We can see this in a group of paintings from 1908, starting with two entitled *Waves* (Munchmuseet), followed by three more, *Childhood*, *Youth* and *Old Age*, showing naked bathers by the sea. In *Youth* (p. 49) and *Old Age*, the background is a reworking in pale shades of the pictorial approach shown in the two *Waves*, which can thus be seen as preparatory works and also as an active ground, of which these paintings are literally the result. It is this temporal wave in its endless movement that shapes and reshapes people from one age to the next, from childhood to youth to old age. We never step into the same river twice because, in its cyclical movement, a river – or the sea – renders us beings in time.[2]

Were we to seek confirmation of this temporal power of water, the place to look for it, as often in Munch's art, is in the more sombre works such as *The Drowning Child* (1904?, Munchmuseet) and *The Drowned Boy* (1907–08, Munchmuseet). Water is time itself, a place of life and joy, sorrow and death. In it we are born, we play, we drown, we are its fruit, like the *Mermaid* painted in 1896, who is a being of water itself, its creature, and the embodiment of cyclical time through which opposing forces flow.

All of life – people and nature – appears as one great, living body, through which there flows a vital energy that is the manifestation of

ceaseless genesis. Like water, blood irrigates Munch's art, from the cyclical blood of puberty to the fantastical blood of the *Vampire* motifs, in which a kiss becomes a transfer of vital, mortal fluid, or the blood as metaphor of *Red Virginia Creeper* (1898–1900, Munchmuseet), which establishes an equivalence between sap and blood, turning nature itself into a great body animated by its networks and fluids.

It is interesting to approach the painting *Weeping Nude* of 1913–14 (Munchmuseet) in this light, not only because of its resemblance to the motif of *Vampire*, but more particularly because here Munch uses the fluidity of living things in two different ways. One is explicit, in the tears indicated by the title, but he also does it in a symbolic and resolutely pictorial way in the colour red that entirely fills the lower part of the painting, as though the flow of tears had turned into a flow of blood, in an exaggeratedly swollen vision of the imagery of both *Puberty* and *Vampire*. This weeping woman (a subject Munch often returned to) becomes a woman bathing in her own blood, a kind of tragic mermaid.

We see here how Munch biologizes the living world. This is a matter of flow and forces, expressed in a coming and going through time that renders everything sinuous. But it is also a matter of rhythm. The counterpart to the abundance of bathers is the multitude of works that reference the seasons, including, among others, *Spring* (1889, Nasjonalmuseet), *Upper Foss Farm in Winter* (1881–82, current location unknown), *Summer Landscape* (1896, Munchmuseet) and *Summer Night in Studenterlunden* (1904, Munchmuseet). A painting of 1891, *Eroticism on a Summer Evening* (Munchmuseet), recalls the entangled circulation of life and desire that we saw earlier in *Metabolism* and *Eye in Eye*. A couple are shown from behind, walking along a sinuous path, watched by a woman who seems to be acting as chaperone. The couple are reduced to two modest silhouettes and it is nature, in the form of a hilly landscape, that is the real protagonist here, its vitality bringing an erotic dimension to the scene. In many works, from *Fertility* (p. 51) to *Attraction in Landscape* (1908, Munchmuseet), Munch develops an imagery of living continuity between human beings and nature, embodied in love, on the model of the couple in Genesis. His approach to landscape adds to this eroticisation of the world, particularly in forest landscapes, where every tree seems to embody the sap flowing through it.

In this light, Munch's preference for wood as an engraving medium has a symbolic significance that goes beyond any technical considerations. He made extensive use of the materiality of his medium. The veins in his wood blocks are integrated into his prints, both because they naturally create sinuous lines, and also because their presence recalls the metabolism of wood, through the network of veins and the inscription of time in the rings of the growing tree.

Cyclical Life

What Munch sees in human beings and things, he also sees on a macrocosmic level. Life, in its fullest sense, can only be understood as active dualism – joys and sorrows, Eros and Thanatos, beginning and end

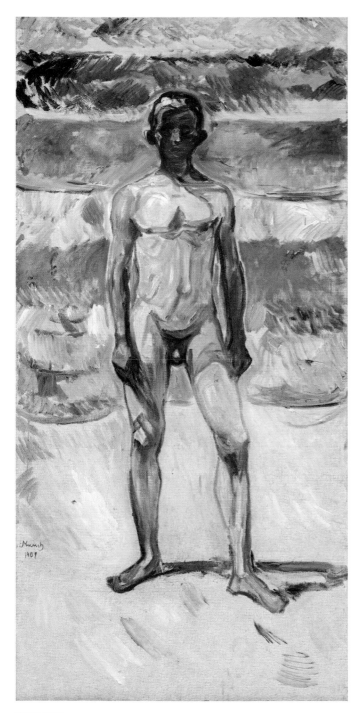

Youth 1908
Oil on canvas, 206 × 100 cm
KODE, Bergen (Rasmus Meyer Collection)

and so on. Critics constantly refer to the dark aspect of Munch's world, as though it could be reduced to his best-known motif, *The Scream,* and, crucially, as though his art were all about anxiety, death and despair. This is to forget that this morbid pole, which is undoubtedly present and powerful, draws strength from its co-existence with a vital pole of which it is the opposite end. There is no hierarchy between the hidden and visible sides: obverse and reverse return in a cyclical way, like a planet turning on its axis. Beyond iconography, we should also remember that what strikes us in looking at Munch's painting is the force it conveys, and which can be understood only as a vital energy flowing through and espousing every line, form and colour, giving it life. As Jérôme Poggi notes, Munch has 'faith in life, "even sickly life", with its roots in the mystery of death, to which he is introduced at a very young age'.[3] If we compare two paintings from the same period, *Death and the Child* (1899, Munchmuseet) and *Inheritance* (p. 54), we can see that each situation must be understood as the reverse of another and we understand the extent to which this principle of reversibility operates both in individual paintings and in Munch's work as a whole. In the first painting a – horrified – girl is seen in a room with her dead mother while, in the second painting, a weeping mother holds her child who has died of syphilis. There are two kinds of reversibility at work here. One is between the two paintings, in which the dead mother and living child of the one are counterbalanced by the dead child and living mother of the other. However, we can also see this reversibility within *Inheritance*, with its title reminding us that the mother has in a sense handed her child a legacy of death, in the form of syphilis, the lethal disease of Eros. When we recall that, in the first version of *Metabolism*, Munch portrayed an unborn child who is like the inverted double of the stillborn child, we can see how the same motif rolls over endlessly from one painting to the next, always showing its dual aspect. In a sketchbook from the years 1927–34, Munch notes, 'We have experienced death at birth – What awaits us is the strangest experience of all: The true birth which is called death – to be born into what?'[4]

A project that Munch began in the mid-1890s, and returned to in 1904, sheds light on his vision and his ambition to understand this dual, cyclical energy as a fundamental generative principle of human life. The subject of this project, which he ultimately named *Alpha & Omega* (p. 57) and which appeared as a portfolio of 18 lithographs and a text in Norwegian and French, is the Genesis of humanity, the 'first human beings'[5] who, in this case, are not called Adam and Eve but Alpha and Omega, in other words, first and last. Munch's written narrative distils the fundamental elements of his imaginary world, which we have seen presented in his works, and describes how the first humans are engaged in a story of love and death with nature, which thus ultimately ends in murder. Omega, a cyclical being with 'changing' eyes and 'variable' moods, bears children by the wild animals of the forest. The text ends as follows:

> **Alpha was sitting on the shore, and she came towards him. Alpha could feel the blood throbbing in his ears, and the muscles swelling in his body, and he struck**

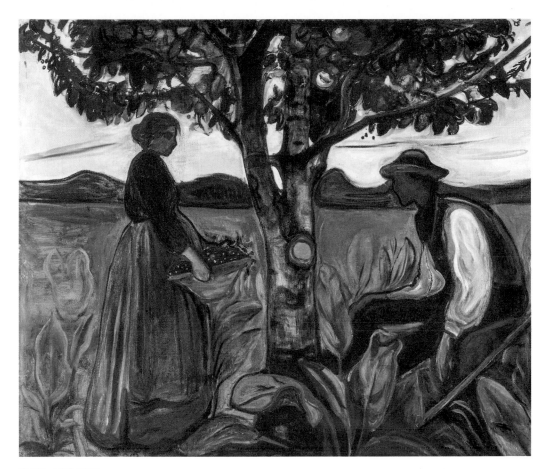

Fertility 1899–1900
Oil on canvas, 120 × 140 cm
Private collection

Omega until she died. When he bent over her dead body and saw her face, he was terrified by her expression. It was the expression she had worn on the occasion in the forest when he loved her the most.While he was still looking at her, he was attacked from behind by all her children and the animals of the island, who tore him to pieces.The new generation peopled the island.[6]

This is an emblematic narrative of Munch's world, with its image of blood as a half-vital, half-lethal sap, its reversibility of emotion between a desire for death and love and its inversion of the generative, generational relationship between parents who give life and children who dispense death in order to find a new beginning.

The story told by *Alpha & Omega* is embodied in the very structure of another of Munch's projects, to which he devoted much of his life and which he periodically reshaped. This is *The Frieze of Life*. The title encompasses a highly ambitious project that was also prone to metamorphosis. In the years 1893–1918 Munch exhibited between 10 and 12 series of works, the content, arrangement and titles of which constantly changed, before finally becoming established as *The Frieze of Life*. In Berlin in 1902 the works appeared as a *Presentation of a Sequence of pictures from life*, while in Prague in 1905, the exhibition was called *From the Cycle: Life*. From one show to the next, there were between six and 22 paintings, none of which were included in every known manifestation. There were some recurring motifs – *The Kiss*, *Madonna*, *Vampire*, *Melancholy*, *The Scream* – but also, as Mai Britt Guleng notes, 'paintings that were executed during totally different periods, with great differences in style and, at times, composition. The mounting in the exhibition venues varied as well.'[7] The narrative engendered by this interplay of constants and variants echoes that of *Alpha & Omega*, since its theme is also the love between man and woman, its birth, development and end, all seen in cyclical terms, perpetually starting anew. It is striking to note that, in the variants Munch introduced, he sometimes includes two versions of a motif in a deliberate repetition that creates a rhythmic, almost musical effect of intensification.[8]

In the exhibition designed for the Berlin Secession of 1902, 'a Sequence of pictures from life', the paintings were arranged in four series, each introduced by a generic title: 'The seed of love' (six paintings), 'The blossoming and disappearance of love' (six paintings), 'Angst' (six paintings) and 'Death' (five paintings). Munch asserted the organic unity of the series in the installation of the paintings, using a canvas passe-partout mount into which he inserted the paintings in one long, continuous frieze. The cyclical dimension, already indicated by the titles (seed, blossom, disappearance, death), was emphasized by the presence of *Metabolism* in the series 'Death'. This painting relaunched the cyclical movement through the presence of the embryonic child yet to be born, and is clearly visible in the painting's central bush.

Munch long thought about showing his cycle in a permanent exhibition, and even tried to design a building to house it (he left several drawn sketches on the subject[9]). Among other options for hanging it,

he devised a singular arrangement that appears in a drawing (p. 15), in which we can recognise the motifs *Metabolism*, *Eye in Eye*, *Angst* and *The Kiss*. This idea is striking for the presence of trees that take on the unifying function of the canvas mount but in organic form, as though the frieze formed a single, natural whole.

Propagation

Examination of *The Frieze of Life* as a work always in progress and, in particular of Munch's inclusion of different versions of the same motif, lead us to reconsider the role he gave to the use of repetition and his reworking of the same motif many times over a long period. Several aspects of this practice have already been noted in the literature, highlighting both its purely material dimension (notably commercial considerations) and those of memory and symbolism – the reuse of the same motif being a kind of remembering.[10] Similarly, the correlation between Munch's approach and Søren Kierkegaard's concept of repetition has also been discussed.[11] We can only concur that the idea of repetition *forwards* (Kierkegaard distinguishes between repetition backwards, the remembering that imprisons repetition in the reproduction of what has already happened, and repetition forwards[12]), in which 'the past and the future in a dynamic relation ship'[13] is consistent with the practice and thinking of Munch, for whom, as we have seen, everything appears caught in a dynamic relationship between past and future. As he said himself, 'I am entirely against what you might call a picture factory – turning out replicas to sell – but I also say, you should promise nothing – and I have in fact often made copies of my paintings – but there was always progress too, and they were never the same – I build one painting on the last.'[14]

This last observation is worth looking into more deeply, based on what we know of the *Frieze of Life* project and what we would now call its DNA. Every motif here gives rise to variants, every painting generates preparatory drawings and countless sketches. This proliferation around every motif, both upstream (preparatory studies) and downstream (the paintings that are variants starting from that motif), suggests that all Munch's works, however finished, are part of the same project and movement. All of them, including the preparatory prints and drawings, can potentially be included in a much larger whole, as moments in a much longer timescale. What is true of the representation of human beings and things is also true of the works themselves. In this regard we can say that in Munch's work the notion of completion, which usually enables us to tell a sketch from the finished painting, is meaningless when we see that the arrangement of works in the frieze is a superior form of completion, which itself remains open to constant reworking. To put it another way, we can perhaps say that the DNA of *The Frieze of Life*, a work always in progress, is the building blocks of Munch's entire oeuvre.

Seen as endless genetic activity, repetition can be understood not as a way of trying to remake, which would undoubtedly be repetition backwards, but rather as a way of trying to grasp the different temporal states of the same being, within a sequence that itself becomes a motif.

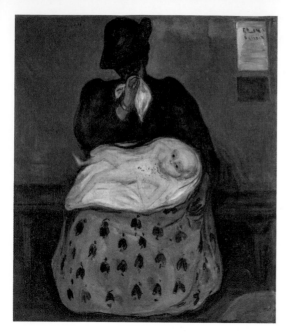

Inheritance 1897–99
Oil on canvas, 141 × 120 cm
Munchmuseet, Oslo

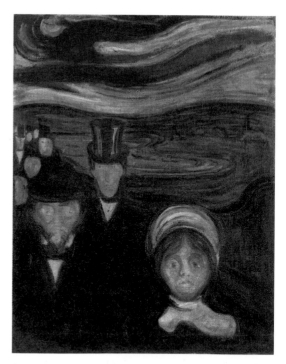

Angst 1894
Oil on canvas, 94 × 74 cm
Munchmuseet, Oslo

Comparing the variants of *Weeping Woman* (p. 219), a series of works of the years 1907–09, we are struck by their difference, which gives the series a musical dimension, as though Munch were producing variations on an absent, even ungraspable theme. Here we can understand why one version of the motif (as opposed to a picture) could replace another in *The Frieze of Life*, and even cohabit with it, not because of their interchangeability but, conversely, because each variant offered its own interpretation, its particular temporal state of the being(s) it portrayed. The pictures are neither copies nor pure repetitions, but updates of the same motif, each one different and unique.

The presence alongside the paintings of the sculpture *Weeping Nude* of 1914 (Munchmuseet), a version of the *Weeping Woman* motif, indicates something else, which we can also see in the multiple versions of *The Scream*, in different media (tempera on cardboard, oil, tempera and pastel on cardboard, pastel, crayon, lithograph). What appears here is the capacity of motifs to circulate from one work to another, and also from one medium to another. This is what Munch's approach to installation constantly tells us, through the canvas passe-partouts and painted trees that act as conduits. The painter's world, traversed by sap, blood and desire, is governed by an active principle of circulation. Whatever is here may be found there, and vice versa. We need only compare *The Scream* (1893, p. 67), *Angst* and *Sick Mood at Sunset: Despair* (p. 127) to understand that the same world is being propagated from one painting to the next. When Munch says, 'I build one painting on the last',[15] he is not thinking in terms of a copy, but of a continuous chain of generation, where every stage is particular, like each avatar in a long metamorphosis. Guleng astutely borrows Ludwig Wittgenstein's idea that Munch's works are all connected by a 'family resemblance', a kinship that does not rule out a degree of dissimilarity.[16] It is tempting to take this idea of family resemblance literally and, recalling *Inheritance*, to say that Munch's paintings resemble each other because in them a world is self-replicating, like a virus carrying life and death. The presence of a lithograph in what we can only call the cycle of *The Scream* reflects this viral function of the motif, since printing – an important technique for Munch – is used for its capacity to promote and extend the artist's world beyond the confines of painting.

Continuity

In 1930 Munch suffered a haemorrhage in his right eye, almost certainly due to high blood pressure. This damage to the eye that he regarded as most important for painting gave rise to extraordinary visual sensations, notably the appearance on his retina of a 'large, dark bird',[17] accompanied by cinematic effects and lights. As his eye healed, Munch worked on a set of drawings and watercolours to document the visions that his pathology had generated. What could have been simply a quasi-medical document, as would have been logical from an artist who readily painted his own self-portrait in a psychiatric clinic (*Self-Portrait in the Clinic*, 1909, KODE), is in fact a kind of manifesto for an art rooted in a belief in the underlying unity of the visible and the hidden, of external and internal worlds. As early

as 1907–08, in a short text entitled *Art and Nature*, he observed, 'Nature is not only that which is visible to the eye – it is also the inner images of the soul – images on the back side of the eye.'[18] Here he overtly locates himself within a Romantic tradition grounded in the topos of looking inward as a condition of art. Reading him, we recall the words of Caspar David Friedrich before him: 'Close your physical eye, so that you may see your picture first with the spiritual eye. Then bring what you saw in the dark into the light, so that it may have an effect on others, shining inwards from outside.'[19] But crucially, Munch also asserts his belief in a continuity that underpins his cyclical conception of art. Instead of affecting his work, the damage to his eye corroborated his original intuition that behind every visible thing there hides a kind of invisible motif, which can be found on the retina, where the hidden element of nature is imprinted. The painter's work, which in this aspect diverges from the tradition embodied by Friedrich, is not to close his bodily eye but to make motifs appear through the combined action of the spiritual eye and the physical eye. This combined work can only be conducted when the painter's attention remains perpetually in motion, never pausing its ceaseless movement from outside to inside and back again, from visible to invisible, life to death, madness to reason, terror to vision, leaving behind it a sinuous line that is at once a trace and the line of life.

1 Guleng 2013, p. 129.
2 This vision of the ages of man has its counterpart in a painting showing different ages of woman, *Woman* (1894, p. 80), sometimes called *Woman in Three Stages* or *Sphinx*, which shows the same symbolism driven by the same elements: the different ages seem born of the sea on the left of the painting, with its sinuous edge.
3 Munch 2011, p. 19.
4 Munch 2018, p. 153.
5 Munch 2011, p. 57, and Munch 1908–09.
6 Munch 2011, p. 59, and Munch 1908–09.
7 Guleng 2013, p. 129. For a presentation and more in-depth analysis of the frieze and its different variants, see this article, from which I have taken a lot of information.

8 Guleng 2013, p. 131.
9 See the excellent website of Munchmuseet: https://munch.emuseum.com/en/
10 See Lampe 2011–12a.
11 See Guleng 2011–12.
12 See Kierkegaard 2008.
13 See Guleng 2011–12, p. 153.
14 Draft letter to Axel Romdahl N 3359. Cited in Lampe 2011–12a, p. 36.
15 Lampe 2011–12a.
16 Guleng 2013, p. 138.
17 See exh. cat. Paris-Frankfurt-London 2011–12, p. 257.
18 Munch 2011, p. 141.
19 Friedrich 2011, p. 64.

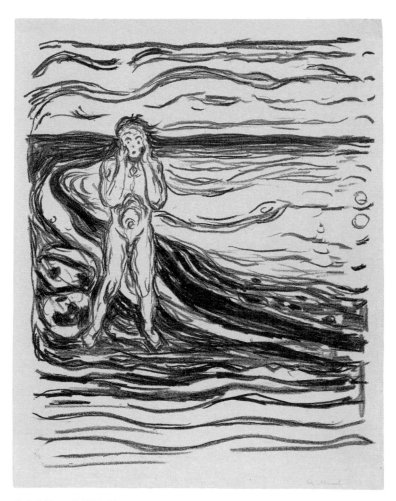

Alpha's Despair 1908–09
Lithograph, 420 × 345 mm
Munchmuseet, Oslo

A Scream Through Nature

Trine Otte Bak Nielsen
Curator
MUNCH, Oslo

The paradoxically transitory but cyclical quality of life is a running theme in the art of Edvard Munch. For the artist, mankind and nature are all part of the same continuum. Munch's writings and pictures express a holistic world view in which connections between everything are paramount, and in which individual elements are only meaningful in terms of their relationship to the whole. In this way, there are no clear divisions between inner and outer existence in Munch's work. He connects mankind with the world around us; as a natural part of a larger entity.

Towards the end of the 19th century, posing existential questions about humanity's relationship to nature had practically become a trend. Where do we come from? What are the connections between human development and nature, and between mankind and the universe? Munch's world view reflects this compulsion to understand the broader connections, in which many questions arose in response to the mass of scientific discoveries and philosophical attitudes at the time, which marked the artist's thinking and remained a theme that obsessed him all his life.

It is interesting to examine the extent of these theories in Munch's circle in the early 1890s, in order to find out the degree to which they influenced his views and his artistic practice, as well as the development of the *Scream* motif.

Currents of Thought

The explosive growth and expansion of most of the sciences in the second half of the 19th century led to the regular appearance of new theories attempting to understand mankind's evolution and connection to nature. Charles Darwin had exerted an immense influence with his theory of natural selection, which changed the way people saw the world and themselves. As art historian Gry Hedin has pointed out, Darwin was often considered to be a philosopher alongside thinkers like Friedrich Nietzsche, focusing 'on the existential rather than the societal aspects of his theories'.[1] Among proponents of Darwin's teachings in Germany, natural scientist Ernst Haeckel was the leading spokesman and interpreter. Starting from Darwin's theory of evolution, he constructed a monist[2] picture of the world, in which he imagined the universe as a unified field of spirit and matter. Haeckel promoted a pantheistic belief system, in which all existence was linked with the sacred. 'Natural philosophy is becoming theology, and the cultivation of nature is becoming the one true form of the sacral', he wrote.[3] Haeckel was read by many in Munch's circle, including Stanislaw Przybyszewski and August Strindberg. This was thanks to, among others, the author, natural scientist and editor Wilhelm Bölsche, who published articles on both Darwin and Haeckel in his Berlin-based journal *Freie Bühne*.[4] Bölsche was a staunch supporter of Haeckel who wrote a great deal about him, including the book *Ernst Haeckel: Ein Lebensbild* (Portrait of a Life), of which Munch also had a copy.[5]

'Theories of everything', coupling science more directly with religion and an assortment of belief systems, were also enjoying increased popularity. The likes of theosophy, occultism and spiritualism, in their

own ways, asserted that everything is connected and mutually dependent on everything else. Nietzsche was a central figure in philosophy with his existential nihilism and declaration that 'God is dead'. Nietzsche, in fact, was a reader of Haeckel and monist literature, and was fascinated by both biological and physiological aesthetics.[6] Holistic approaches to understanding humanity's connection to the world were on the rise within most academic subjects, and disseminated via a host of articles and new journals. The urge to communicate also led to the creation of richly detailed illustrations and photographic documentation, which at the same time introduced a new aesthetic from which artists could take inspiration.[7]

All in all, the increasing number of popular science publications contributed to these theories becoming common knowledge. You didn't necessarily need to bury yourself in books in order to know what was going on in the field. In Norway, the journal *Samtiden* was founded in 1890, and quickly became the leading publication on 'literature and society'. Here you could read articles on anything from spiritualism, Knut Hamsun and Wilhelm Bölsche to reports on Munch's reception in Berlin. Even if Munch was not aware of all the new research, we do know that he was extremely interested in scientific discoveries, and paid close attention to them.[8]

Holistic Visions

One can detect Munch's quest for understanding and deeper meaning in art and life in many examples of his writing. In many instances, he describes a connection between all beings as an eternal process, in which the decomposing human corpse nourishes new life and art. This reflects a kind of materialistic monism in which nothing ceases to live, but merely changes its state. Here is Munch in 1934, looking back and writing: 'As I noted in my records 10 years ago, and 20 and 40 years ago, everything is alive – even among the "hordes of the dead" there is life – There are constellations in an atom and life can spring up there too, as on Earth – So there is no death, and matter is alive – There is life in everything, there is "god" in everything – and we are "god" – If life consists of matter, in other words "dead nature", then it's simply that life is transformed, and life gets converted from matter into something else.'[9]

It may have been Christianity's prominent role in his upbringing that laid the groundwork for this quest. After his father's death in 1889, Munch notes, 'What I wanted he didn't understand. What he valued most I didn't understand. God divided us.'[10] His brother Andreas's interest in the natural sciences may have sparked his curiosity. Munch noted in a schoolbook that electromagnetism, telegraphy and Daguerre's invention of photography were 'The most important Inventions of this Century'.[11] When Munch joined Kristiania's literary and artistic circles in the 1880s, he became more familiar with the currents of thought at the time. Among his greatest sources of inspiration was the author Hans Jæger, who had studied philosophy for many years – and for whom Hegel was an especially significant figure. Together with the writer Gunnar Heiberg, Jæger had published the book *Kants fornuftskritik* (Kant's Critique of Pure Reason, 1878), but he is best known as a leading figure in the Norwegian Bohemian movement.

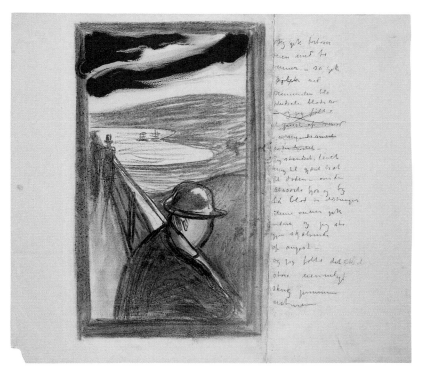

Despair 1892
Charcoal and oil, 370 × 423 mm
Munchmuseet, Oslo

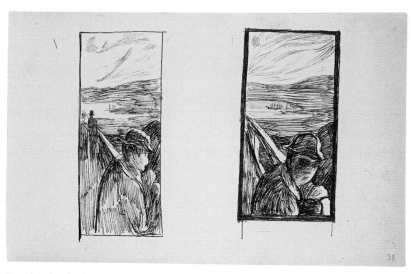

Two sketches for *Despair* 1892
Pen, 170 × 270 mm
Munchmuseet, Oslo

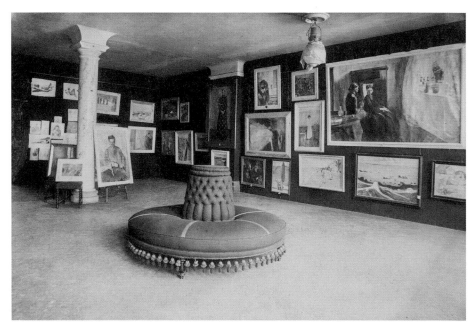

Edvard Munch's exhibition at the Equitable Palast in Berlin, 1892–93
Photo: Atelier Marschalk. Munchmuseet Archives

Already around 1890, Munch describes an inherent connection between humanity and the earthly cycle. These notes date from his stay at Saint-Cloud on the outskirts of Paris,[12] where he spent a great deal of time working out what it was about art that meant so much to him. He placed great weight on sincerity in the face of art, such that the 'public should feel the sacredness of it – and they should remove their hats, as if in church'. Clearly influenced by symbolism, Munch confirmed that 'Nature appears according to one's mood.'[13] Symbolism's focus on subjectivity and humans' interior life was also important for the Danish poet Emanuel Goldstein, who came to visit and took a room in the same hotel as Munch.[14] They developed a firm friendship in which they discussed art and literature, and shared a common fascination with symbolism, but also more existential ideas, as when Munch writes:

> I walked up there on the hill and relished the gentle air and the sun – The sun only warmed occasionally, some cool breezes – as if from a burial chamber. Steam was coming off the damp soil – it smelled of rotting leaves – and how quiet it was around me – and yet I felt it decomposing and coming alive – in this steaming earth with the rotting leaves – on these bare twigs, they would soon put out shoots again and the sun would shine on the green leaves, and the flowers and the wind would bend them down in the balmy summertime. It felt like a rush of lust to become as one with this earth that is constantly decomposing and that is forever lit up by the sun living – living – out of my decomposing body would grow plants – and trees and plants and flowers and the sun would warm them and I would be in them and nothing would pass away – it is eternity.[15]

Munch wrote several texts reflecting a kind of cyclic natural philosophy, in which the thread of life from generation to generation, and humanity's bond with nature, are a natural part of the world's evolution. Nature seeds itself in rotting corpses, and nothing perishes entirely; everything continues to live – just in a different form.

Towards an Iconic Motif

Munch made the first sketch with a direct connection to *The Scream* around 1890–91. *Ljabru Chaussee: Man Leaning Against a Railing* shows a man standing alone on a road, looking out over the landscape. Lonely figures absorbed in their thoughts, contemplating nature, was a theme Munch kept coming back to in this period.[16] He also continued writing about nature with an undertone of existential wonder, such as here in Nice on 12 December 1891: 'out there – behind the azure blue horizon – back there behind the luminous clouds – what is there – I once thought the end of the world was there – now I know nothing! […] the sea opens its mysterious green-blue gullet as if to show me what resides down there in the deep.'[17] A little later, on 8 January 1892, and with a more obvious debt to monism, Munch explained nature as a single piece of everlasting matter: 'Nothing perishes – one has no example concerning this matter in nature – the body that dies – that does not disappear – the substances disintegrate – are transformed.'[18]

Two weeks later, in the same notebook, Munch writes his first text about *The Scream*. His existential wonder has become a visual story in which the 'I' figure is totally overwhelmed by nature:

> **I was walking along the road with two friends – the sun was setting – The sky suddenly turned blood-red – I felt a wave of sadness – I stopped, leaned against the fence tired to death – gazed out over the flaming clouds like blood and swords – the blue-black fjord and city – My friends walked on – I stood there quaking with angst – and I felt a vast, endless scream through nature.[19]**

Over time, Munch writes many versions of this text, which shows how important it was for him to express this existential angst. It's here that he describes the *Scream* motif for the first time. The charcoal drawing *Despair* (1892, p. 61), with a sky of intense, fluctuating red brushstrokes, might be the first visual motif that corresponds to the text. Compared with the first Ljabru Chaussee sketch, the man is pulled closer to the viewer, which makes it easier to identify with the figure and his experience of the landscape. Nature practically 'pops' out of the image with its red brushstrokes. By placing the text next to the charcoal drawing, Munch makes it clear that they belong together. There are also two black and white pen drawings, *Two Sketches for Despair* (1892, p. 61), in which we find him working on the motif, gradually coming closer to what became *The Scream* as we know it, and in which the male figure no longer stands with his back to the landscape but has turned towards us. In both drawings, we also see uneasy clouds in the sky.

Munch's artistic practice is now developing apace, and he appears to have become somewhat dissatisfied with symbolism. He is no longer following the Symbolist path and is calling all his previous influences into question. In a letter of 8 February 1892 he writes to Goldstein: 'all those incredibly realistic sketches we both did that time in Paris – all the phonographic reproductions of scenes – which were so well thought-out – will they ever be used – You probably have a massive pile of them as well – I suppose you and I are the same about painting, maybe it's true that we just can't get rid of realism.'[20] Munch was not interested only in the interior life; neither did he make any distinction between art and nature, while the Symbolists treated physical-world phenomena only as symbols of mental concepts. His art does not reflect this 'either/or' position, representing monistic instead of dualistic thinking, as when he associates feelings with art and nature. As the art historian Reinhold Heller has also pointed out, Munch's practice had nothing to do with the French Symbolists of the time: 'The practices of Naturalism were thus adapted, not superseded, by Munch and Goldstein.'[21]

It is most likely during this spring that Munch paints *Sick Mood at Sunset: Despair* (1892, p. 127), which he later described as 'the first Scream'.[22] Here we can recognise the characteristic sky and the urban landscape nestled in the Oslo fjord. The deep reds and yellows almost shudder on the canvas, while the impressionistic brushwork used for the sky marks it out from the darker cityscape. Perhaps it was while working

on this sky that Munch wrote: 'If the clouds in a furious sunset have the effect of a bloodstained sheet, there is no use painting more conventional clouds [...] The effect of a work of art depends on what it is trying to say – What's needed is an essence of nature – the square root of nature.'[23] He makes no mention of the male figure, who is still standing on his own, his back turned. The sky is what differentiates this painting from everything Munch has painted previously. It's the sky and nature that occupy our gaze, and which give rise to the mood of despair. When the painting is exhibited for the first time in Kristiania that autumn, it gets plenty of attention. But more importantly, it leads to Munch being invited to stage his first exhibition abroad.

On 5 November, just one month after the Kristiania exhibition closed, Munch opened a new one at the Verein Berliner Künstler (Association of Berlin Artists). Even though it was shut down after only five days due to vociferous protests, it created such a stir that Munch's art became widely known in Berlin's artistic circles, and he happily reported in a letter home that he had received 'many glowing notices'.[24] In fact, his success was so great that he decided to live there, which proved crucial to the further development of the *Scream* motif in the following year.

In Berlin, Munch got to know the writers Stanislaw Przybyszewski and August Strindberg, with whom he spent much time at the Black Piglet drinking hole, which had become a hangout for the city's artistic scene. Przybyszewski's multifarious background – studying architecture, medicine and Haeckel's theories – and his recently published essays on Nietzsche and Swedish writer Ola Hansson, presumably lay behind the literary recommendations he passed on to members of the Black Piglet group, in the fields of psychiatry, biology and philosophy.[25] We may also assume that they discussed Haeckel's lecture 'Monism as a Link Between Religion and Science', when it was printed in the November 1892 edition of *Freie Bühne*.[26] Haeckel introduces his intention to 'pull together the empirical and the speculative views of nature, realism and idealism'. Later he states that it is only 'through a natural union of the two that we can approach a realisation of the highest goal of mental activity – the merging of religion and science in monism'. Haeckel's pantheism also comes to the fore here: he treats the sacred as something innate to reality. Despite calling himself an atheist and not believing in the biblical Creation, he refused to criticise Christianity. This may have pleased Munch, who also never quite let go of it and who developed a pantheistic vision that only started to emerge clearly some years later: 'Everything is in us – and we are in everything – The smallest unit splits into smaller parts, the largest gather into one great Unity – The Earth is a living Cell and we are Microorganisms on its surface – God is in us and we are in God.'[27]

Wilhelm Bölsche's interests in monism, philosophy and literature were, as we have seen, reflected in *Freie Bühne*. What is more, Bölsche was a central figure in the Friedrichshagen Circle, a loose-knit group of writers who met on the outskirts of Berlin and who were interested in everything from nature mysticism to social reform. Several members of the circle were also in the Black Piglet group, including Hansson, Strindberg,

Przybyszewski and Max Dauthendey. It's safe to assume that all of them supported the publication of 'The Munch Affair', written in defence of Munch following the closure of the exhibition at the Association of Berlin Artists.[28]

December 1892:[29] Strindberg reads K.G. Dobler's new book *Ein neues Weltall* (A New Universe). In it, the artist is presented as the interpreter and medium of a new view of the world, via a synergy that Dobler calls 'astro-embryology'. Munch also owned a first edition of this book, in which he could learn that the universe was a single organic structure that 'belongs to a higher, more powerful whole, a being consisting of spirit and matter, made of flesh and blood, created from the same chemical bonds as us, our Earth, our sun, our solar systems'.[30] Strindberg was clearly fascinated by Dobler's theories, and noted that Dobler 'believes that our system is a whole'.[31] Strindberg and Munch were spending a good deal of time together in that period, which makes it very probable that they discussed the book's contents. Munch also painted the writer's portrait.

In any case, we can assume that Munch's main focus was the reopening of his Berlin exhibition. He rented spaces in the Equitable Palast and the show opened on 26 December 1892 (p. 62). Now, at last, many more people had the opportunity to see the exhibition, including the writer and artist Dauthendey, who looked around the whole thing twice, also met Munch, and wrote about it.[32] The paintings made a strong impression on him: 'the shadows were glittering with details, as in nature, the lights were flickering, and everything was alive. A chill coursed through my blood, like one who has spent a long time alone and now suddenly is surrounded by these vivid colours.' Clearly taken with the paintings, Dauthendey featured Munch in his next book, *Verdensaltet*. The book was a kind of aesthetic manifesto, in which the artist is compared to the scientist and Munch is held up as the leading painter of the new art which was to reach out across idealism and realism in a world consisting of 'a single great Stream – the eternal Mass's eternal Life (Force). There is no such thing as absolute Death. There is only Form, which dissolves.'[33] In order to create the 'sublime in art', the 'artist need only turn directly and exclusively to Nature'.[34] Again, we can identify parallels with Munch's own writings.

In March 1893, Swedish natural scientist Bengt Lidforss arrived in Berlin, an important sparring partner for Strindberg, who was working on his own book *Antibarbarus I, or the World in Itself and the World for Me*, which is yet another example of the popularity of monist thought at the time. With a background performing chemistry experiments and an interest in natural sciences stretching back several years, Strindberg published the book at the end of the year, describing it as 'a wide-ranging study of the nature of the elements, and a new way of looking at alchemy in terms of the guiding monist theory of the oneness and unity of nature, as used by Darwin and Haeckel'.[35] Despite moving away from Berlin before publication, Strindberg kept in touch with Munch, who presumably was aware of the book project.

Although Munch enjoyed his time in Berlin, he wrote disappointedly to Johan Rohde that 'Here in Berlin the [paintings] have been highly praised, but I have not yet found an opinion that is actually understanding.'[36]

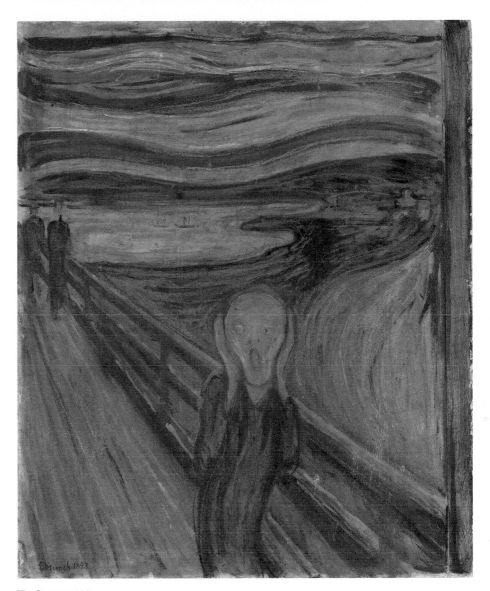

The Scream 1893
Tempera and oil on cardboard, 97 × 73.5 cm
Nasjonalmuseet, Oslo

Munch hoped things would be different in Copenhagen, where Rohde was to help with an exhibition. Here, notably, Munch signalled his wish that 'A red sky and a young man leaning against a railing' should be given a prominent position. When the exhibition was over, Rohde informed him that two of the paintings, *Vision* and *Sick Mood at Sunset: Despair*, had been poorly received. Perhaps as a response to this criticism, Munch says in a letter that from now on he will do things differently: 'For now I am carrying on with my studies for a picture series, which by the way several of my paintings at Kleis belonged to – e.g. *Man and Woman on the Beach* – the red air – the painting with the swan – These are currently pretty incomprehensible – I think when they are all put together – they will be easier to understand – it will be about love and death.'[37] This desire to include his various paintings in a series to enhance their meaning is indicative of Munch's holistic artistic practice. The existential motifs he develops then resonate within a larger whole: *The Frieze of Life*.

We have seen how this was an intense and at the same time inspiring period for Munch. He had established a network of scientists and artistic types who could keep him updated. In March, Munch writes home delightedly from Berlin that he is working 'incredibly and will be able to have a new exhibition ready for the autumn'.[38] He had already started planning the exhibition in which *The Scream* would be shown for the first time.

The Scream

We don't know exactly when or where Munch made the two first versions of *The Scream* in 1893. One was drawn in crayon and the other painted in tempera and oils. By comparing them to *Sick Mood at Sunset: Despair*, we can see why he called the latter a 'parallel painting to *The Scream*',[39] with its roughly similar composition and colour scheme. We can also see that Munch has made one crucial change in *The Scream*: he has turned the subject to face us and given it its final shape as the undulating, genderless, screaming figure. The figure is reduced in size and set a little further back, so that the landscape appears more enormous. Unlike *Despair*, the *Scream* figure practically becomes one with the landscape in the background. We see this most distinctly in the painted version, in which the brushstrokes almost blend into each other above the sky and the city and down to the road and the figure. Now the figure is depicted in the same colour scheme and with the same brushwork, 'at one with nature'. The painting has altered to a more unified composition in which the human figure and nature are given equal emphasis. Now the inner and the outer are linked together – the human with the world around it – and the scream appears to emanate from inside and outside simultaneously.

The feeling of being tiny in a huge landscape may reflect the era's melancholy view of the human condition as lonely and abandoned by society and the world, just as many portrayed the city as a source of alienation. In *The Scream*, Munch not only evokes the social environment, but also the existential angst that causes people to feel disempowered; as in the Danish philosopher Søren Kierkegaard's description of angst,

which is set against human freedom and a world of possibility. Munch would discover Kierkegaard's writings later in life, and came to hold this 'father of existentialism' in high regard.

When *The Scream* was exhibited for the first time that winter,[40] it was, according to the catalogue, shown as one of six 'studies' for the 'Love' series, which consisted of the paintings *Summer Night's Dream*, *The Kiss*, *Vampire*, *Madonna*, *Jealousy* and *The Scream*. As the final piece in the sequence, *The Scream* came across as a transitional work. The decision to hang the painting as part of a series the first time it was shown was in line with Munch's holistic vision and demonstrates the cyclic nature of his art. Munch wanted to be understood, as he wrote to Rohde, but instead of an explanatory text, he supplemented *The Scream* with several other motifs, in a narrative that seems almost like an evolutionary history. In this way, *The Scream* can also be seen as an existential cry at the transitoriness of life, at love's place in the natural cycle, at the world around us, and at the realisation that all of it is connected.

1 Hedin 2012, p. 122.
2 Monism is a metaphysical explanation of diversity in the world based on one type of matter or one basic principle, and thus stands in opposition to dualism and pluralism.
3 Bliksrud & Rasmussen 2002, p. 69.
4 Haeckel 1892 and Bölsche 1893.
5 Bölsche, 1900. Held in Munch's preserved library, Munchmuseet.
6 Brain 2010.
7 On the connections between physiology and Munch's art at the end of the 19th century, see Cordulack 2002.
8 We can see this in his preserved library at Munchmuseet, which contains books and journals on philosophy, astronomy and biology.
9 Sketchbook T 2748, 1927–34. Munchmuseet.
10 Note N 18, 1889. Munchmuseet.
11 Schoolbook T 2805, 1878. Munchmuseet.
12 Several notes and letters have been preserved from Saint-Cloud, among others Sketchbooks T 2893, 1889–91, and T 2770, 1890. Munchmuseet.
13 Sketchbook T 127, 1890–94. Munchmuseet.
14 Hôtel-Restaurant du Belvédère, 12 Quai Carnot, Saint-Cloud.
15 Note T 365, 1890. Munchmuseet.
16 *The Path of Death* (1890), *Night in Saint Cloud* (1890), *Night Mood. From Nordstrand* (1890), *Melancholy* (1891).
17 Sketchbook T 2760, 1892. Munchmuseet.
18 Sketchbook T 2760, 8 January 1892. Munchmuseet.
19 Sketchbook T 2760, 22 January 1892. Munchmuseet.
20 N 3036. Munchmuseet.

21 Heller 1984.
22 Note N 122, 1927–33. Munchmuseet.
23 Note N 59, 1890–92. Munchmuseet.
24 Letter to Karen Bjølstad N 787, 26 November 1892. Munchmuseet.
25 As well as Haeckel's texts on biology and monism, Przybyszewski read Jacob Moleschott's *Der Kreislauf des Lebens*, Théodule Ribot's *Les Maladies de la volonté* and *Les Maladies de la personnalité*, and Hippolyte Bernheim's 'De la suggestion'. See Brain 2010.
26 Haeckel 1892.
27 Sketchbook T 2759, undated. Munchmuseet.
28 *Freie Bühne* 1892.
29 Strindberg 2010.
30 Dobler 1892. Held in Munch's preserved library, Munchmuseet.
31 Strindberg 2010.
32 Dauthendey 1933.
33 Uddgren & Dauthendey 1893.
34 Uddgren & Dauthendey 1893.
35 Strindberg 2010.
36 Letter to Johan Rohde PN 20, 8 February 1893. Munchmuseet.
37 Letter to Johan Rohde PN 20, 8 February 1893. Munchmuseet.
38 Letter to Karen Bjølstad N 3679, 16 March 1893. Munchmuseet.
39 Letter to Jens Thiis N 314, 1933–40. Munchmuseet.
40 The exhibition opened on 3 December 1893 in galleries on Unter den Linden, and consisted of 50 paintings.

Munch and the Symbolist Theatre

Ingrid Junillon
Art Historian
Institut National du Patrimoine,
Paris

In December 1884 the young Edvard Munch wrote to a friend, 'Our great Salon has just closed and none of it made much of an impression. Norwegian respectability in every way ... Not one of those paintings left me with an impression comparable to pages of a play by Ibsen.'[1] These words reveal the importance of dramatic literature – and notably the work of Henrik Ibsen – in the painter's art. Munch constantly explored contemporary theatre, seeing it as both scenographic and literary material, and drew inspiration from it. In addition to reading whatever interested him and using it as a source of visual ideas, he also seized opportunities to get involved.

Born into a family that included several well-known intellectual figures, Munch received the usual education of his social milieu, in which literature played an important part. This gave him an erudition noted by his friends, and which is also apparent in his writings. Since childhood he had been a reader of Ibsen's poetry and historical plays, which were part of the Norwegian national and romantic repertoire, and his vision became more political when Ibsen turned his attention to the field of 'modern tragedy' and developed a vitriolic social critique, which turned him into a prominent dissenter and generated public debate far beyond the literary sphere. Munch was 16 at the time of the publication of *A Doll's House* (1879), a play about the condition of women that proved controversial, as did subsequent plays such as *Ghosts* (1881) and *An Enemy of the People* (1882). Ibsen became a figurehead for the Kristiania Bohemians, who developed a radical form of dissent based on a libertarian philosophy. Although he did not subscribe to their more extreme ideas, Munch experienced this period as a liberating 'whirlwind'.[2] Above and beyond his subversive subjects, Ibsen also introduced a new kind of writing in which suggestion and what is left unsaid add weight to what is seen on stage. This theatre of depth and ambivalence used a vocabulary of metaphor to explore the uncanny and the workings of the unconscious. The 1890s saw Ibsen achieve international recognition from both the naturalist avant-garde and the Symbolists, breaking ground for Nordic theatre more broadly. Munch retained an awed respect for Ibsen, who returned to Norway in 1891 after 27 years abroad. Ibsen was a daily visitor to the Grand Café in Karl Johan Street, where the Bohemians also met – 'the place where we could feel the pulse of Kristiania'[3] – but he remained unapproachable and, while Munch had plenty of opportunity to observe him at a distance, few words were exchanged between the two. Those that were remained etched on the painter's memory and gave rise to the portraits he created later (p. 225). Munch was particularly touched by the support Ibsen showed him in visiting his poorly reviewed exhibition at the Blomqvist gallery in 1895, describing this encounter more than 30 years later in his essay 'The Origins of the Frieze of Life'.[4]

From his earliest days as an artist Munch gravitated towards literary circles, forming closer and more lasting friendships with writers than with painters. One of his closest friends was the Danish poet Emanuel Goldstein, with whom he enthusiastically explored Symbolist ideas during time spent in Paris in the years 1889–91. The two witnessed the emergence of the

dramatist Maurice Maeterlinck and of Paul Fort's Théâtre d'Art, marking the birth of a new Symbolist approach to theatre, which rejected the illusionist tradition in favour of pure poetic form. Theatre played an important part in the aesthetic discussions between Munch and Goldstein, who regarded it as the quintessential genre of Symbolist literature: 'Imagine a play in which every piece of dialogue is a stroke of the bow and the audience member becomes the violin. That's what is too often forgotten in naturalist art, that readers themselves must contribute to the mood.'[5]

November 1892 saw the opening of Munch's first exhibition in Berlin. To promote a painter who was unknown even to the organisers and whose work was totally unlike the Norwegian art with which the German public was familiar, the publicity promised 'Ibsenian atmospheres',[6] attracting interest in Munch from the Berlin theatre world. Theodor Wolff, a founder of the Freie Bühne (Free Stage) company, was one of the critics who supported Munch in the furore generated by his exhibition. Munch's meeting with another Freie Bühne founder, Julius Elias, was also to prove crucial. An art historian and Scandinavian literature specialist, Elias went on to work on the German edition of the complete works of Ibsen and Bjørnstjerne Bjørnson. From Munch's first weeks in Berlin,[7] Elias regularly invited him to events and receptions, including those held after performances by Freie Bühne.[8] Through Elias, Munch soon entered the high society world of Berlin's intellectuals and, encouraged by his *succès de scandale*, settled in Berlin, where he stayed until 1895. He remained in contact with Elias down the years, mentioning him after his death as a friend from 'the time of Freie Bühne and the beginning of the cult of Ibsen'.[9]

Even more crucial was the friendship Munch developed around the same time with the Swedish writer August Strindberg, his senior by 15 years. No sooner had they met than Munch began working on Strindberg's portrait, which he displayed in a prominent position in his exhibition of December 1892 at Equitable Palast, as a manifesto of the Scandinavian modernism apparent in both theatre and art.[10] A cosmopolitan, avant-garde group of writers and artists sprang up around Munch, Strindberg and the Polish writer Stanislaw Przybyszewski and the Norwegian poet Dagny Juel – who soon became a couple – meeting in a tavern called The Black Piglet (*Zum schwarzen Ferkel*). Throughout Munch's career, and despite rivalries and destructive behaviour, this core group of friends was to remain his most important forum for thought and inspiration. Freie Bühne offered the group's members an audience, both in the theatre and through its literary review.[11] In this period Strindberg was deeply involved with the theatre, to which he hoped to bring new kinds of writing and performance. Influenced by André Antoine's Théâtre-Libre and its reaction against bourgeois comedies in the Italian style, Strindberg used the preface to *Miss Julie* (1888) to announce his ideas for a new, 'intimate theatre'. This would be performed in small spaces enabling direct communication between stage and audience and allowing actors to tone down their performance style in order to convey the subtleties of modern psychological drama. Freie Bühne headed by Otto Brahm

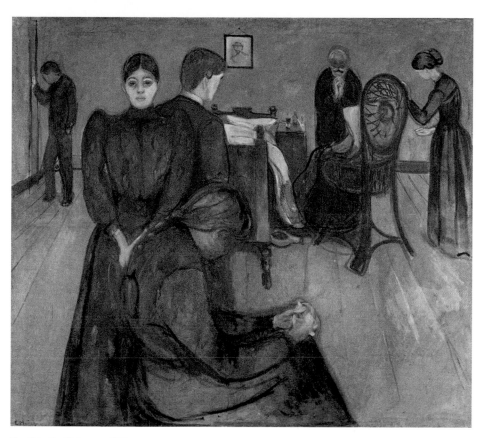

Death in the Sickroom 1893
Tempera and crayon on canvas, 169.5 × 152.5 cm
Nasjonalmuseet, Oslo

Paul Sérusier, Programme for Gerhart Hauptmann's
The Assumption of Hannele at Théâtre de l'Œuvre, 1894
Lithograph, 311 × 235 mm
National Gallery of Art, Washington DC

was in a similar experimental spirit. Founded in 1889 to promote contemporary and socially orientated writing, and opening with Ibsen's *Ghosts*, the company used its non-commercial status to get around the imperial censorship and underlined its naturalist focus with provocative performances of Gerhart Hauptmann's social tragedies *Before Daybreak* (1889) and *The Weavers* (1892). The contrasts between naturalism and Symbolism fuelled aesthetic debates at The Black Piglet, where Hauptmann sporadically joined the group's meetings and whose members he knew.[12] At the same time Freie Bühne was introducing Strindberg's plays to German audiences, from *The Father* in 1890, to a single performance of *Miss Julie* in 1892, followed the year after by *Creditors* and the one-act plays *The First Warning*, *Facing Death* and *Playing with Fire*. When Strindberg died, the most lasting memories described by Munch were their evenings at The Black Piglet and the premieres of his plays in which, 'the lines fell like [...] – words of iron – sometimes a sword, sometimes a dagger'.[13]

Munch's participation in the theatre world did not lead to any concrete collaborative projects during his time in Berlin, but it did leave its mark on the artistic system he was developing and which later led to *The Frieze of Life.* The influence of the theatre can be seen in the static poses and gestures of his hieratic figures, forming a scene frozen in suspended time. Munch's condensed compositional approach, focusing on the expression of a character's psychology – and made explicit through titles reduced to a single emotion, such as *Melancholy*, *Jealousy* or *Despair* – also echoes the drastic reduction of plot in the contemporary theatre, notably in Strindberg's plays, to a simple encounter between different emotions, or a character's efforts to escape his own inner meanderings. Symbolist painting and theatre developed an aesthetics of fragmented reality questioned through the prism of emotion or memory, or by the sudden appearance of mysterious phenomena that can be interpreted as the work of either supernatural powers or 'deranged sensations'.[14] Strindberg's anxious exploration of his own subjective perceptions is central to his proto-Expressionist theatre of this period, for which *The Scream* is an equivalent in the visual arts. Without always going quite so far, many of Munch's paintings are constructed within a shifting space-time where the active protagonists are seen with figures called up by their thoughts, or even by an avatar of their past selves. Munch's painting *Death in the Sickroom* (1893, p. 73) reasserts the lasting nature of his mourning for his sister Sophie, who had been carried off by illness 16 years before. The composition uses a theatrical format in a clearly defined cubic space. The chorus of adult siblings, Edvard, Laura and Inger, appear downstage, as the terrible scene from the past plays out in the background. The painter's silhouette connects these two spaces, while on the lower left a young man walks away from the unbearable scene. This is the other Edvard, the 14-year-old boy through whose pain-filled eyes the adult still sees the event.[15] Since the time of its creation, this painting has been

compared to Maeterlinck's play *Intruder*.[16] Both works adopt the same approach to the internalisation of 'everyday tragedy', which is not so much concerned with the actual event and its protagonist as with the people close to that individual and their responses to the event. But the fate of characters imprisoned in the past is an eminently Ibsenian theme, the bi-temporal construction of the stage offering a parallel to Ibsen's retrospective dramaturgy.

Death in the Sickroom was first shown at an exhibition in Berlin in December 1893, alongside the study *By the Deathbed: Fever*,[17] an early version of a major work (p. 144). The study shows the same family members gathered around the bed, from which only the top of the dying girl's head emerges. What the viewer sees is her vision – spectral heads looming and laughing. A month before the exhibition, Hauptmann's play *The Assumption of Hannele* had been a great success in Berlin, leading Aurélien Lugné-Poë to stage it in Paris two months later (p. 74). The strength of this play lies in the way that it connects the naturalist sphere of poverty in society to the typically Symbolist realm of the 'other world'.[18] Its entire plot consists of the dying moments of a teenage girl who kills herself to escape abuse. She experiences what may be either delirium or some kind of miracle and sees celestial apparitions, ranging from her late mother to Christ. These apparitions remain present throughout her assumption until the play's final words, spoken by the doctor, return the scene to the cruel reality. In this 'dream drama' the author gave directions for the staging of these spiritual interventions in a naturalist narrative. In light of the connections between Munch and Hauptmann[19] and the response to the play, it is tempting to conclude that *The Assumption of Hannele* might have been a direct source of inspiration for *Death in the Sickroom* and *By the Deathbed*, two important paintings from *The Frieze of Life*. Certain parallels in the play, such as the age of the girl and the dead mother, may have reminded the artist of his own family tragedy and encouraged him to return to a subject he had depicted eight years earlier in a completely different style. While fantastical elements (including a skeleton) play a major role in the first of several studies for *By the Deathbed*, they become less prominent from one version to the next (p. 145). The figure on the right separates from the others and becomes fixed, as though Aunt Karen's features were overlaid by the spectral figure of her sister. Shortly afterwards Munch reused the main motif of his earlier painting *The Sick Child* in a lithograph (p. 167) in which he shows both faces in two separate spaces, an approach not dissimilar to that of Sérusier's programme for *The Assumption of Hannele*.

Other echoes of Strindberg's theatre in Munch's art can be sensed in the evolution of the painter's depiction of women during his time in Berlin. The painting *Ashes*, an allegory of the dangers of fleeting pleasure when expiation turns love into hate, strongly recalls the last act of *Miss Julie* and many of Strindberg's one-act plays. The dramatist's concept of alienating love, the connection that becomes a chain and the life sentence to which two people are condemned by unbearable but indissoluble union,

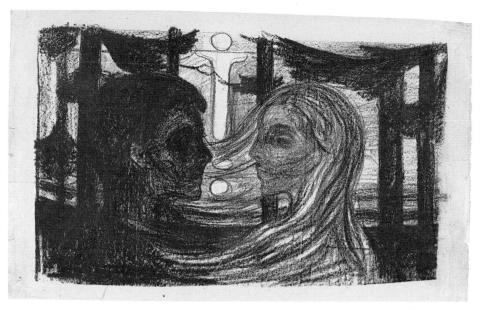

Attraction II 1896
Lithograph, 396 × 625 mm
Munchmuseet, Oslo

John Gabriel Borkman: Borkman in the Forest 1928–30
Pen and wash, 205 × 176 mm
Munchmuseet, Oslo

finds its equivalent in Munch's work in the recurring motif of a woman's unbound, unending hair, winding its way around a man and ensnaring him. This motif can be seen with more or less emphasis in *Ashes* (p. 35), *Vampire* (p. 136) and *Separation*, where it becomes the painting's central element, holding the man back against his will and neutralising physical separation by maintaining a mental connection like a 'telephone cable'.[20]

This rope-like hair is an anxiety-laden reinterpretation of a proto-surrealist approach imagined by Maeterlinck in his play *Pelléas et Mélisande*.[21] Here, Pelléas glimpses Mélisande high in a tower and is amazed to see her hair suddenly falling down to him, like 'a thousand links of gold' that 'tremble', 'quiver' and 'flood [him] to the heart'.[22] In 1894 Maeterlinck's Danish translator, a friend of Munch's, suggested to the artist that he create illustrations for the play. Although the project was never realised, it is during this period that we see the emergence of the first drawings on the theme of *Attraction*, featuring two metaphors that are important in *Pelléas et Mélisande*. One is the hair that is also a tie and the other is the fixed stare, a manifestation of the dialectic of sight and blindness that recurs in the play, from Mélisande's first meeting with Golaud (who cries, 'I'm looking at your eyes. Do you never shut your eyes?') through to Pelléas despairing that he has 'not yet looked upon her look'. The hypnotic 'vision of looking' offered by these frighteningly staring eyes in deep, outlined sockets, becomes a recurrent motif, with the different drawn versions of *Attraction* leading to the painting *Eye in Eye* (1899–1900, p. 46).

A further period in Paris, from February 1896 to May 1897, offered Munch a brief opportunity to renew his friendship with Strindberg (p. 234), but the attack of acute paranoia the dramatist was experiencing at the time put a distance between them. However, Munch was able to make use of contacts with Ibsen's translator Count Prozor and with Lugné-Poë, established during a Scandinavian tour of the previous year by Théâtre de l'Œuvre. Munch seized the opportunity to join the Paris literary circles, benefiting from the vogue for Scandinavian theatre, as he had in Berlin. Théâtre de L'Œuvre, founded in 1893, sought a new approach to the materiality of the stage, which the Symbolist poets had initially seen as quintessentially incompatible with a literary work, but had gradually accepted on condition that it underwent an aesthetic revolution. The new approach involved rejecting the use of stage sets to create literalist illusion. Instead pared down sets would highlight the abstract nature of the space through 'a purely ornamental fiction that supplements the illusion through analogies with the drama that are created in colour and line'.[23] Lugné-Poë frequently called on his Nabi friends – particularly Édouard Vuillard – to design his sets and also provided them with a new outlet by producing programmes illustrated with a print, which was also sold without text as a separate item.[24] He put together a cosmopolitan repertoire dominated by Nordic writers – in seven years Théâtre de L'Œuvre staged 16 Scandinavian plays, including nine by Ibsen.[25] In 1896 Lugné-Poë began working on *Peer Gynt*, a challenging project due to its many different settings and characters. He planned to use a variety of realist and abstract designs for the 18 different settings[26] and brought

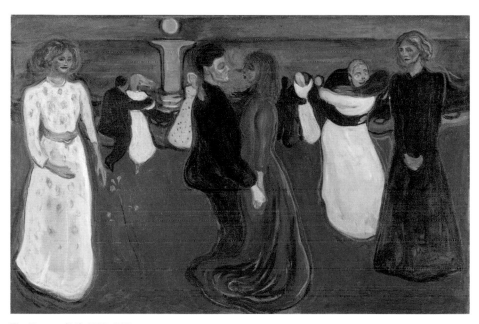

The Dance of Life 1899–1900
Oil on canvas, 191 × 125 cm
Nasjonalmuseet, Oslo

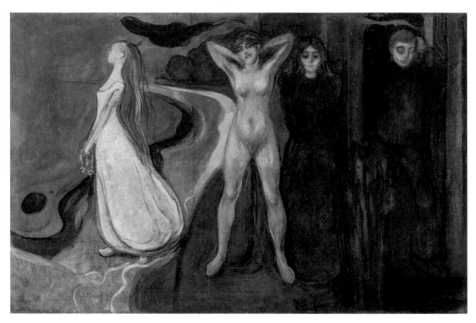

Woman 1895
Oil on canvas, 164.5 × 251 cm
KODE, Bergen (Rasmus Meyer Collection)

in a team consisting of Munch and the Impressionist Frits Thaulow, whose landscapes of snow and water were highly regarded. Munch's involvement in the set designs seems in fact to have been marginal, but he very much liked the two lithographs he made for the programmes – *Peer Gynt* in 1896 and *John Gabriel Borkman* in the following year – which he afterwards often exhibited. They reflect a period in which Munch was developing his skills as a printmaker and seeking to win over a reluctant French public with his graphic output, which was less disparaged than his paintings. The programme for *Peer Gynt* (p. 224) met the requirement for local colour with the prominent depiction of a vast mountain landscape, in which the hero exists only through the two waiting women who love him. The soft lines reflect Munch's efforts to remain consistent with the Nabi aesthetic, without entirely departing from his own 'bitter flair',[27] seen in the melancholic face of the mother, Åse. *Peer Gynt* was one of Munch's favourite plays, to which he often returned, playing around with various graphic variations down the years, many of which are overt or concealed self-portraits.

The idea of portraying the play's author rather than its character for the programme for *John Gabriel Borkman* (p. 224) came from Théâtre de l'Œuvre's previous series of 'portrait programmes'. Toulouse-Lautrec's programmes of February 1896 for Romain Coolus's *Raphaël* and Oscar Wilde's *Salomé* showed the authors in their respective cities. Munch had recently worked on a project for an illustrated edition of Baudelaire's *Les Fleurs du Mal* (p. 226) and portrayed Ibsen in a coastal landscape lit by a lighthouse, in reference to the poem 'Les Phares', in which Baudelaire pays tribute to the greatest painters whose genius lights up the world. 'Ibsen at the lighthouse', as Munch called the programme, was the first in a series of portraits of Ibsen made in the years 1898–1910, including one of the sketches for the Aula (festival hall) at Kristiania University, showing the dramatist alongside Nietzsche and Socrates in *Geniuses*.[28]

In the summer of 1898, having returned to Norway, Munch was invited to contribute to an issue of the Berlin journal *Quickborn* celebrating Strindberg's 50th birthday. Despite the writer's reservations concerning Munch's contribution, which went ahead without any communication between the two men, Munch accepted the commission, warning that he would provide images arising out of 'his personal atmosphere'[29] rather than illustrations – a response that reflects Symbolist debates on the art of illustration. In practice he contributed both new and pre-existing works relating to the texts sent by the publisher. For the cover he created *Blossom of Pain* (p. 222), which draws on the myths of both Narcissus and the mandragora, a flower much favoured by Strindberg for its ambivalence. The dramatist had recently mentioned this flower 'of wickedness' which 'in the old days cured madness' in his play *The Road to Damascus* (Act I). *Quickborn* published German versions of a short story, poems and the one-act play *Simoom* (1889), a variation on the biblical story of Judith seen through the Strindbergian prism of the 'battle of the brains' and 'psychic murder'. During the invasion of Algeria, a woman, Biskra, succeeds in driving a French lieutenant to despair and death using only persuasion, plus the assistance of the burning hot Sahara wind. Biskra's final speech,

in which she deals the man a death blow by presenting him with a skull as his reflection, inspired Munch to create two prints, *The Kiss of Death* and *Harpy* (p. 227). These images move away from the theatrical context towards allegorical depictions of a woman's murderous power, in which long hair or black wings fall like a shroud around a man reduced to a skeleton.

While Munch was working on his contributions to *Quickborn* in the second half of 1898, he simultaneously embarked on a new and larger project inspired by the theatre. In the summer his friend the poet and dramatist Helge Rode had sent Munch his new play *Dansen gaar* (The Dance Unfolds).[30] This work of decadent inspiration celebrates the pure soul of the artist, who cannot survive in a corrupt society. The love between the painter Aage and the beautiful Klara Hauge is hampered by jealousy and financial interests. The melancholic, solitary painter who struggles to see anything but pain in life is clearly – almost explicitly – based on Munch. The lovers declare their passion during a dance held at the Hauge's magnificent residence and the moment of grace Aage feels while they are dancing gives him the idea for a large painting. 'My painting will be called *The Dance of Life*. Two people dancing [...] on a clear night in an avenue of black cypress trees and red roses. The delicious blood of the earth will flow through these red roses, Klara. He holds her tight against him. He is deeply serious, but happy. [...] She will be afraid, and yet this awakens something in her. A force emanating from him will flow into her. Before them the abyss' (Act II). But tragedy is taking shape: their ideal will be defeated by jealousy and materialism. The painter decides to take his leave of the world. Klara intends to accompany him into death, but wavers at the last moment.

This play was immediately interpreted artistically by Munch. After reading it he created several works on the subject of dance, including sketches that led to the monumental painting *The Dance of Life* (p. 79). Reworking the figures and setting of his previous painting *Woman* (p. 80), he portrayed them in a dramatized scene of dancing on a summer night. In the centre of the composition, the pair of lovers are disconnected from the surrounding frenzy. The atmosphere precisely recreates that of Aage's speech on the gravity and solemnity of love. The insertion of the triad from *Woman* into the fiction gives it added depth and complexity, offering a diachronic portrait of Klara, from the carefree girl of the past to whom Aage was attracted to the weeping widow she becomes at the end of the play. This monumental painting became the cornerstone of *The Frieze of Life*, exhibited in Berlin in 1902. In an ironic twist, in 1900, just as Munch was completing *The Dance of Life*, Strindberg was writing his conjugal drama *The Dance of Death*.

The circumstances of Munch's next long period in Germany in 1905–08 were paradoxical, the fame he had at last acquired coinciding with serious mental deterioration. However, he did accept opportunities to re-engage with the theatre world. He met Max Reinhardt, Otto Brahm's former assistant and successor at the Deutsches Theater, who revolutionized dramatic art with his visual sense, technical innovations

and involvement of the audience. Reinhardt realised Strindberg's dream of a chamber theatre in the new Kammerspiele in Berlin. Moving away from the Symbolist concern for distancing and abstraction, he sought to enable the greatest possible osmosis between stage and audience, notably through the rigorous direction of actors to ensure that they conveyed the psychology of the characters. 'Every opportunity to make emotional contact between the actors and the audience must be exploited.'[31] Reinhardt opened the Kammerspiele in the autumn of 1906 with *Ghosts*, in homage to Ibsen, who had recently died, and with a 'quintet' of actors, the small cast heralding the new, intimate theatre. He managed to persuade Munch to work on the play, on the basis that he would provide 'mood studies' (*Stimmungsskizzen*) rather than set designs and, in a commission 'that no painter's soul could resist',[32] would decorate a room in the theatre entirely as he chose. In practice, Munch became increasingly involved in the set design of both *Ghosts* and *Hedda Gabler* (p. 221) and ultimately designed the set down to its smallest details, as well as providing mood studies. *Ghosts* was a major success (and Munch's contribution much noted), but *Hedda Gabler* was not. Munch continued his work on the foyer frieze until Christmas 1907, and considered painting various portraits of actresses (Gertrud Eysoldt, Adele Doré), which were never realised. Involvement with the Deutsches Theater proved difficult for Munch, unused as he was to the pace and constraints of collective creation. However, it did open up new horizons, leading him to explore the expressive relationships between figure and space and the use of objects in enclosed settings, such as *The Green Room* (p. 217). In his unstable psychological state, immersion in these two plays awakened personal echoes, triggering identification with Ibsen's characters in different situations. *Ghosts*, which explores heredity and illness, inspired him to return to work on earlier paintings, while *Hedda Gabler*, the ambivalent heroine who causes the death of the poet Tesman, took Munch back to his own love affair with Tulla Larsen and their dramatic split, leading to several works on the theme of the female murderer (p. 218). In 1908 the psychological issues he had suffered since the split – and which inspired him to venture into playwriting with the burlesque satire *The City of Free Love* – led to him spending eight months in a psychiatric clinic. Being forbidden to paint in the early months, he spent more time reading, and read Ibsen yet again. In a letter to a friend he said, 'I'm rereading Ibsen and read him as myself'.[33] So began a new and final period of theatrical interpretation which, this time, remained almost entirely confined to the personal sphere.

Munch's return to Norway in 1909 went hand in hand with a profound lifestyle change. His years of wandering and bohemian life gave way to a reclusive existence which pushed him to draw ever more deeply on his own world and on literature. His subtle reading of Ibsen, deepened through contact with Reinhardt and with his friend Professor Sigurd Høst,[34] inspired him to create many graphic interpretations. Images from plays by Ibsen appear in drawings and prints made over the years in his sketchbooks and notebooks or on separate sheets, notably based on *Peer Gynt*, *John*

Gabriel Borkman, *Ghosts*, *When We Dead Awaken*, all plays in which Munch identified with the main character. A final unsuccessful project of 1917 for an illustrated edition, in this case of *The Pretenders*, gave rise to a fine series of woodcuts while confirming that Munch was incapable of submitting to the requirements of illustration. Over the years, he created hundreds of graphic works ranging from hasty sketches to fine drawings, conveying entirely personal 'reader's impressions'[35] with total freedom. These offer us a glimpse into his artistic process and his constantly fluctuating ideas and readings focused on emotions, and show him adopting the viewpoints of the characters in order to explore personal issues. This art made away from the spotlight sometimes contributed to his paintings – *Sleepless Night: Self-Portrait in Inner Turmoil* (p. 215) has its origins in drawings of the solitary *John Gabriel Borkman* (p. 77) – or else was an opportunity for Munch to revisit his own repertoire. In this way Ibsen's characters appear in playful sketches reworking scenes from *The Frieze of Life* or in experimental hybridized form in prints of earlier graphic works. For the woodcut *The Girls on the Bridge* of 1918, Munch printed a few versions of the image to which, in a strip above the main motif, he added another scene showing a woman carried off by men on horseback in a medieval setting. The juxtaposition of the two apparently unconnected images can be understood in the light of lines from Ibsen's play *The Master Builder* and its heroine young Hilde. Munch's private graphic quotation lends a specific, singular tone to this iteration of the frequently depicted *Girls on the Bridge*, and reflects the endless play of associations between fictional characters and his own iconographic repertoire. The painter's lasting interest in the theatre and literature can particularly be seen in his fascination with Ibsen's work, which continued throughout his life and artistic career, leading him from avant-garde theatre to the intimacy of the reading room.

1. Letter to Olav Paulsen PN 303, 14 December 1884 (Nasjonalbiblioteket, 518). Munchmuseet.
2. Munch & Schiefler 1987, p. 63.
3. Munch 1928, p. 13.
4. Munch 1929, p. 13–17. He notes the interest Ibsen showed in his works, notably *Woman* (p. 80), and the parallels with his last play *When We Dead Awaken.*
5. Letter from Emanuel Goldstein K 1500, 13 February 1892. Munchmuseet.
6. 'On the paintings of Munch which, according to the association's publicity, express "Ibsenian atmospheres", there is no reason to say more, for they bear no relation to art' (*Kunstchronik*, no. 4, 1892, pp. 74–75). My warmest thanks to Inger Engan at Munchmuseet's library for her help.
7. Munch's correspondence reflects this important relationship which began in November 1892, and also long-term exchanges with Theodor Wolff. Julias Elias might be the man portrayed in a sketch on cardboard of 1893–94 (Woll 2008, no. 308).
8. See Lathe 1983, p. 195.
9. N 415. Munchmuseet. Munch attended Elias's receptions with Strindberg and the Norwegian playwright Gunnar Heiberg, to whom he was close until 1902.
10. On the relationship between Munch and Strindberg, see Dittmann 1982.
11. Przybyszewski published the first critical essay on Munch in *Neue Deutsche Rundschau* (*Freie Bühne*) in 1894.
12. Bernhardt 2007, pp. 4, 75 and 107. The author mentions that Hauptmann drew on the relationship between Przybyszewski and Juel for his play *Die Jungfern vom Bischofsberg* of 1907.
13. Note N 25, 1912. Munchmuseet.
14. Strindberg, 'Sensations détraquées', *Le Figaro*, 17 January 1894. On the influence of the theatre on Munch's art, see Lathe 1983 and Lachana 1997.
15. This silhouette has traditionally been identified as Munch's brother Andreas, but the age difference between the silhouettes, which is sometimes even more apparent in the graphic versions, makes this unlikely.
16. On Munch and Maeterlinck, see Pica 1905, Eggum 1983, Eggum 1991–92b and c, Aitken 1991–92, Lachana 1997 and Rioual 2017.
17. Woll 2008, Vol. I, nos. 327–330.
18. See Losco-Lena 2010.
19. Munch also met Gerhart's son, the painter Ivo Hauptmann, who noted that in their first conversation in 1905, Munch 'often talked about Gerhart Hauptmann but never about painting' (Hauptmann 1947).
20. Draft letter to Jens Thiis N 43, 1933–40. Munchmuseet.
21. Rioual 2017, p. 265.
22. Maurice Maeterlinck, *Pelléas et Mélisande*, Act II, scene 2.
23. Quillard 1891, p. 181. See Coppel 2019.
24. See Aitken 1991–92, pp. 222–239, and 'Les programmes lithographiés du Théâtre de l'Œuvre', in exh. cat. Paris 2005, pp. 67–83.
25. Godet 2005, p. 89.
26. Losco-Lena 2010, p. 96.
27. Natanson 1895, pp. 477–478.
28. On these portraits, see Junillon 2009, pp. 73–82.
29. Draft letter to Emil Schering, 1898, N 3416. Munchmuseet.
30. Næss 2011, p. 159, and Høifødt 2010, pp. 72–73.
31. Max Reinhardt, 'Über das ideale Theater' (1928). See Lampe 2011.
32. Arthur Kahane in *Berliner Tageblatt*, 28 October 1926; French translation of the complete article in exh. cat. Paris–Frankfurt–London 2011-12, p.12.
33. Draft letter to Jappe Nilssen N 1908, 27 December 1908. Munchmuseet.
34. Sigurd Høst published a major book on Ibsen in 1927. On the exchanges between them, see Junillon 2009, pp. 52–56.
35. See Junillon 2009 and Templeton 2008, which both draw on the seminal work undertaken by Munchmuseet.

Munch's Aula and the Theatre of *The Sun*

Patricia G. Berman
Feldberg Professor of Art
Wellesley College, Massachusetts

I saw the small and the large planets that adhered to the laws of nature and moved in their predestined orbits ... I saw the little planet Earth as it moved on its orbit around the sun ... I saw where the change in matter began – how the air corroded the hard matter – and the transitional forms between stone and atmosphere were created: the living – human beings, animals and plants ... I saw the single individual – from the first moment the light entered it – how its desire slowly but surely developed ... It screamed after nourishment – it saw the sun and stretched its arms towards it. [1]

Between 1909 and 1916, Munch worked on one of the most consequential projects of his career: the eleven monumental murals for the festival hall (Aula) of the Royal Frederick University in Kristiania (now the University of Oslo).[2] The murals consist of three focal images and eight narrower paintings, all 4.5 metres high and rendered in mixed media on canvas (p. 91).[3] Occupying the room's long lateral walls are reinterpretations of conventionalised National Romantic motifs, *History*, on the left, and *Alma Mater*, on the right. In front, at the centre, is a rising sun. Each is framed by separate paintings of nude figures allegorising academic disciplines.[4]

The Sun, measuring 7¾ metres across, is the backdrop for the Aula's stage, a *mise-en-scène* for the university's official business. While working on the project, Munch rendered two full-scale monumental versions of *The Sun* and eight smaller compositions, all displaying a dazzling variety of unorthodox techniques and painterly gestures. In small variations, in which the foreground landscape liquifies into pure gesture, a dark form at the centre of the sun takes on the aspect of an eye, an identification of light with its optical reception.[5] Functionally, in the festival hall, the multicoloured rays seem to jump beyond their frame as their expanding directional lines are met with continuing prismatic dispersion into the neighbouring murals. Thematically, the sun embodies the very notion of enlightenment or illumination, the pedagogical work of the university. Ideologically, it is a motif that replaces human educators with the image of nature as teacher, with light as the animating source of knowledge itself and of the minds and bodies of its audiences.

In August 1916, as Munch had prepared for the official unveiling of the murals, a satirical magazine published a caricature of the artist transporting the sun. Captioned with the title 'Heat Wave', the artist heroically climbs a ladder on which hangs a palette dripping with paint, and clutches the radiant sun (p. 88). The artist's ascension seems to disturb the air at his feet, sending tiny waves of motion into the lower left corner. As sunbeams stream across the room, they seem to magnetically vector crayon lines that describe the mural *History*. Perhaps unwittingly mimicking a photograph staged by Munch in 1911 to record his progress on the paintings (p. 97), this satirical homage points to some of the mural's actions as a spatial, and not merely optical, phenomenon.

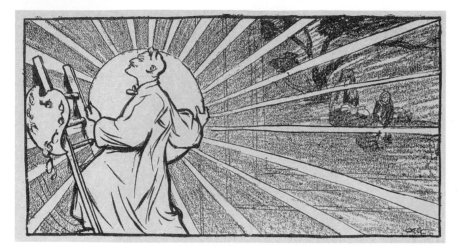

Caricature by Otto Hjort, published in *Hvepsen*, August 1916

Camille Flammarion, 'The Planetary System',
in *Astronomie populaire*, 1881

Seeing the Sun

Decades after painting the Aula murals, Munch wrote simply: 'I saw the sun rise over the rocky shoreline. I painted the sun.'[6] The landscape setting for *The Sun* corresponds to a view near Munch's house in Kragerø. There, the artist's close friend and relative Ludvig Ravensberg spent extensive time as Munch undertook initial work on the project. He later commented on the artist's preoccupation with invisible energies and human reception:

> **[Munch] often expressed intuitively what science later has revealed, his perception of flames, waves and crystals, and in *The Sun*, the central image in the Festival Hall, he has given these thoughts life and form, allowing it to extend the rays out into the side panels, where science experiments with its reports and analyses and creates life; no one before has created something out of this enormity as a decorative idea.[7]**

Munch may have simply looked at the sun, but his representation of it, as suggested by Ravensberg, was invested with other visualisations. To look directly at the blazing sun is to cause pain, sear the retinas, and create protective afterimages in the optical field. Therefore, in conceiving the sun as a spoked and spiralling orb, Munch drew upon the widespread visual cultures of physics, including graphic representations of radiation, solar flares and planetary movement published in popular sources such as Camille Flammarion's *Astronomie* (1880). Flammarion's writing, in which observational science intermingled with occult speculation, accorded with Munch's own cosmology: 'If we had other cords to our lyre,' argued Flammarion, '... the harmony of nature would be transmitted to us more complete than it is now, by making these cords all feel the influence of vibrations. ...The late discovery of the Röntgen rays, so inconceivable and so strange in its origin, ought to convince us how very small is the field of our usual observations.'[8] Munch's later writings echo such references to x-rays, cosmic vibrations, and bodily reception: 'If we possessed other, more finely tuned organs – or organs that were adapted in a different way – we would see and feel differently'.[9] He also noted, 'Everything is motion ... (Already in my notes from 20 years ago) ... Thoughts could be transferred through space. X-rays that passed through bodies were discovered. Radios.'[10]

Munch's ambition to give material form to the intangibility of light and energy was, of course, a central issue of artists of his generation who wished to see 'beyond material circumstances', to investigate what they construed to be animating universal forces.[11] The increasing scientific capacity to record and graphically represent light and its effects on the body created a notion of vibratory convergence between energy and the operations of vision.[12] As, throughout the 19th century, the composition of light was increasingly understood to be wavelike, the question of what could be seen, felt or heard due to vibratory receptivity was an ongoing aesthetic preoccupation. Does pure light have materiality?[13] Does the mind register what the eye cannot specifically see or can the body experience light and colour beyond vision?[14] These were questions that run throughout Munch's voluminous writings.[15]

Munch's speculations about human consciousness and the larger universe embody the Monist principles of Ernest Haeckel, the Jena-based zoologist who was Germany's most influential interpreter of Darwin.[16] Haeckel's system of thought attempted to reconcile differences between the realms of science, mysticism and organised religion. Dispensing with the belief that humans stood outside of nature, Haeckel argued for the understanding of human life and evolution in concert with all living things, linked by an elastic connective matter, a kind of 'vibrating ether'.[17] He proposed that all space is filled with light as vibrating particulate matter that, 'whatever else it may be – is always and everywhere an electrical phenomenon.'[18] Sunlight was the animating agent: The evolution of earth and 'its entire individual life is a product of sunlight'.[19] According to Haeckel's cosmology, sunlight was vibratory, electrical and cellular. Robert Brain notes that Haeckel established a 'comprehensive biological vision' of reverberant ectoplasm that assisted Munch in his ambition to seek convergence between the material world and invisible forces of electromagnetism and particles.[20] Within this arena, the body was coextensive with, receptive to, and vitalised by universal forces.

Animating the Aula

The university project was initiated at a critical point in Munch's career, just as he decided to move permanently to Norway after years of living abroad. This was also an auspicious juncture in Norway's history: The Royal Frederick University had begun construction on the new festival hall in advance of its centenary in 1911. As Norway had only become independent from Sweden in 1905, and the university had undergone recent revision to embrace modern sciences as foundational to its prestige, the building and its decoration bore the weight of exceptional expectation.[21] In conceiving of public art for that institution at that intertwining moment of new beginnings, the artist was able to assert his speculations about science, the forces of nature, and the affective dimension of art, the culmination of Ravensberg's characterisation of 'enormity as a decorative idea'.

The hall was, from its conception in 1908, the centre of critical controversy and opprobrium.[22] Its stripped-down classical design incorporated large tracts of wall to receive decorations; when the competition to design the paintings was announced, the only criterion offered was that they should harmonise with the architecture.[23] Munch began to bid for the project in spring 1909, but only after months of contentious public debate was he invited to present sketches to a panel of judges.[24] In 1910, Munch submitted a version of *History*, which the jury identified as promising, and *The Human Mountain*, which was rejected. For a second round of judging in 1911, Munch had developed variations on eleven motifs that he exhibited both in the Aula and in a local exhibition hall to be evaluated by the larger public. One of the jurors admired Munch's work but stated that 'it is not appropriate to use our university's Aula as an arena for experimentation.'[25] The jury reached no decision.

The university's period of vacillation, which extended until 1914, was a point of frustration for the artist, who produced a vast number of

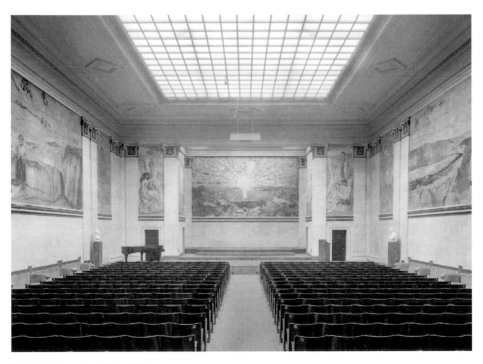

The Aula, University of Oslo, 1927
Photo: Hans Henriksen

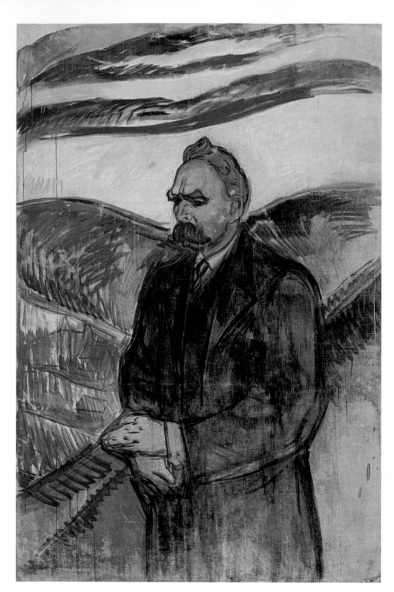

Friedrich Nietzsche 1906
Oil and tempera on canvas, 201 × 130 cm
Munchmuseet, Oslo

drawings for the murals, and close to 170 paintings, a significant number of them at full monumental scale. He constructed outdoor studios on two coastal properties to accommodate the massive canvases (p. 97).[26] He transported versions of the colossal canvases back and forth to Kristiania for trial hangings in the Aula,[27] as well as solo exhibitions to garner popular support for his project. The artist's physical labour alone was exceptional.

So, too, was his labour as a strategist.[28] Determined to win the prestigious commission, Munch exhibited sketches for and versions of the murals in numerous exhibitions, including adaptations in half-scale that he sent to the Berlin Autumn Exhibition in 1913.[29] Only after German critics lauded Munch as the greatest monumental painter of the epoch[30] did the university finally agree, in 1914, to accept Munch's murals as a gift arranged by his close supporters.

The competition, the university's intransigence, and Munch's sketches were part of public discourse in Norway, the locus of discussion for that country's self-image, its image abroad, and its aesthetic future far beyond the institutional concerns of the university.[31] An emphasis on the paintings' national rootedness was threaded throughout Munch's public statements as he endeavoured to secure the commission. In 1911 he stated to the jury:

> It has been my wish that the decorations should form a unified and autonomous world of ideas, and that its visual expression should be both specifically Norwegian and universal. With regard to the hall's Greek style, I believe that there are a number of points connecting it and my painting style, in particular in its simplification and surface treatment, with the result that the hall and the decorations 'fit together' in a decorative sense, even though the pictures are Norwegian.[32]

In 1918, a few years after installing his paintings, Munch wrote more intimately of the university murals' indebtedness to his *Frieze of Life* as a thematic framework:

> The *Frieze* should be considered as a sequence of decorative paintings that when brought together should give an impression of life ... *The Frieze of Life* should also be viewed in relation to the University decorations – of which it was the precursor. Without the *Frieze*, the University decorations might never have materialised. The *Frieze* developed my decorative sense. The two works – *The Frieze* and the University decorations – also belong together in terms of intellectual content. *The Frieze of Life* portrays the joys and sorrows of individual people seen at close quarters. The University decorations represent the great forces of eternity.[33]

In a draft letter to Munch's friend and (in the 1930s) biographer Jens Thiis, the artist emphasised the murals' decorative, architectonic effects:

> When you mention the Life Frieze and the various images termed symbolic or literary, you must remember that, simultaneously, there were parallel artistic lines – These pictures were steps towards later murals and the Aula paintings

> – I searched for simplification – ... and the idea was already present then, e.g. with [Henry] van de Velde.[34]

The last statement suggests a more ambitious vision for the Aula paintings than the first; for the paintings to be part of an affective environment. In this sense, the sun's radiance may be seen as somatic as well as optical.

To See with the Body

In 1929, Munch wrote to the composer Frederick Delius: 'one certainly does not see with the eyes alone, but with the whole body.'[35] The architectural historian Wenche Volle identifies Munch's ways of thinking about environments, such as the galleries that displayed *The Frieze of Life*, as spaces of psychological and somatic affect, places of receptivity.[36] She cites the numerous art and psychological theories of empathy that were published from the 1880s through the 1910s that intersected with Munch's conception of architecture as an affective frame for art.[37] Empathy – *Einfühlung* – was 'a form of spectatorship that was simultaneously haptic and optic', a state of being connoting psychological absorption.[38] Volle also notes Munch's shared fascination with the idea of the interior as a projective and absorptive arena with Jens Thiis, who was among the first curators in Europe to create a unified *art nouveau* interior at Nordenfjeldske Kunstindustrimuseum in Trondheim. Art historian Julius Meier-Graefe, who founded La Maison Moderne in the 1890s, was also a significant friend and early supporter of Munch. Meier-Graefe's theories of 'the decorative' as a unifying aesthetic and psychological force within interior design also aligned with Munch's elaboration of *The Frieze of Life* as a spatial as well as visual ensemble.[39] Meier-Graefe's notion of art 'that makes the air around it vibrate',[40] echoed Munch's vision for *The Frieze of Life* as sonic as much as narrative.[41] Volle particularly notes the importance of Munch's interactions with Henry van de Velde, the architect of the Nietzsche archives in Weimar where Munch spent considerable time in 1905–06. The historian Rune Slagstad, moreover, notes that Munch's work at the Nietzsche archives, when he was commissioned to paint a portrait of Friedrich Nietzsche in monumental scale, marked a turning point in the artist's career as a decorative painter (p. 92). He proposes also that Munch's conception for the posthumous portrait was bound up in the idea of the receptive body.[42]

The receptive body was a theme that ran throughout Munch's work as well as in the maintenance of his own body. Often vulnerable to lung ailments, Munch sought the benefits of open-air bathing and mountain cures promoted by the period's medical establishment and alternative practices.[43] His painting *Bathing Men* (p. 197), one of a number of the artist's depictions of cold-water bathing from 1907–08, records his involvement with the physical wellness aspects of the Reform Movement.[44] Photographs that show his work on *Bathing Men* on the beach in Warnemünde directly locate his body as an instrument in the production of the painting and as an organ of receptivity, a conduit between the sun and the canvas. The European culture of restorative

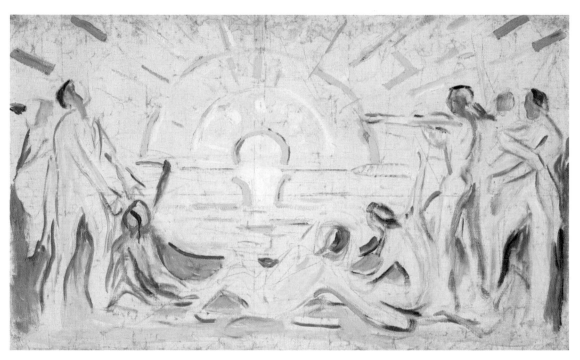

The Sun and Awakening Nude Men 1910–11
Oil on canvas, 70 × 116 cm
Munchmuseet, Oslo

sunbathing, which was rooted in the use of mountain and seaside tuberculosis cures in the last decades of the 19th century, was founded on the notion that the sun's rays were curative, even nutritive.[45] Within the various practices that constitute the northern European Vitalist movement – in Germany *Freikörperkultur*, open-air nudism – the sun was the source of personal and collective renewal. The skin was a permeable membrane that registered the action of the sun both through tanning and by acting as a pathway to the body's interior environment. In the words of health pioneer Florence Nightingale, 'The sun is not only a painter but a sculptor ... we must admit that light has ... real and tangible effects upon the human body.'[46]

While Munch was developing his concepts for the Aula murals, one early proposal for the front wall entitled *The Sun and Awakening Nude Men* (p. 95) gave shape to his vision of the radiant sun – of nature as healer.[47] Holding gestures that echo the rings that seem to radiate outward from the sun, its multiple naked figures align with the bowl-like contours of the landscape. As Munch continued working on the Aula project, he relocated the figures to independent paintings adjacent to *The Sun* and isolated the image of the sun into a sovereign composition. Thus liberated from its role as a narrative element in a figurative painting, the radiance of Munch's sun vitalises the entire architectural surroundings.

The Theatre of Sensation

Through Munch's exploration of *The Frieze of Life* as a comprehensive interior decoration, as well as a cyclical story, architecture became an active element in his work. Munch adapted some of the motifs from the frieze for the mural cycle that he had created for the nursery of Dr Max and Marie Linde's home in Lübeck, reinterpreting them in vibrant colours and energised brushwork. This project served as a cautionary tale, as the paintings were viewed as inappropriate for the site.[48] But it also served as a source for one of the murals in the Aula, of women picking fruit, representing the discipline of Botany. The diaphanous painting series that Munch created for a vestibule at Max Reinhardt's Kammerspiele in Berlin drew on motifs from *The Frieze of Life* to immerse theatregoers within a dream-like landscape, a series greatly admired by Max Pechstein (p. 203).[49] Munch's work for Reinhardt also extended to theatre design in 1906, for which the artist produced interiors meant to evoke a mood rather than serve as simple stage sets (p. 220).[50]

In the years just prior to the Aula project, Munch also began to approach paintings of interior spaces (a theme throughout his career) with a greater emphasis on architecture as animated and often distorting and oppressive – in other words, as mood-inducing. In paintings understood to constitute *The Green Room* (1907) series, space is both a projection of human emotion and an actor in the domestic drama (pp. 217 and 218).[51] One of the hallmarks of Munch's work, in fact, is the commingling of bodies and their environments as shared and unified psychic arenas. Munch's poetic fragments paralleling *The Scream*, which he inscribed in the wooden frame of the pastel variation, repeatedly linked the sense of sight to one of bodily reception: 'I felt a great scream through all of nature.'[52]

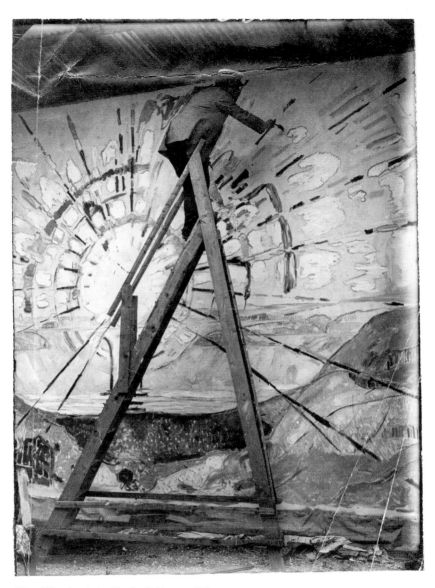

Edvard Munch painting *The Sun* in Kragerø, 1911
Photo: A.F. Johansen. Munchmuseet Archives

Signe Endresen calls the effect of architecture in Munch's painting 'the theatre of space'.[53]

In the Aula, Munch had at his disposal space as theatre. With *The Sun* rising at the centre and, on the long walls, *History*, the representation of an old man passing intergenerational knowledge to a young boy; and *Alma Mater*, a woman suckling a baby and watching over other children, Munch created a new life cycle for the Aula. As I have suggested elsewhere, the figures, seated in their monumental landscapes and bracketing the audience, operated as national archetypes that would continually shape and reshape a common idea of what Munch termed the 'specifically Norwegian and universal'.[54] To sit between the large rural progenitor and progenitrix, and to face the radiant sun, was to be perpetually vitalised as part of an imagined genealogy that extended back through time and forward to future generations, an ongoing national genesis. In this sense, the sun's rays moved not just laterally across canvases, but vibrated into the audience.

Afterlife of the Project

Even after the university finally allowed the murals to be installed, the Aula remained one of Munch's ongoing preoccupations. He requested changes that should be made to the architecture and the lighting. He also continued to work on the motifs, developing *The Human Mountain*, with its internal life cycle from death through solar reanimation, as an independent composition in numerous iterations.[55] He also produced variations of *History* and *Alma Mater* through the 1930s. Particularly dissatisfied with *Alma Mater*, Munch episodically reworked the motif, going so far as to receive permission from the university to install a variant, entitled *The Researchers*, over *Alma Mater* in the 1920s. Perhaps more important, the Aula project gave the artist a reason to relocate back to Norway, and provided the framework for a renewed consideration of landscape as an emotive motif. Unlike the case with *The Frieze of Life*, the university gave Munch's art a permanent home.

When, in 1917, the German composer Richard Strauss arrived to perform in Kristiania, an impresario – an acquaintance of Munch – secured the Aula. According to the impresario's memoirs, Strauss, the composer of *Thus Spake Zarathustra* (1896), was so enthralled by the paintings that he barely glanced at the sheet music on his piano. Accompanying this anecdote is a tiny drawing of a figure gazing up at a blazing sun.[56]

1 Notebook N 655. Munchmuseet. Translated in Tøjner 2001, p. 103, also quoted in part in Berman 2022.

2 On the history of the commission, see Boe 1960, pp. 233–246; Thiis 1933; Berman 1989; exh. cat. Oslo 2011–12; Berman & Anker 2011. Pettersen 2008, pp. 829–851, provides a chronology of the developing motifs in Munch's Aula paintings.

3 Clockwise, the paintings are: *Chemistry* (Woll M 1227), *History* (Woll M 968), *New Rays* (Woll M 1225), *Women Turned Towards the Sun* (Woll M 1223), *Awakening Men in a Lightstream* (Woll M 1222), *The Sun* (Woll M 970), *Geniuses in Lightstream* (Woll M 1221), *Men Turned Towards the Sun* (Woll M 1224), *Harvesting Women* (Woll M 1228), *Alma Mater* (Woll M 1220) and *The Source* (Woll M 1226). See Woll 2008, Vol. III.

4 Berman 2022.

5 Rousseau 2011–12; Rousseau 2003–04.

6 Notebook N 286. Munchmuseet.

7 Ravensberg 1946, p. 193. Also quoted in Berman 2011–12, p. 49.

8 Flammarion 1900, pp. 12 and 14.

9 Sketchbook T 2785. Munchmuseet. Translated in Tøjner 2001, p. 108. Welsh-Ovcharov 2016–17, p. 285, discusses Munch in relation to Flammarion. See also exh. cat. Paris 2003–04.

10 Sketchbook T 2748. Munchmuseet. Translated in Tøjner 2001, p. 11.

11 See for example Gamwell 2002 and exh. cat. Toronto 2016–17.

12 Henderson 2002, pp. 128–132.

13 Rousseau 2011–12, p. 162. See also Rousseau 2003–04, pp. 123–139.

14 Shiff 2010.

15 Cordulack 2002.

16 See especially Cordulack 2002.

17 Rousseau 2011–12, p. 169.

18 Haeckel 1895, p. 23.

19 Haeckel 1895, p. 34.

20 Brain 2010, p. 8.

 Berman 2011–12, pp. 41–71, and Berman 2011, pp. 47–70. On the university's history in the period, see Kyllingstad & Rørvik 2011, Vol. II.

22 On the architecture, see Johansen 2011–12, pp. 207–221.

23 Berman 2011, p. 52.

24 The artists invited to submit paintings in 1910 were Gerhard Munthe, Eilif Petersson, Emanuel Vigeland and Munch. Vigeland and Munch were invited to expand their work for the competition in 1911.

25 Dietrichson 1911, p. 17.

26 The artist's work in the towns of Kragerø and Hvitsten, where Munch built his studios and created the murals, is traced in Flaatten 2013b and in Flaatten 2016.

27 Pettersen 2008, pp. 836–838.

28 Berman 2011, pp. 47–70; Yarborough 1995.

29 See Pettersen 2008 and Pettersen 2011–12, pp. 257–269.

30 Berman 2013, p. 166.

31 See Friedman 2011, pp. 25–45.

32 Munch 1911, pp. 4–5. English translation in exh. cat. Oslo 2011–12, p. 287.

33 Munch 1918, p. 3.

34 Draft letter to Jens Thiis N 43. Munchmuseet. Quoted in Berman 2013, p. 163.

35 Quoted in Smith 1983, p. 136, and in Cordulack 2002, p. 43.

36 Volle 2012.

37 Volle 2012, p. 20. See also Silverman 1989.

38 Koss 2010, p. 67.

39 On Meier-Graefe's theories of the decorative interior, see Anger 2005, pp. 21–239.

40 Anger 2005, p. 214.

41 Heller 1968 continues to be the foundational source of study.

42 Slagstad 2008a, pp. 546–559.

43 See exh. cat. Oslo 2006, esp. Berman 2006, pp. 44–60.

44 See Körber 2014 and Berman 1993a.

45 Woloshyn 2017. See also Berman 2008a, pp. 68–85.

46 Woloshyn 2017, p. 26.

47 Pettersen 2008, p. 931, identifies this work as having been exhibited by Munch as 'third sketch for [the] main picture' in 1919.

48 Eggum 1982.

49 Berman 2013, p. 164. Pechstein 1960, p. 47. Quoted in exh. cat. Berlin 1978, p. 42.

50 Lampe 2011–12b, pp. 15–16.

51 Endresen 2015, p. 38 and chapter 2. See also Ohlsen 2013, pp. 198–200.

52 On the variations of Munch's prose poem, see Heller 1973, pp. 65 and 103–109.

53 Endresen 2015, p. 92.

54 Berman 2003, pp. 207–228.

55 Petra Pettersen reconstructed the complicated history of *The Human Mountain*, which, installed in one of Munch's open-air studios, served as a giant collage of separable parts as the artist added and subtracted canvas amendments. See Pettersen 2008, pp. 846–848.

56 Strauss then met Munch, who created a lithographic portrait (1917; Woll G 607). Rasmussen 1943, pp. 2–21, and Vollsnes 2011, p. 8. I am grateful to Lasse Jacobsen for providing this information as well as for the video he produced that animates this encounter: https://www.youtube.com/watch?v=Hv6E1r62IBE

The Literary Munch

Hilde Bøe
Scholarly Editor of Munch's Writings
MUNCH, Oslo

The drafts of my literary works are bequeathed to the City of Oslo, who will, according to expert advice, decide the manner and the extent of their publication.[1]

With the passing of time, it has become an increasingly well-known fact that Edvard Munch, the visual artist, authored works of literature as well as letters and diaries. Munch probably began writing his fiction in the late 1880s and reached his most fevered pitch in the early 1890s, but he kept up his interest in what he called, in his will, his 'literary works' and continued writing throughout his life. New texts and revisions of older writings were still being produced as late as the 1940s. In letters to friends, he repeatedly wrote that he was reading and editing his writing, and in his last will and testament he included a clause stating what he wanted done with it. Some of the notebooks include instructions both that they should be burnt and that they might be considered for publication by 'understanding and free-spirited friends' (p. 102).[2] In the event, the vast majority remained unpublished.

Munch's family background – the educated middle class – laid the foundations for a wide range of reading: everything from newspapers, journals and history books[3] to novels, plays and poetry. Munch wrote letters to family and friends from the age of 11 and kept a diary from 13 onwards. In it he wrote, among other things, that he was borrowing books from the library.[4] From early on, Munch's circle of friends included exponents of that era's literary avant-garde. He was inspired by Hans Jæger and the Kristiania Bohemians, but also by such writer friends as the Dane Emanuel Goldstein, with whom he regularly corresponded, especially about the process of writing; the Swedes Ola Hansson, Tor Hedberg and August Strindberg; and the Norwegians Vilhelm Krag and Sigbjørn Obstfelder. We know that throughout his whole life he read and was extremely interested in the plays of Henrik Ibsen, but also that he read authors such as Arne Garborg, Knut Hamsun, Fyodor Dostoyevsky, Stéphane Mallarmé and Charles Baudelaire. So it's hardly surprising that he began practising creative writing alongside his artistic work.

As a young boy, Munch's writing style was both conventional and correct, in terms of both his handwriting and his form of expression. This gradually changed when he reached his twenties, and for the rest of his life Munch's handwriting and style remained sloppy. His idiom was the Norwegian of the day, which still closely resembled Danish, but he liked to use a phonetic way of writing (again, perhaps, in the manner of Jæger) and apparently cared little for correct spelling or punctuation.[5] Neither his handwriting nor his tone was influenced by any particular genre, and his correspondence was written with as little precision as his draft letters and all his other writing. The few texts he did publish, however, appear to conform to the correct Norwegian of his day – see for instance the text accompanying *Alpha & Omega*[6] – and no trace of any discussion of this has ever been found, so spelling and punctuation do not appear to have been essential to Munch's preferred means of expression.

Notebook T 2770 1890
Munchmuseet, Oslo

To be
burnt
E. Munch

Crossed out and replaced with:

To be evaluated by
understanding and free-spirited
friends
after my death
Edvard Munch
Sept. 1932

Portfolio T 2547 1896
Munchmuseet, Oslo

Moonlight glides across your countenance
that [is] full of all the earth's beauty –
and grief
Your lips are like two ruby red snakes
and filled with blood like the crimson fruit
– They separate as though in pain
A corpse's smile[.] For
now the chain has been linked which
ties generation
to generation –
As one body we drift out onto
a great ocean – On lingering waves
that shift
colour from deep violet to blood red

The influence of the contemporary literary renaissance is apparent both in his subject matter, Munch's choice of genre, and in his writing style. Up until the turn of the century his preferred forms were the literary sketch and the prose poem, but he later also attempted short stories and, especially, drama. Like his friends and role models, Munch wrote about the modern spiritual life, taking as his starting point significant experiences from his own life.[7] He wrote about inheritance, illness, family, death and love, all of which are central themes in his visual art, not least in the pictorial series he called *The Frieze of Life*. There are, however, also many motifs in his art which he did *not* write about (in a literary sense). They can be divided into categories such as portraits, self-portraits, landscapes, people at work and in particular locations (bathing, farming, forestry, gardening, etc). In contrast, there are certain themes he wrote about which never feature in any of his visual art. There are central themes, particular to these literary sketches, which are possibly a little difficult to represent visually, but which were both of their time and which preoccupied Munch: travel, noise, silence and boredom.[8]

Munch's prose poems are closely connected with the themes and motifs that surfaced in his drawings, prints and paintings. *The Scream* is an obvious and well-known example, with five versions of the image and more than ten textual versions; but there are also many pictorial and textual versions of *Vision* (p. 106). The same applies to *Meeting in Space*, *Madonna* and *The Voice*. Indeed, in several of these cases, there are versions where text and image are literally juxtaposed. In other words, there is a close relationship between Munch the writer and Munch the visual artist, and which marks him out as a *storytelling* painter. That is to say, his pictures frequently show people in action – a story is inscribed in the image, which can be 'read' as part of the viewer's encounter with the picture.[9]

As well as themes arising out of childhood memories of the death of his mother, his sister's illness and death, his own illness, and sexual and romantic experiences in early adulthood, the literary sketches also deal with travel, especially in Norway and France, and playing roulette at a casino in Monte Carlo. The sketches often seem rooted in Munch's own experience and have been eagerly interpreted as windows into Munch's (inner) life. However, he wrote repeated versions of them. He used fictitious names or didn't bother using any names at all. He wrote just as much in the third person as in the first person, sometimes even using both in the same text. In the notebook dubbed *The Illustrated Journal*,[10] there is a meta-commentary, a rare example of the author's planning-out of his own writing. To the right of the text on sheet 2r, Munch has added a vertical note along the side of the page: '[I] shall speak in the first person' (p. 106). The text and the illustration is about his mother's death. It exists in at least six versions,[11] but all of them are told from a third-person perspective.[12]

There are many reasons why a writer might choose to write about a traumatic event from his or her own life, in a way that keeps the event at a distance. Yet the nature of the form itself is a good reason to remain sceptical that such narratives arise directly from the author's or artist's life and experience. The fictionalised elements are plentiful: third-person,

invented names and the writer's meta-comments. These signs of fictionalisation make it clear that you cannot draw any wider conclusions about the connection between the text (and image) and the life. As in his visual art, in his writings Munch seems to circle around the same motif in a steady stream of new versions, as if the repetition itself is the crucial factor; as if that is the source of inspiration and further creativity, whether as a text or as a picture.

The name *The Illustrated Journal* does not come from Munch himself, and the description 'journal' should not be taken literally. Most likely what lies behind the name is the generic term 'literary journal'.[13] However, 'literary journal' barely covers the entirety of Munch's written oeuvre;[14] a better term might be 'fragments',[15] since the texts are never joined together to form a whole with bridging passages. They are left to stand for themselves. I prefer the term literary sketches, because 'sketch' not only connects with Munch's visual art, but it also denotes something unfinished – something sketchy – about these texts, which is not found in finished versions, nor was ever published by the artist himself.

After the turn of the century, Munch began working in two new genres, writing both what could be called drafts of short stories (narratives) and drafts of plays. The more the versions of the prose poems and the literary sketches can be dated to the 1900s, the more likely they are to be iterations of earlier texts with no new themes. The drafts of the short stories and plays, on the other hand, contain plenty of new material. The short story Munch seems to have worked on most is *The White Cat*, which he also called simply *The Cat*. This exists in one fragment and two drafts, all probably from 1904.[16] This uncanny tale has much in common with horror literature and appears to have been inspired by an experience with a cat that Munch let into his rooms in Paris in 1896. Two brief tales in a 1908 notebook[17] also deal with the morbid and the eerie. The first is about being present at the slaughtering of a bull, and the second is about a woman persuading a man to commit suicide. These stories have no direct parallels in Munch's visual art.

Munch's first draft of a play is probably *The City of Free Love*, which exists in two versions.[18] *The City of Free Love* is a comedy which satirises and pokes fun at easily recognisable personalities from the Kristiania Bohemians. The writer himself can be identified as the main character, 'the Singer'.[19] Some years later came *The Aula Paintings: Beautiful Helen*,[20] about the controversy related to the university festival hall (Aula) decoration project. Here, too, the tone is mocking and the genre comic, and Munch himself described the piece as 'a tragi-comedy that makes fun of the way my Aula paintings were sabotaged'.[21] There is also a small dramatic outline from late in his life, about two children and their nanny, in which Munch has included the following casting notes: 'Dada aged 15 / lawyer Nørregaard / Kristian aged 10 played by painter Munch / Tulla aged 5 played by Miss Inger Munch'.[22] Here, the tone is quite different: Kristian is a well-brought-up older brother who needs the nanny's help to get away from his little sister's annoying games.

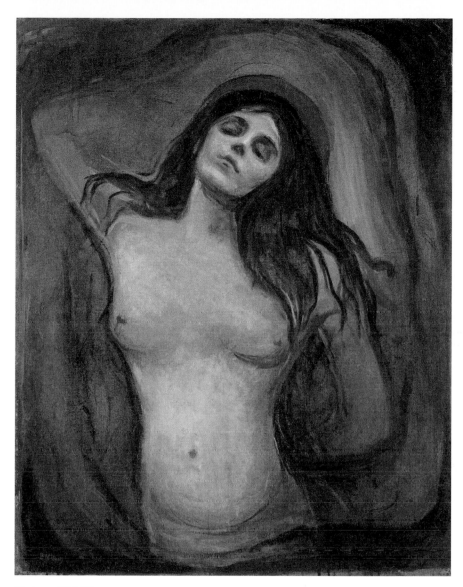

Madonna 1894–95
Oil on canvas, 90 × 71 cm
Nasjonalmuseet, Oslo

Note T 2908 1892–93
Munchmuseet, Oslo

I lived down in the depths
amid slime and creatures –
I forced my way up to the
water's surface out of longing for
the bright colours –
– A blindingly white
swan glided by over there on
the shimmering surface – its
pure lines reflected in
the water – which also reflected
the bright clouds in the sky –
I reached out to it
with my hands – entreated it to come
– But it could not
Simply could not get past
the ring of scum and slime that
surrounded me – it soiled
its white breast and glided away

Sketchbook T 2761 1889–90
Munchmuseet, Oslo

At the bottom of the large double bed they sat pressed
together on two small children's chairs;
the tall figure of a woman stood next to them, big and
dark up against the window
She said she would be leaving them was forced to
leave them – and asked if they would be grieved
when she was gone – and they had to promise her
to keep close to Jesus then they would meet her
again in heaven
They did not really understand but thought it was
unbearably sad and then they both started to cry,
to sob –

[I] shall speak in the first person

Munch's fourth attempt at dramatic writing deals with a court case against Poulsen, an eccentric artist.[23] It has similarities with the last play Munch wrote,[24] which is also a legal drama, this time about the fate of Gunnerud's dog. Both these drafts take material from Munch's own disputes with his neighbours and would have been satirical comedies if they had been finished – especially, perhaps, the final one about Gunnerud's savage hound. This is also accompanied by various satirical and humorous drawings and lithographs with corresponding captions, e.g. 'Dog attacks milk boy' (p. 109). These neighbourhood disputes took place in the 1920s, but their artistic representation in the form of drawings, lithographs, paintings and dramatic script seem to have been mainly created in the late 1930s. Common to most of the scripts are the jokes, mockery and caricatures, as well as the fact that they, like the literary sketches, stem from events in Munch's life.

Munch kept parts of his textual material as inserts in some of his notebooks and sketchbooks. For preservation purposes, these inserts have been removed from the books and archived separately. Their original positions have been recorded, so the previous page order can be recreated. Nine of the books have been documented as having these inserts.[25] The total number of inserts varies from two to 71 per book. One of them is an accounts book[26] in which Munch has used a few pages to make notes about his earnings, among other things. Munch has then written headings on a number of pages: 'Childhood' (p. 3), 'Philosophy' (p. 25), 'Moods' (p. 35), 'Atmospheres' (p. 39), 'Memories of Youth' (p. 51), 'Love' (p. 70), 'Sex' (pp. 71, 73, 75, 79, 85) and 'Madness' (p. 379). Apart from these, the pages are empty, with only rust marks from the paperclips used to attach inserts into the book, on 71 pages.

It appears as if Munch intended to organise his writings into thematic sections, and this work may have been accomplished after he moved into Ekely in 1916. The texts he inserted into this book are an all-encompassing collection. Among them are several that exist in multiple versions, some combining texts and drawings and, confusingly, even a couple of drafted letters. The oldest texts may date from the late 1880s, while the most recent are probably from the same time as (or possibly after) the book's financial accounts. To what extent the texts' subject matter relates to the placement of the pages in the book under the various headings has not been investigated in detail, but it might seem to be the case. Is the arrangement of the texts simply a thematic 'archiving', or is it an attempt to put together a novel?

A draft of Munch's will[27] makes mention of 'studies for a novel', and in one notebook[28] there is a reference to an 'Oslo novel which is about the 1880s' in a list of manuscripts. Evidently, he entertained thoughts of combining his literary texts into a novel, but what its contents would have been is harder to determine. There are at least 170 entries[29] corresponding to loose sheets of paper (many of which were inserts in books) and 22 notebooks all containing 'literary works', but none of these appear to be completed manuscripts. On the contrary, irrelevant lists, notes and drafts of letters keep on cropping up among the 'literary works'. Perhaps future

research will be able to uncover connections we have not been able to detect up to now.[30]

Another such project is the portfolio, consisting of various media, known as *The Tree of Knowledge of Good and Evil*.[31] In *The Tree of Knowledge* Munch has glued in or inserted loose leaves containing writings, drawings and prints. He has assembled motifs taken from the majority of his artistic production. It has been difficult to ascertain when he started working on this – possibly around 1916 – and it seems as if he may have pressed on with it right up until the 1940s.[32] *The Tree of Knowledge* is an entirely different type of project than a novel, but it's possible that the portfolio's loose, disparate format can tell us something about what a Munch novel might have looked like.[33]

One obvious disadvantage when studying the literary works is that neither Munchmuseet nor others have worked systematically on all the aspects of this part of Munch's written legacy. The texts were transcribed in the same way as the letters, and printed transcriptions have been available for visitors to the museum's library. A database was created, but the focus tended to be on physical descriptions of the objects (written medium, type of paper, watermarks, etc) rather than the content or the relationships between the objects, even though the recipients of every letter and drafted letter were registered.

The 'Edvard Munch's Writings' project encompassed all of Munch's own texts plus letters addressed to him and ended up as a digital archive.[34] The project needed to limit itself to proofreading, digitising and publishing the transcriptions, documenting the people and institutions mentioned in the texts, and classifying the texts in more detail, and in a better way, than before. The term 'notes', therefore, today includes – above and beyond the literary texts – teenage diaries, art-related and biographical notes, and more. There have not been enough resources to delve deeper into genre classifications, dating, different versions, or the links with his artworks.[35] Limited access to, and knowledge of, the literary work has too often led to the same texts being read, commented upon, cited and published again and again. In addition, until now no one has researched the entire body of work.[36] This is understandable, but it has left a limited picture of Munch's writing.

When you look through Munchmuseet's collection database and catalogues at emunch.no, you can find around 290 entries containing what might be called 'literary works'. The majority of them refer to loose sheets of paper. These items range from a single sheet to documents of up to 50 pages. They also include 22 notebooks and sketchbooks, each of which contains different numbers of texts, as well as drawings. The individual texts in these books have still not been catalogued as separate entries and have therefore not been given any type of classification. The books not only contain literary writings, but also such things as accounts, to-do lists and rough drafts of letters, as well as art-related and biographical notes. The single loose-paper entries also occasionally contain several texts, and sometimes even other kinds of notes (as well as drawings). So the total number of individual texts we are dealing with is still unknown.

The Dog Attacking the Milk Boy 1938
Black crayon, 395 × 500 mm
Munchmuseet, Oslo

Judge – Didn't the dog bite the milk boy?
The dog was just doing his duty. The boy was inside the fence –
Judge – Does one deserve to be bitten
if they are doing a service for a man?

Self-Portrait with Sketchbook 1925–30
Hectograph, 180 × 185 mm
Munchmuseet, Oslo

We do know that many of the texts exist in more than one version, but these have not been fully documented. Nor is it easy to decide what constitutes a stand-alone text or which ones belong together. There are clusters of texts dealing with the same topic, in which the contents of the various items overlap, either wholly or in part. The texts were catalogued just as they were found in the late Munch's estate. This order may not always be consistent with the way Munch worked on them or arranged them himself. He stored his papers in a pretty messy fashion, as he himself admitted both in writing and in drawings (p. 109), so loose-leaf texts may have been split up into separate items or placed together simply because that's the way they were found in his surviving papers.

Some of the notebook pages feature paperclip marks despite these volumes not having any inserts when they were catalogued as a part of the estate. In these cases, Munch himself has probably removed papers that he had originally fastened there. What it was that was fastened, we can still only speculate – it could even have been lost, but it would be interesting to search for the corresponding markings among the loose papers. In the same way, it would be fascinating to see if we could identify the pages that have been torn out, wherever the ripped edges are visible in the notebooks. All of this would aid the work of documenting and understanding Munch's writings.

Munch's 'literary works', therefore, are still a fairly unresearched area, deserving of more attention. It is interesting to see what he both wrote about and made pictures of, what he *didn't* write about but made pictures of, and what he wrote about but did *not* make pictures of. The texts show aspects of him that do not reveal themselves in the art alone, and thus display a complexity that is otherwise harder to perceive. The fact that Munch hardly published anything that he wrote perhaps also locates the writinsg as part of his whole creative process. He rarely finished things, didn't complete everything, and never threw away anything he made; instead he held onto it, and repeated many motifs and subjects over and over again throughout his life. If you stand back and look at it, the whole endeavour is one part of a constant, unending creative process, which only came to an end with the artist's death.

1 Edvard Munch's will, Regional State Archives in Oslo.

2 See also similar instructions in notebooks T 2893, 1890, and T 2760, 1891–92. N, T and UT are Munchmuseet's (MM's) inventory number prefixes for Munch's writings, to be found at https://emunch.no.

3 His uncle, the historian P.A. Munch, was also one of Munch's inspirations.

4 See, for example, diary entries T 2914, 16 May 1876–20 January 1878, and T 2924, 10 March–30 December 1878.

5 See Bøe 2011 and Dybvik 2011a.

6 UT 32, 1908–09.

7 Today this kind of 'autofiction' is recognisable in many contemporary Norwegian writers, including Vigdis Hiorth and Karl Ove Knausgaard, but it was equally prevalent in Munch's day.

8 See Kittelsen 2014, pp. 50–68, for an account of how these manifested themselves.

9 See Guleng 2011.

10 Notebook T 2761, 1889–92.

11 As well as T 2761, it can be found in literary sketches N 474 (undated), N 488 (1892–93), N 636 (1887–1909), T 1265-verso (1887–89) and T 2265 (1893–94). N 477 (undated) has an alternative version, but this is also third-person.

12 Dybvik 2011b, p. 147, notes that the text that follows on sheet 2v is in the first person. But what is important here is the meta-commentary itself – the way Munch comments on his own act of writing.

13 The term 'literary journal', to denote Munch's writing and notebooks, probably came into use by Munchmuseet prior to 1984.

14 See Dybvik 2011b, pp. 143–144.

15 See Andersen 2011.

16 Notes N 292, N 654 and N 656.

17 Sketchbook T 2785.

18 Sketchbooks T 2786, 1905–09, and T 2803, undated though probably roughly contemporaneous.

19 See Thue 2011.

20 Note N 317, 1909–17.

21 Notebook T 2797, undated.

22 Notebook T 185, 1936–42. The text is written upside down.

23 Notebook T 206, 1935–39.

24 Notebook T 2849, 1938–40.

25 Notebooks and sketchbooks T 2725, T 2734, T 2748, T 2794, T 2797, T 2892, T 2893, T 2781 (not yet digitised) and T 2782 (1915, see MM.T.02782 at https://www.munchmuseet.no/objekt/MM.T.02782).

26 Notebook T 2782 (see note 25).

27 Note N 568, undated.

28 Notebook T 2797, undated.

29 By 'entries', I refer to individual entries in the collection database.

30 Kittelsen 2014 investigates whether it is possible to identify the draft of a novel among Munch's surviving texts, and her project will be a good starting point for further research.

31 The portfolio T 2547 is currently dated 1892–1930, referring to when the contents were created.

32 See Nora Nerdrum's text in Munch 2021 for a summary of what we know of, and the research into, *The Tree of Knowledge*.

33 Guleng 2011–12 notes similarities between the collage-like forms in the accounts book and *The Tree of Knowledge*, and like Andersen 2011 and others, she views the notebooks with literary sketches as novelesque constructions, comparing them to Arne Garborg's *Weary Men* (1891) and Ola Hansson's *Sensitiva Amorosa* (1887).

34 Munchmuseet's project was initiated in 2007. Phase one was launched in 2011 and involved most of the letters and notes in the museum's collection. Phase two took place between 2011–12, involving a selection of Munch's own art-related texts and literary sketches being translated into English. Phase three was carried out in the period 2012–16, and published about three-fifths of the correspondence he received. This means that the archive is still missing some of Munch's own texts (especially letters in private ownership) and a considerable number of letters he received. This material will, over time, end up being published. See: https://emunch.no

35 In recent years, prompted by the writing of a Munch biography by Ivo de Figueiredo, Munchmuseet brought forward a survey of Munch's letters and draft correspondence in order to organise and date them. This demanding work has brought to light and corrected many incorrect dates, narrowed down the broader timescale, and identified previously unknown recipients of letters.

36 An overview of the secondary literature on the texts can be found by searching for 'Munch's texts' in the museum library database, which is available online. I also recommend reading Elin Kittelsen's 2014 MA thesis, which is one of the most comprehensive surveys I have seen of that section of Munch's secondary literature that deals to some degree with the texts. Moreover, it includes a very interesting discussion of the best ways to read and interpret the writings of Munch.

Artworks exhibited at the Musée d'Orsay

All introductory texts:
Estelle Bégué
Documentary Research Officer
Musée d'Orsay, Paris

From the Intimate
to the Symbolic

One shall no longer paint interiors, people reading and women knitting. They will be people who are alive, who breathe and feel, suffer and love. [...] I would create a number of such pictures. [...] People would understand the sanctity and power of it and would take off their hats as in a church.[1]

Edvard Munch was introduced to painting and drawing in childhood by his aunt Karen Bjølstad and, at the age of 17, after brief and disappointing studies at the Technical College in Kristiania, decided to make a career as an artist. He enrolled at the Royal College of Drawing, but did not receive any real artistic training, as Norway did not have a proper academy at that time. During his first trips abroad, notably to France and Germany, he was interested in landscapes and genre scenes, but soon adopted a far more personal mode of painting, dominated by portraits of family and friends. These paintings of personal life also reflect the important role of Munch's own experience in his art. He painted a great many self-portraits, each of which, beyond its introspective dimension, reveals the painter's particular relationship to other people and the world. His image constantly wavers between involvement in the outside world and inward retreat. Munch turned some personal experiences into a group of major works painted between the mid-1880s and the late 1890s. These iconic works mark a crucial turning point in his art, when he moved towards Symbolism, and also herald the beginning of his adoption of the principle of cycles.

Laura and Inger: Early Models and Seedbeds of Influence

In the 1880s Munch very often portrayed members of his family and their domestic interiors. This interest in subjects from everyday life can be understood by the immediate availability of models and their emotional closeness. By observing those around him the young Munch was able to create portraits that reveal both the family ambiance and the psychology of his subjects. Several paintings depicting scenes of family life are known, notably evenings spent reading, and centred around the figure of the father, Christian Munch.[2] The painter conveys the strict, almost austere atmosphere of the home, dominated by his father's deep religious devotion. In the second half of the 1880s, following his first trips abroad, Munch painted several portraits of his sisters Laura and Inger, which clearly reveal the multitude of influences he had received and which he was now distilling into a new synthesis.

Evening (p. 120) shows Laura sitting on the doorstep of a house by a lake or a fjord, probably during a family holiday. The scene seems very peaceful and shows a girl enjoying the summer evening light, while in the background a couple are at work by the water's edge. This painting reflects the naturalist tradition much in vogue among Scandinavian artists at the time, of whom the most prominent was Christian Krohg,

sometimes regarded as Munch's first teacher.[3] The Nordic naturalists advocated painting outdoors and found their subjects in everyday life, taking inspiration from both the French naturalist movement and the new art of the Impressionists, which was much discussed in the Norwegian press.[4] During a trip to France in 1885, Munch was able to see for himself the works of artists from both movements, and both influences can be keenly felt in this portrait of Laura. The careful brushwork with light hatching, the use of pale colours and the luminous quality of the painting are directly taken from Impressionist technique, as is the non-realist approach to colour, such as the blue shadows on the grass and the front of the house. But Munch has not confined himself to these formal aspects and has sought in this portrait to capture a salient aspect of his sister's character, giving the painting a certain Symbolist intent. Though placed in the foreground and immediately visible to the viewer, the figure of Laura remains inscrutable and isolated from the rest of the composition. Her staring eyes are empty and she seems to be entirely indifferent to the landscape. In reality Laura was wrestling with deep-seated psychological problems. From her 20s she was regularly interned in psychiatric institutions, in which she spent most of her life. The sitter's inaccessible inner world, entirely closed in on itself, gives the whole painting a profoundly melancholic air and provides very early confirmation of the expressive power of Munch's art.

Around a year later, Munch painted a portrait of his youngest sister Inger, to whom he was very close and who had already posed for him several times. *Summer Night: Inger on the Beach* (p. 121) was painted in Åsgårdstrand, a small fishing village towards the southern end of Oslo Fjord, where Munch and his family often stayed. The characteristic beach, with its many rocks worn round by the waves, is perfectly recognisable here. Yet Munch has avoided a naturalist depiction, creating a landscape of highly simplified lines with an unfinished air. He contrasts the grey and blue hues of the rocks and sea with Inger's white dress, using colour to enhance the evocative power of the painting. Inger's figure is isolated against a background entirely painted in dark colours, which can be read as reflecting her melancholic thoughts.

A later portrait painted in 1892, *Inger in Black and Violet* (p. 123), confirms Munch's interest in using large areas of colour to render space. Here the composition is extremely simple, placing Inger against a background reduced to two expanses of colour. This non-figurative setting has been interpreted as both a reflection of the possible influence of Manet's portraits, which Munch could have seen during his trips to France, and as an example of his interest in the synthetist principles developed by Émile Bernard and Paul Gauguin.[5]

Our attention is centred on the figure of Inger, clearly outlined in black and shown in an austere, cold pose that seems almost otherworldly. When this portrait had its first public exhibitions in 1892 and 1893, Munch titled it *Harmony in Black and Violet*. This direct reference to Whistler's titles reveals both

Munch's interest in the study of colour and its expressive capacities and his very close links to the Symbolist movement in the early 1890s.

In his family portraits, Munch also clearly demonstrates his great curiosity in relation to the artistic innovations of his day, and his ability to integrate them into his highly personal solutions. He has frequently been described as a Symbolist artist, both by later historiography and by critics of his period, but he never claimed to be part of any particular movement. Today's experts tend to agree that Symbolist principles are not in themselves enough to encompass the complexity of his work. Munch was also often described by his contemporaries as a marginal artist,[6] whose powerful works divided and disorientated the public.

Kristiania Bohemians: Developing on the Margins

This marginal dimension was accentuated by Munch's own mentality. Almost certainly in reaction against the burdensome religiosity of his family, from the mid-1880s he was closely involved with a group of young artists and writers who rejected the constraints placed on them by Norwegian bourgeois society. This group, known as the Kristiania Bohemians, gave Munch the environment he needed to develop his artistic persality. Its central figure was Hans Jæger, depicted by Munch in an eloquent portrait (p. 119) a few years after their first meeting. Jæger was an anarchist sympathiser and free thinker who rejected established social conventions such as marriage. He is known primarily for his book *Fra Kristiania Bohêmen* (From the Kristiania Bohemians) published in 1885, which earned him a spell in prison for indecency and sedition.[7] In the painting, Munch shows him in a casually disdainful pose, highlighting Jæger's irreverent personality. In a composition revealing the great importance Munch already placed on the construction of space, the portrait is structured by a strong diagonal from the table corner in the foreground to the corner of the walls behind the armchair, which establishes a distance between figure and viewer. The higher angle and cold colours reinforce Jæger's air of cold cynicism.

Munch's portraits are notable for his great skill in using the most appropriate visual means to express the psychology of his sitters. He also put this skill to great use in the many self-portraits he created throughout his life, and which mark important moments in his career. In 1895, when he was involved with Berlin's literary avant-garde based in the café Zum schwarzen Ferkel (The Black Piglet), he portrayed himself as a young dandy in *Self-Portrait with Cigarette* (p. 124). The painting shows Munch's head and torso in three-quarter profile and strongly contrasting light, elegantly dressed. Apart from his face and right hand, the entire picture has a vaporous, abstract quality, as though clouded by cigarette smoke. The artist's intense eyes have a look of enigmatic surprise, as though he had suddenly emerged out of deep thought and was astonished to find himself face to face with the viewer. Here Munch was seeking to express the complexity of his personality and also to portray himself as a prominent artist. By the time of this painting he was very well known in German and Scandinavian artistic circles, having had his first great public successes, and also his first scandals, including the one that followed the opening of his solo show at the Verein Berliner Künstler in October 1892. His status is emphasised by the presence of the cigarette as the attribute, if not the identifier, of the young avant-garde. The intensity and depth of the colours, in a range of violets and blues, add to the expressive quality of the portrait. Munch exhibited this work as soon as it was painted, notably at the Autumn Exhibition in Kristiania, where it was fiercely criticised, the vaporous atmosphere being seen as evidence of his mental illness.[8] Munch's mental state would remain central to his work and art historians have long debated whether it could be seen as a key to interpretation or on the contrary a language entirely controlled by the artist, who was well aware of the critics' opinions on the subject.[9] Be that as it may, for Munch self-portraits were always psychological experiments, in which he pushed the boundaries of the expressive potential of visual art.

Icons of the 1890s: A Genius Emerges

In the second half of the 1880s and throughout the 1890s, Munch experimented with many unconventional techniques to enable him to create works that could express the emotions he wanted to convey. His concern with the psychological dimension of his works became fully developed and was manifested in a striking convergence with Symbolist aesthetics. In these years Munch painted some of his great masterpieces, which together could almost sum up his entire career. Undoubtedly swept along by the great sense of rivalry between European artists, Munch reached unparalleled heights in the expressive capacities of his colours and the evocative power of his works. In this regard, the first version of *The Sick Child* of 1885–86 marks a milestone. According to Munch's many descriptions of the genesis of this work,[10] one day, while accompanying his father on medical visits, he met a very sick girl whose suffering immediately caused him to relive the death of his sister Sophie in 1877. Munch endlessly sought to give the most accurate possible portrayal of the violence of this vision, which came to him as a kind of flashback of trauma, and he deliberately scratched the thick paint to create visual effects of an entirely new kind. The picture was shown at the 1886 Autumn Exhibition in Kristiania with the title *Study* and caused a major scandal. The reviewers criticised Munch for its air of mental disturbance, which they regarded as unfit for public exhibition. Yet this bold, disturbing approach was intended to enhance the expressive power of the work, in which the violence of the technique conveys the violence of the memory. The scratching highlights the artist's symbolic or literal desire to erase these overwhelming memories.

Munch was quick to assert the importance of this painting, observing, 'In the sick child I paved new roads for myself – it was a breakthrough in my art. – Most of

what I have done since had its genesis in this picture.'[11] He painted several versions and made several graphic variants. The second painting was commissioned in 1896 by the collector Olaf Schou (p. 125). In it Munch used a much finer layer of paint and more saturated colours. However, he recalled the scratching of the first version by adding fine scratches to the entire painting.

The major work of the 1890s, and probably of Munch's entire output, undeniably remains *The Scream* (p. 67). The origins of the motif date back to the period 1890–92 and can be clearly seen in a group of writings and drawings produced in Norway and the South of France, where Munch was living in late 1891.[12] In the spring of 1892 he painted *Sick Mood at Sunset: Despair* (p. 127), which he later described as 'the first Scream'.[13] In this already very accomplished painting, the strong diagonal of the balustrade sends the eye to the blood red sky with circular clouds, which symbolises the disturbing thoughts of the man in the foreground, probably a self-portrait. This version contains the seeds of all the elements that together constitute the motifs and composition of *The Scream*. The transformation of the individual in the foreground into an undefined screaming figure infinitely multiplied the work's expressive power, turning it from the depiction of the artist's personal experience into a universal allegory of fear and anguish.

In the 1890s Munch took on another subject of great importance for his later work, that of love and different representations of woman. In *Puberty* (p. 126) he conveys all the emotional complexity of the transition from adolescence to adulthood. A puny girl sits naked on the edge of a bed, her arms crossed as though to shield her from prying eyes. Her unconfident pose and worried expression communicate a vague sense of disquiet. The painting is structured by the contrast between horizontal bands of colour, forming the bed and the wall in the background, and the vertical shape of the girl. Her shadow on the wall, uncannily enlarged by lateral lighting, is almost a second figure. This undefined presence, which could be a projection of the girl's anxieties or a symbol of her fading childish self, gives the painting a heavy, lugubrious air. Munch painted several versions of this motif, which he first created in the mid-1880s.[14] He also included it in many exhibitions of *The Frieze of Life*.

1 Note N 63, 1889. Munchmuseet.
2 See for example *Christian Munch on the Couch*, 1881, oil on canvas, 21.5 × 18 cm (Munchmuseet); *Karen Bjølstad in the Rocking-Chair*, 1883, oil on canvas, 47.5 × 41 cm (Munchmuseet); or *At Supper*, 1883–84, oil on canvas, 49 × 59.5 cm (Munchmuseet).
3 Munch's first studio, which he rented in 1882 with several painter friends, was in the same building as that of Krohg, who gave them very informal teaching. Krohg also later supported Munch at his early and controversial public exhibitions.
4 On this, see Eggum 1991–92a.
5 On this, see Eggum 1991–92b.
6 On this, see Berman 1993b.

7 On the importance of Hans Jæger in Munch's life, see Øystein Ustvedt's essay 'Munch's Haunts and Social Circles' in this book.
8 On this, see Berman 1993.
9 On this, see Claire Bernardi's essay 'Creating an Oeuvre. Munch's Story of Himself' in this book.
10 On this, see Clarke 2013.
11 Note N 570, undated. Munchmuseet.
12 On this, see Trine Otte Bak Nielsen's essay 'A Scream Through Nature' in this book.
13 Note N 122, 1927–33. Munchmuseet.
14 It is thought that the first version of this painting was made in 1886 and lost in a fire. See Woll 2008, Vol. I, p. 331.

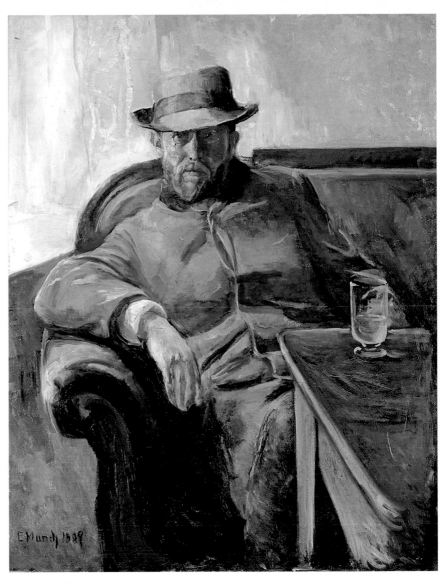

Hans Jæger 1889
Oil on canvas, 109 × 84 cm
Nasjonalmuseet, Oslo

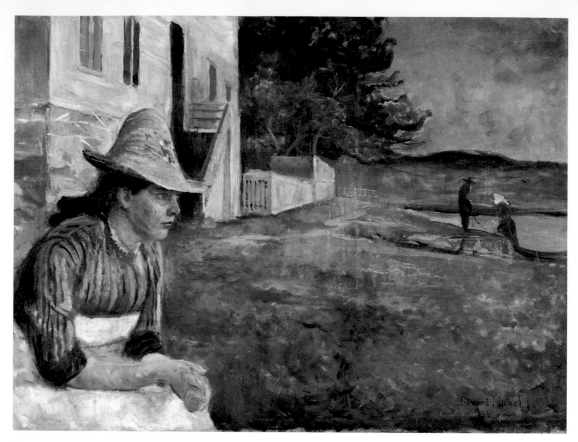

Evening 1888
Oil on canvas, 75 × 100.5 cm
Museo Thyssen-Bornemisza, Madrid

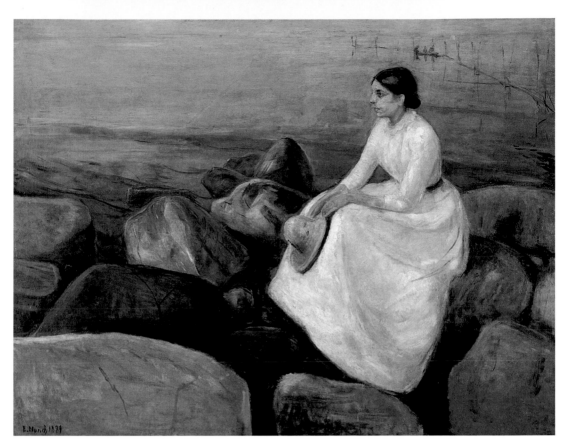

Summer Night: Inger on the Beach 1889
Oil on canvas, 126.5 × 161.5 cm
KODE, Bergen (Rasmus Meyer Collection)

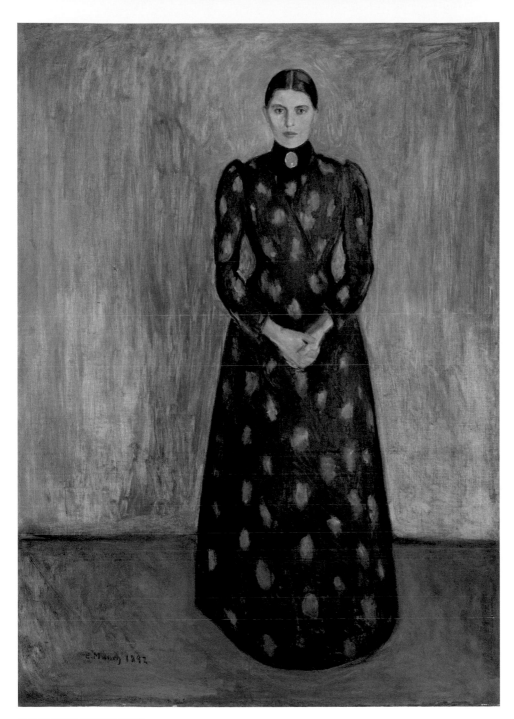

Inger in Black and Violet 1892
Oil on canvas, 172.5 × 122.5 cm
Nasjonalmuseet, Oslo

From the Intimate to the Symbolic

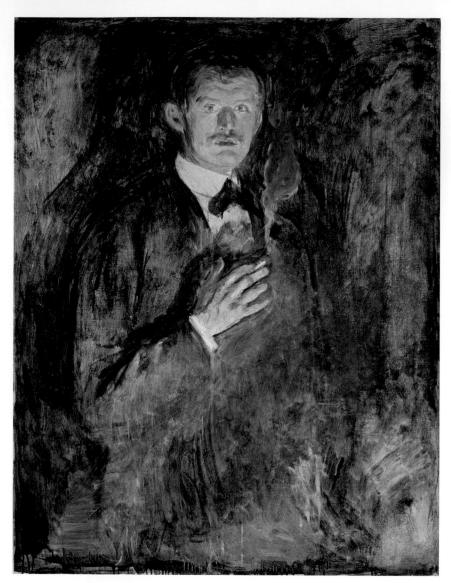

Self-Portrait with Cigarette 1895
Oil on canvas, 10.5 × 85.5 cm
Nasjonalmuseet, Oslo

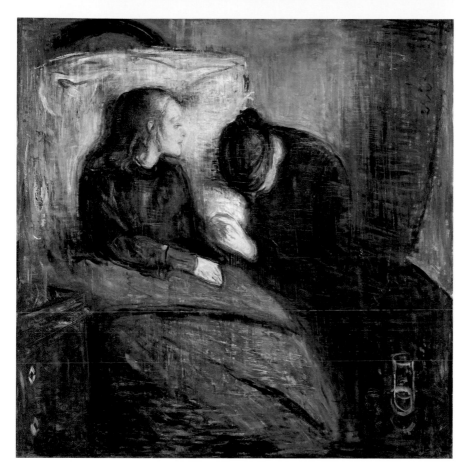

The Sick Child 1896
Oil on canvas, 121.5 × 18.5 cm
Göteborgs Kunstmuseum, Gothenburg

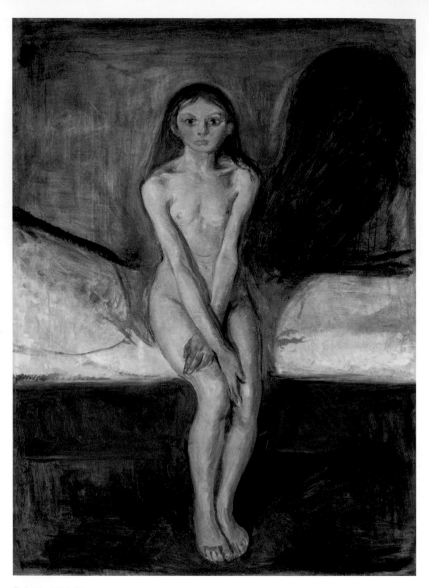

Puberty 1894–95
Oil on canvas, 151.5 × 10 cm
Nasjonalmuseet, Oslo

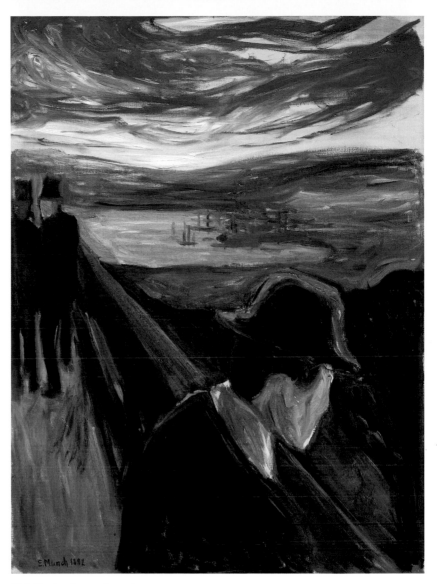

Sick Mood at Sunset: Despair 1892
Oil on canvas, 92 × 67 cm
Thielska Galleriet, Stockholm

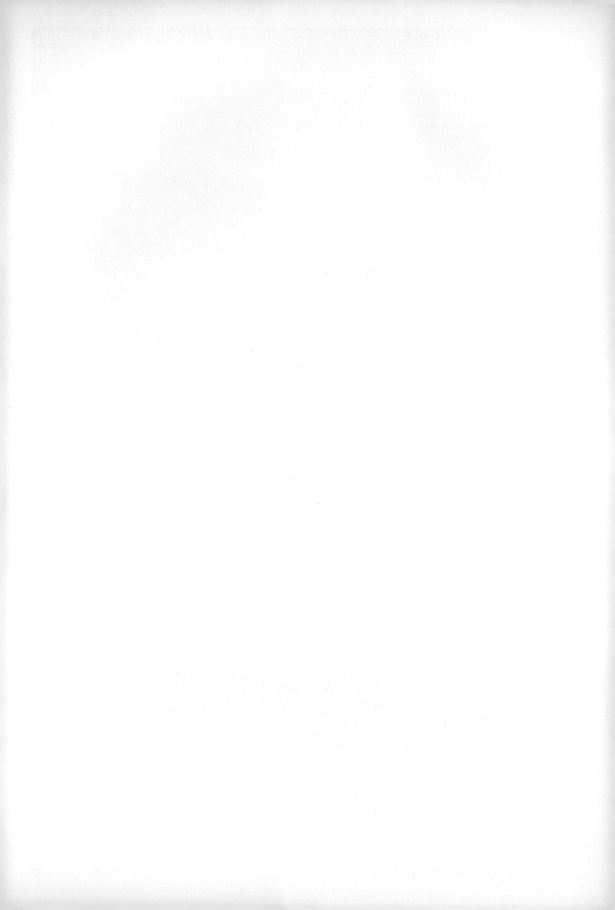

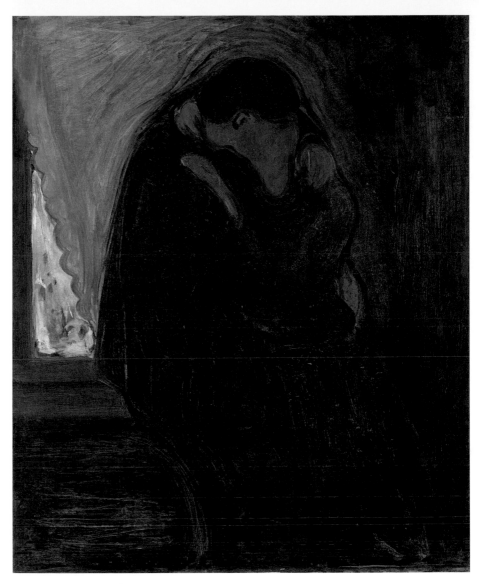

The Kiss 1897
Oil on canvas, 99 × 81 cm
Munchmuseet, Oslo

The Frieze of Life

The Frieze is intended as a number of decorative
pictures, which together would represent an image
of life. [...] The Frieze is intended as a poem about life,
about love and about death.[1]

The Frieze of Life is so absolutely central to Edvard
Munch's work that it can be said to sum up the key
aspects of his career. He worked on its component
paintings throughout his career and developed it in the
light of his research and explorations, both aesthetic and
spiritual. He was quick to note correspondences between
his works and used them to increase the expressive
power of his art. Towards the end of his life he explained,
'I have always worked best with my paintings around
me – I arranged them together and felt that some of
the pictures were connected to each other in content.'[2]
He began gradually to give more importance to their
resonances, bringing the works together in a single vast
project in which the different ages of life are evoked
through the feelings and emotions they can engender.
The first public exhibitions of these works, in the 1890s
and early 1900s, played a central role in the development
of Munch's ideas and artistic project.[3] Some motifs recur
throughout the frieze with particular frequency and serve
to link the compositions, one example being a woman's
long, sinuous hair. Munch was fascinated by this image,
which evoked for him the energy that connects human
beings to nature, and to their inner being.

A Series about Love
The paintings that would become *The Frieze of Life*
were first grouped together for the exhibitions of 1892
at Tostrupgården, Kristiania, and in December 1893 at
a gallery in Unter den Linden, Berlin. At this time Munch
was primarily concerned with the representation of
love and the different emotions to which it gives rise.
For example, the key motif of *The Kiss* (p. 129)[4] depicts
the fusion of two lovers and was reworked by Munch in
different variations in both paintings and graphic works.
Along the way, he increasingly isolated the couple from
the background and dissolved the faces into a single,
indistinct form, thereby asserting his wish to move away
from the anecdotal to depict a moment of fusion that
erases the world around the lovers.[5] The same intensity
of love can be seen in the *Vampire* series of paintings,[6]
originally entitled *Love and Pain*, in which a woman
with hair cascading around her shoulders holds a man
in her arms. The definitive title was provided by the
Polish writer Stanislaw Przybyszewski, who saw it as
an image of a vampire sucking the life force out of the
man.[7] Munch accepted his friend's interpretation and
turned this painting into a symbol of the dangerous
woman leading the man to his destruction. The woman's
shadow in the background has a slight air of menace
and becomes more prominent through the different
versions until, in the painting of 1895 (p. 136), it surrounds
the couple completely. The shadow can also be seen
in the various lithographs on the same theme (p. 162).

In reality Munch's depictions of love are never without
troubling elements, such as the mysterious version of
Dance on the Beach of 1899–1900 (p. 135). Supposedly
symbolizing the joys of life and youth, the title scene is
shown from a very unusual viewpoint for Munch and
placed at a distance in the middle ground of the painting.
The carefree dancing figures thus appear far away and
their happiness becomes physically inaccessible. The
two black silhouettes looking on add to the vague sense
of threat that the composition conveys.

Some works are entirely concerned with jealousy
and infidelity, both of which Munch regarded as
inevitable offshoots of love. In these works he drew on
the tumultuous experiments with sometimes painful
consequences that he had experienced with the Kristiana
Bohemians and then with the group based at the café
known as The Black Piglet (Zum schwarzen Ferkel) in
Berlin. *Melancholy* (p. 137) conveys the bitterness felt by
his friend Jappe Nilssen when his lover Oda left him to
return to her husband, the painter Christian Krohg. The
reunited couple appear in the background of the painting,
about to board a boat at the end of the pier. In *Jealousy*[8]
(p. 165), Munch illustrates the complex relationship
between Stanislaw Przybyszewski and his wife Dagny
Juel, in which the freedoms offered by non-exclusivity
did not prevent resentment. Munch shows his friend's
agonized face staring at the viewer, while, in the
middle ground, Juel represents Eve the temptress in
an evocation of the Garden of Eden. Meanwhile the
Separation series depicts what Munch regarded as the
inevitable outcome of love. In the lithograph *Separation I*
(p. 164), a man in the grip of great suffering, perhaps
Munch himself, clutches his chest as a woman turns away,
her hair still flowing towards him. In *Separation II* (p. 166),
the woman's hair has reached across the man's heart, in
a direct reference to a note by Munch in which he reveals
the importance he gives to the symbolism of hair: 'Her
blood-red hair had entangled me – coiled itself around
me like blood-red snakes – its most delicate strands
had infiltrated my heart [...] I still felt the pain where my
heart bled – for the threads could not be severed[.]
Her hair the colour of blood flowed over me.'[9]

Representations of Women
These variations on the course of a love affair led Munch
to portray a variety of female figures, projecting onto
them his highly complex, always ambivalent image of
women as at once fascinating, conquering, venomous
and murderous. One of his most beautiful depictions of
a woman can be seen in the painting *Madonna* of 1894–95
(p. 105).[10] Shown in one of Munch's first public exhibitions
with the title *Woman Making Love*,[11] the painting shows
the head and torso of a beautiful woman portrayed
with great softness, in the throes of ecstasy. Munch
subsequently changed the title in 1895, after which the
painting was exhibited as *Madonna*. Having literally
become an object of worship, this image is a consecration
of feminine beauty as worthy of love and devotion. Munch
later endlessly reworked it in graphic versions where the

message is even more explicit. A series of lithographs (p. 159) appear with a red frame, in which can be seen a foetus and sperm, formally highlighting the role of women as the source of life. However, a morbid connotation is apparent in the depiction of the foetus, which bears some resemblance to a corpse. This ambivalence is confirmed by a very unusual drypoint (p. 160) in which the macabre aspect of the figures is made plain. Many of Munch's works show the same duality of sensuality and eroticism, which always contains a source of danger.

In the lithograph *The Hands* (p. 155), based on a painting of 1893–94,[12] Munch offers the image of a powerful woman, sure of her seductive power, atop a pyramid of hands eager for pleasure and reaching out to grasp her. The vision is very different in the lithograph *The Alley* (p. 154), which can be seen as the counterpart of *The Hands*. Here the pyramid is inverted so that the woman appears at the base, naked and surrounded by a crowd of men in formal dress, pressing in around her and about to give way to their desires. The painting *Red and White* (p. 138) equally establishes a very clear contrast between the two female figures, the one in white symbolising female chastity, the one in red implying female eroticism.

The same ambivalence can be found in the representations of Munch's girlfriends. The violinist Eva Mudocci, with whom he began a brief relationship in 1903, appears in a series of lithographs entitled *The Brooch* (p. 157) that are odes to her beauty and sweetness. Conversely, *Woman with Red Hair and Green Eyes: The Sin* (p. 158) is probably a portrait of Munch's previous girlfriend Tulla Larsen and delivers a far more troubling message. In both portrayals we can again note the importance given to the women's hair, which was an object of fascination for Munch and seems to take on a life of its own in his art, connecting figures and amplifying their emotions. It may have positive connotations, as in *On the Waves of Love* (p. 161), where the hair merges with the background to form the waves on which the couple float, or it may suggest something more disturbing, as in *Salome* (p. 156) or *Man's Head in Woman's Hair* (p. 163), where it appears to imprison the man.

Death and the Anguish of Life

As he deepened his thinking on *The Frieze of Life*, Munch gradually added motifs linked to death and the anguish of life. He showed *Sick Mood at Sunset: Despair* and *The Scream* as soon as he had painted them, in 1892 and 1893. In the same period he also painted *Evening on Karl Johan* (p. 139), which shows a crowd with ghostly faces in a disturbing, almost cynical evocation of the Kristiania bourgeoisie on their customary afternoon stroll along the city's main street. Here the silhouettes with their wide staring eyes advance towards the viewer in a menacing crowd. In the middle of the avenue a lone man walks in the opposite direction, probably Munch himself.

A synthesis of *The Scream* (p. 67) and *Evening on Karl Johan* can be seen in the painting *Angst* of 1894 (p. 54), which combines certain key features of the

two, including the sky with undulating lines and the disembodied crowd. Munch also reworked his motifs in a series of prints (p. 140) in a simpler style, but with the same evocative power. The lithographic version of *The Scream* (p. 143), in black and white lightly retouched with gouache, is also surprising for its striking graphic modernity. Munch pursued his study of faces in a crayon and tusche drawing of c. 1898 (p. 141), where the face surrounded by many raised hands has echoes of the lithographs of *The Hands*.

When exhibiting *The Frieze of Life*, Munch included the painting *The Sick Child*, in which he addresses death and sickness. This image was of cardinal importance for him. After a first version in pastel,[13] in 1895 he painted *By the Deathbed* (p. 144), which directly depicts the death of his older sister Sophie. She is hidden from the viewers' eyes, lying on a bed covered in white sheets that contrast very strongly with the group of figures gathered at her side. Munch places all the members of his family by the bed, including, in the foreground, his mother, who had been dead for almost ten years at the time of Sophie's death. Her greenish colour and sunken eyes have a corpse-like appearance. Next to her we can identify Munch's father, his hands joined in desperate prayer. Then come Munch's younger brother Andreas and his sister Laura, with her face ravaged by sickness, albeit of a psychiatric nature. In the background the group ends with Inger. She is easy to identify, as Munch painted her in a similar pose in a portrait of 1892 (p. 123).

In the many graphic variations he made of *By the Deathbed*, Munch used different methods of printmaking to keep heightening the dramatic effect of the scene. In one lithograph (p. 145) he shows his mother directly facing the viewer against a background of lines strongly reminiscent of *The Scream* and *Angst*, containing the ghostly images that his dying sister saw in fevered hallucinations. The same dramatic intensity can be found in the graphic variations of *The Sick Child*. In his prints, Munch uses all his technical inventiveness to reproduce the very disturbed aspect of his layers of paint. In one, highly singular lithograph (p. 167) the sick girl's face and hair, both very finely drawn and almost evanescent, contrast starkly with the rest of the composition, comprised of thick lines covered in scratches. After printing, Munch added a cadaverous face in gouache, reminiscent of his mother's face in the variants of *By the Deathbed* and foreshadowing the girl's fate.

This omnipresence of death in Munch's thought has a particular form of expression in *The Frieze of Life*. For the Berlin exhibition of 1902, the painter included a picture then called *Life and Death* (p. 147), a profoundly symbolic image that might initially seem surprising. For Munch this work was the real centre point of *The Frieze of Life*. In 1918 he wrote that it was as necessary to his project 'as a buckle is for a belt'.[14] This almost trivial simile in fact offers the best possible expression of Munch's cyclical vision of life and of his work. Placed between *By the Deathbed* and *Summer Night: The Voice*,[15] the painting represents both the beginning and

end of *The Frieze of Life*. It shows two figures who could be Adam and Eve, standing on either side of a Tree of Knowledge. The composition is extended by a frame carved by Munch, showing that the tree has its roots in a decomposing corpse while its branches support the heavenly city of Jerusalem. A drawing almost certainly made in preparation (p. 146) shows a skull above the motif. The painting's original iconography was much reworked – most probably at the time of the exhibition of 1918 – and is known through photographs of the Leipzig exhibition of 1903.[16] These show a luxuriant plant rising from the corpse, in an even more literal rendering of the Symbolist notion of life engendered by death. The background landscape, which is hard to make out in the old photographs, was probably added for the exhibition of 1918 to include the shore at Åsgårdstrand, which acts as a link between all the works of the *Frieze*.

The Lasting Importance of the Frieze in Munch's Work

The 1902 exhibition was very important for the development of *The Frieze of Life*. For Munch it was his first opportunity to turn his project into reality and see if it worked. Following its success, he drew on the motifs for other projects in progress. In 1904 Dr Max Linde gave Munch his first commission for a decorative cycle, asking him to paint around ten panels for his children's nursery in the Linde family home in Lübeck.[17] In working on this project Munch pursued the ideas he was then working on and reused certain central motifs. One of these was *Dance on the Beach* (p. 150–151), which he recreated in a monumental version, loosely painted in bright colours and deeply influenced by the principles of Synthetism. The painting was regretfully returned by Dr Linde, along with all the other works Munch produced for this commission, due to their unsuitability for their intended purpose. However, Munch continued to take inspiration from this version of *Dance on the Beach*, reworking it in the late 1910s and early 1920s. At this time the success of his decorations for the Aula at Kristiania university, on which he had worked intensively in the 1910s, enabled him to return to *The Frieze of Life*. This resulted in a new exhibition in October 1918, at the Blomqvist gallery, Kristiania, where Munch showed older works in combination with more recent versions, created or reworked for the occasion. He also used the painting from the Linde frieze to develop another variant of *The Dance on the Beach*, adding a strip of canvas to the lower edge so that he could portray the figures full length. He then copied this new composition to create one of the works that would be part of the decorations for the canteen at the Freia chocolate factory.[18]

The deathbed motif also remained very present in Munch's thought and, in 1915, he painted a monumental work directly based on *By the Deathbed* entitled *Death Struggle* (p. 152). This variant uses exactly the same composition, but to heightened dramatic effect due to the force of its colours and the extreme stylization of the figures, to a degree that renders them almost ghostly.

Following his work on the saturation of space in the series *The Green Room*,[19] here Munch reduces the wallpaper patterns to simple marks, which also recall the ghostly faces he included in several graphic variations of this motif. These visual approaches reveal the artist's stylistic advances, at a time when he was turning towards a very intense Expressionism.

In 1924–25 Munch painted *Vampire in the Forest* (p. 148), which reuses the motif developed in the late 1890s, but here with the figures shown full length amid luxuriant, almost overwhelming vegetation. A small group of paintings adopt the same background, combined with the figures from *Consolation* of 1907.[20] Here, the unusual setting of a primitive forest for a depiction of destructive love reinforces the sense of anxiety that emanates from the works.

1 Munch 1919.
2 Note N 46, 1930–34. Munchmuseet.
3 See Claire Bernardi's essay 'Creating an Oeuvre. Munch's Story of Himself' in this book.
4 This motif emerged in a drawing of 1889–90, *Adieu (Kiss)* 271 × 207 mm (Munchmuseet), and a painting of 1891, *Kiss by the Window*, 72 × 64.5 cm (Munchmuseet).
5 The uncharacterized depiction of the faces was met with a range of responses from Munch's reviewers. Foremost among these was Strindberg who, in an article on Munch's exhibition at Salon de l'Art Nouveau in *La Revue blanche* in 1896, described the painting in surprising and pessimistic terms: 'Kiss. – The fusion of two figures, the smaller of which, in the shape of a carp, seems about to swallow, as is habitual among vermin, microbes, vampires and women' (Strindberg 1896, p. 525).
6 The first painting on this theme dates from 1893: *Vampire*, oil on canvas, 80.5 × 100.5 cm (Göteborgs Konstmuseum, Gothenburg, Woll M 334).
7 Exh. cat. London 1992–93, p. 68.
8 This motif first appeared in a painting of 1895: *Jealousy*, oil on canvas, 66.8 × 100 cm (KODE, Rasmus Meyer Collection, Woll M 379).
9 Note N 614, undated. Munchmuseet.
10 *Madonna*, 1894, oil on canvas, 90 × 68.5 cm (Munchmuseet, Woll M 365).
11 See Woll 2008, Vol. I, p. 352, no. 365.
12 *The Hands*, 1893–94, oil and crayon on unprimed cardboard, 91 × 77 cm (Munchmuseet, Woll M 336).
13 *By the Deathbed: Fever*, 1893, pastel on cardboard, 59 × 78.5 cm (Munchmuseet, Woll M 327).
14 Exh. cat. London 1992–93, p. 90.
15 *Summer Night: The Voice*, oil on canvas, 90 × 19.5 cm (Munchmuseet, Woll M 394).
16 See Woll 2008, Vol. II, pp. 470–471, no. 428.
17 On this, see the essay 'Munch and the Grand Decorations' in this book.
18 *The Dance on the Beach*, 1921–22, oil on canvas, 200 × 310 cm (Munchmuseet, Woll M 141).
19 See the essay 'Mise-en-scène and Introspection' in this book.
20 *Consolation*, 1907, oil on canvas, 89 × 108 cm (Munchmuseet, Woll M 770). This painting was also shown at the exhibition of *The Frieze of Life* in 1918.

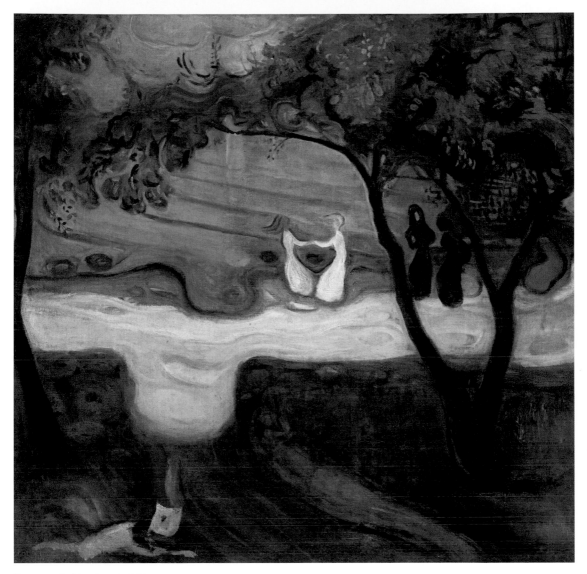

Dance on the Beach 1899–1900
Oil on canvas, 99 × 96 cm
National Gallery Prague

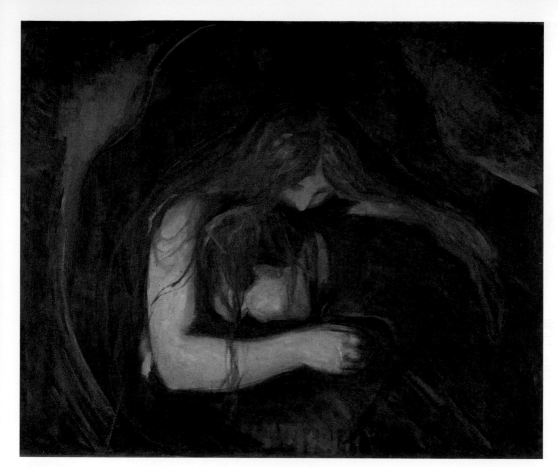

Vampire 1895
Oil on canvas, 91 × 109 cm
Munchmuseet, Oslo

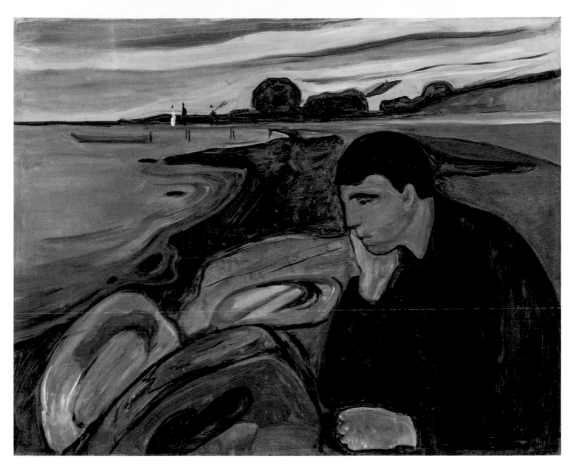

Melancholy 1894–96
Oil on canvas, 81 × 100.5 cm
KODE, Bergen (Rasmus Meyer Collection)

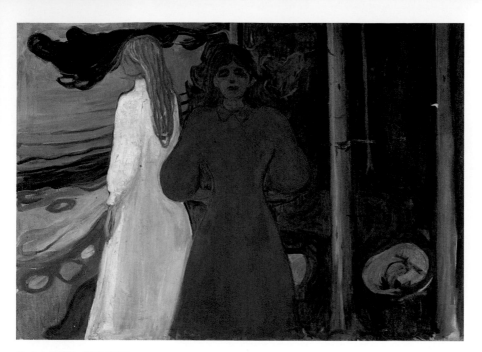

Red and White 1899–1900
Oil on canvas, 93.5 × 129.5 cm
Munchmuseet, Oslo

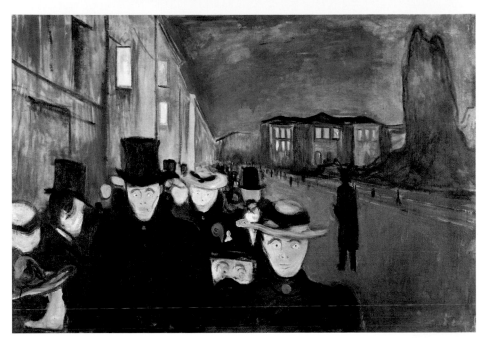

Evening on Karl Johan 1892
Oil on unprimed canvas, 84.5 × 121 cm
KODE, Bergen (Rasmus Meyer Collection)

Angst 1896
Woodcut with gouges and chisel, 455 × 375 mm
Gundersen Collection, Oslo

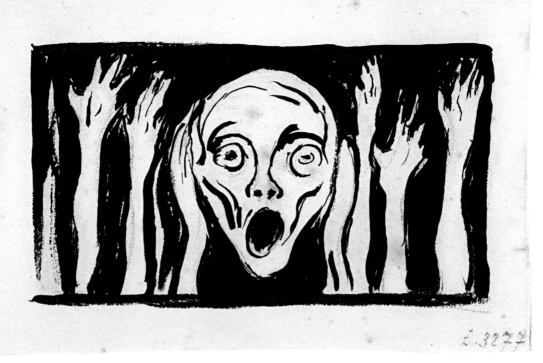

Head of *The Scream* with Raised Arms c. 1898
Crayon and tusche, 380 × 476 mm
KODE, Bergen (Rasmus Meyer Collection)

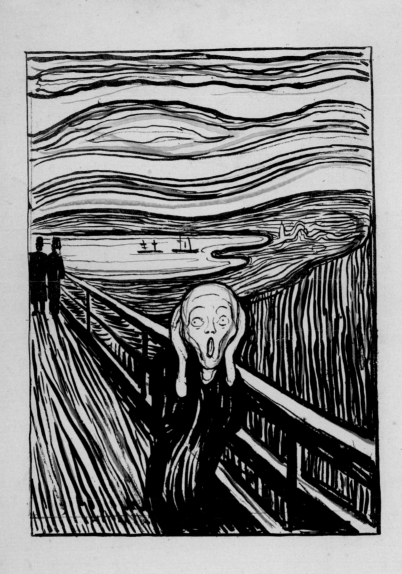

Geschrei

Ich fühlte das grosse Geschrei
durch die Natur

The Scream 1895
Lithographic crayon and tusche, 445 × 254 mm
Gundersen Collection, Oslo

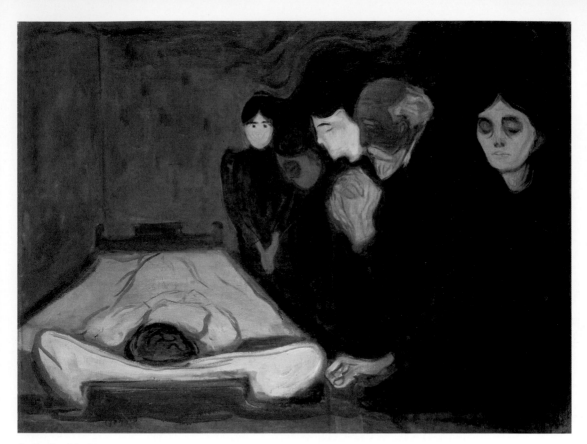

By the Deathbed 1895
Oil and tempera on unprimed canvas, 90 × 120.5 cm
KODE, Bergen (Rasmus Meyer Collection)

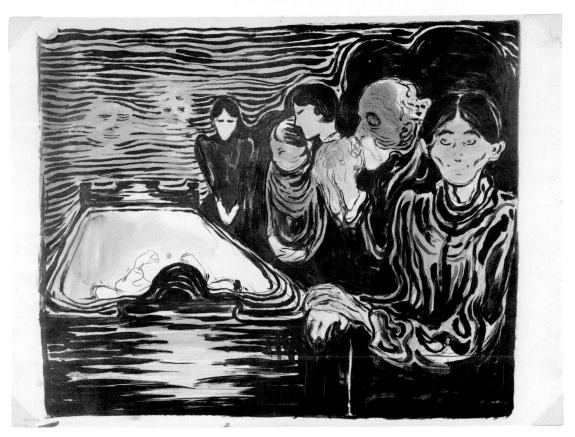

By the Deathbed 1896
Lithographic crayon, tusche and scraper, 418 × 510 mm
Munchmuseet, Oslo

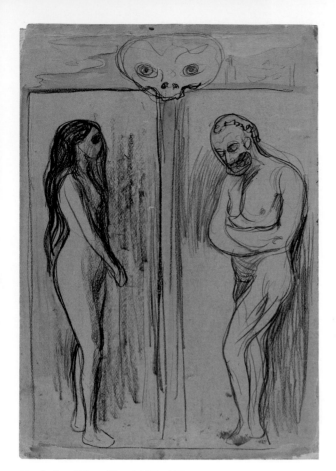

Metabolism: Life and Death 1898–1903
Crayon and watercolour, 810 × 555 mm
Munchmuseet, Oslo

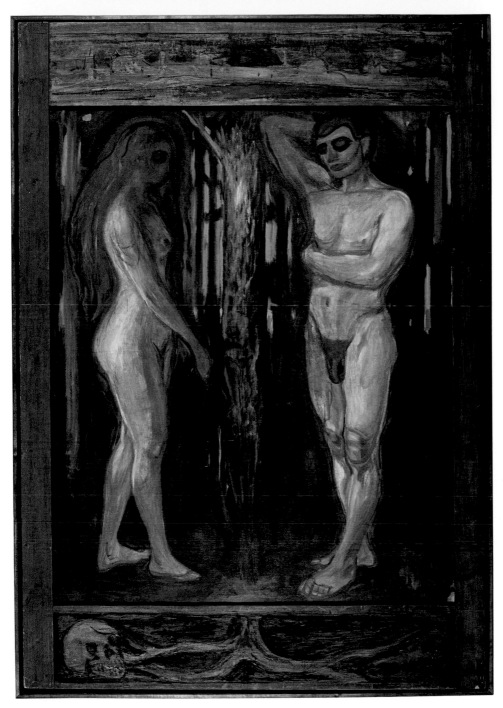

Metabolism: Life and Death 1898–99
Oil on canvas, 172.5 × 142 cm
Munchmuseet, Oslo

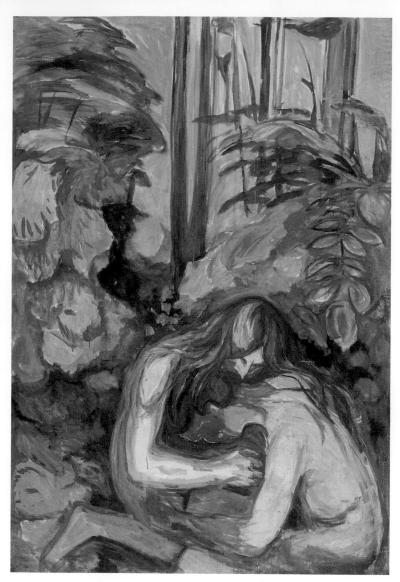

Vampire in the Forest 1924–25
Oil on canvas, 200 × 138 cm
Munchmuseet, Oslo

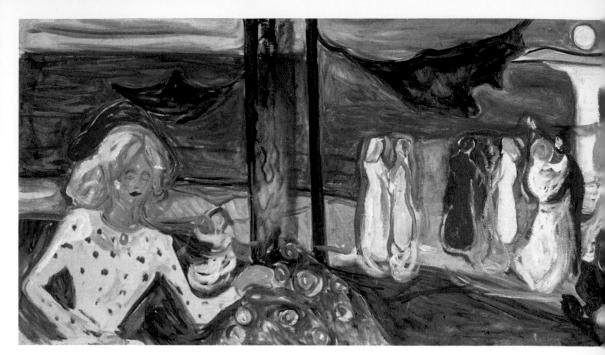

Dance on the Beach (The Linde Frieze) 1904
Oil on canvas, 90 × 316 cm
Munchmuseet, Oslo

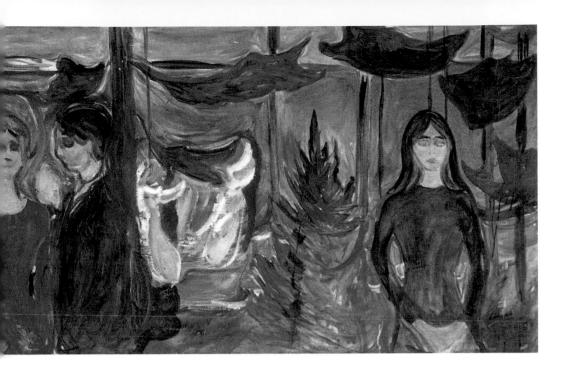

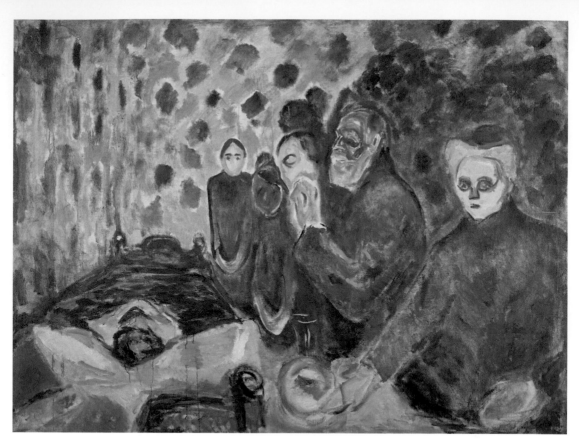

Death Struggle 1919
Oil on canvas, 174 × 230 cm
Munchmuseet, Oslo

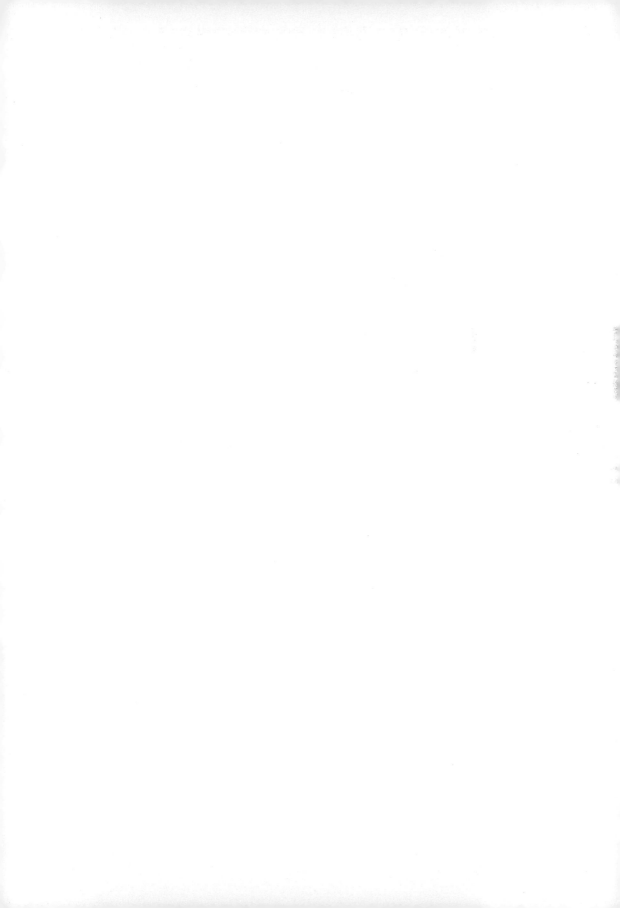

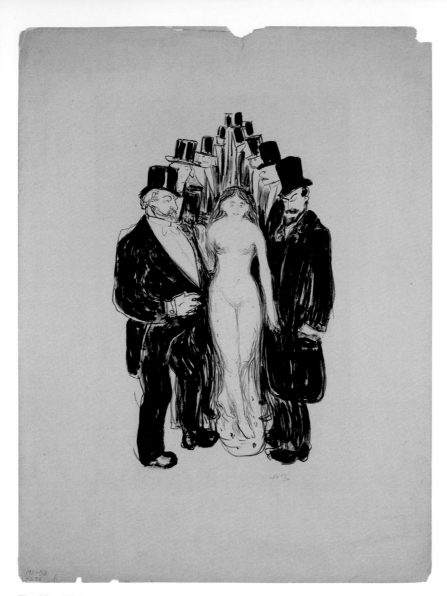

The Alley 1895
Lithographic crayon and tusche, 427 × 266 mm
Munchmuseet, Oslo

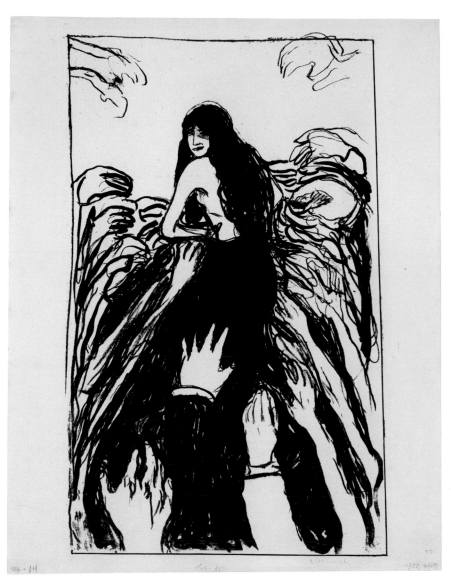

The Hands 1895
Lithographic crayon and tusche, 484 × 290 mm
Munchmuseet, Oslo

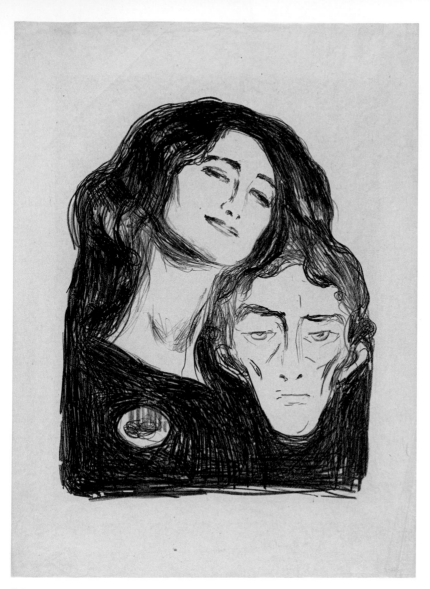

Salome 1903
Lithographic crayon and scraper, 395 × 305 mm
Munchmuseet, Oslo

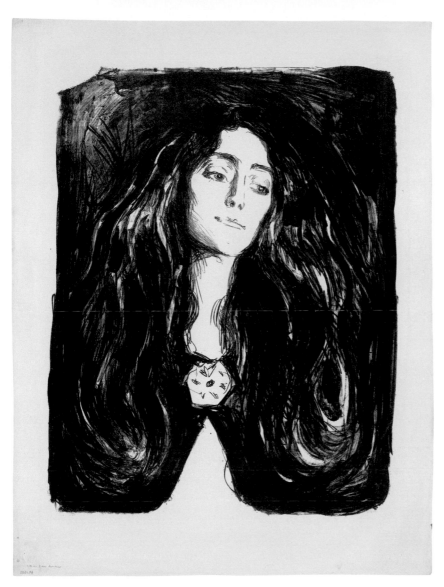

The Brooch: Eva Mudocci 1903
Lithographic crayon, tusche and scraper, 597 × 460 mm
Munchmuseet, Oslo

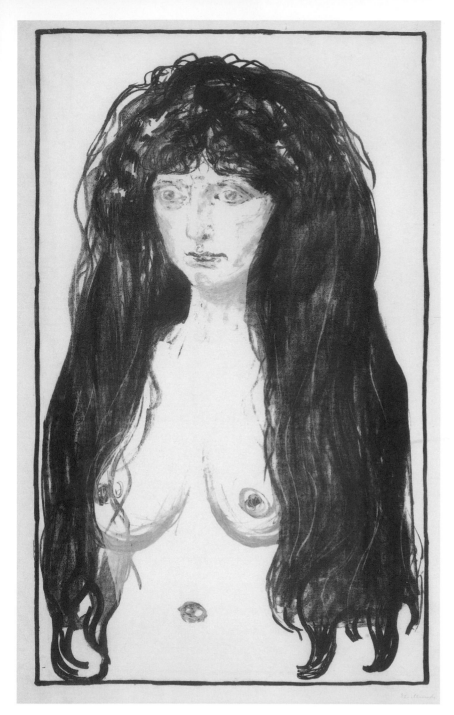

Woman with Red Hair and Green Eyes: The Sin 1902
Lithographic crayon, tusche and scraper, 698 × 402 mm
Gundersen Collection, Oslo

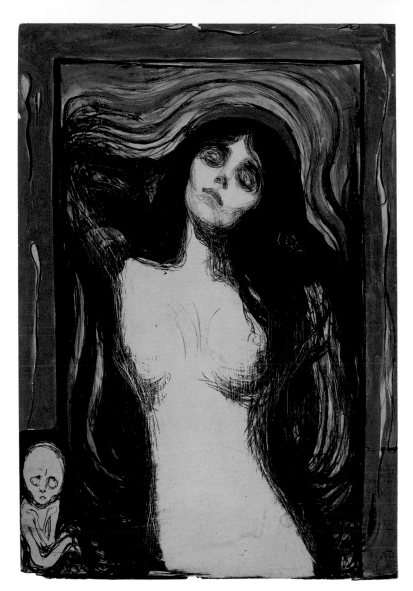

Madonna 1895/1902
Lithographic crayon, tusche and scraper, 595 × 440 mm
Gundersen Collection, Oslo

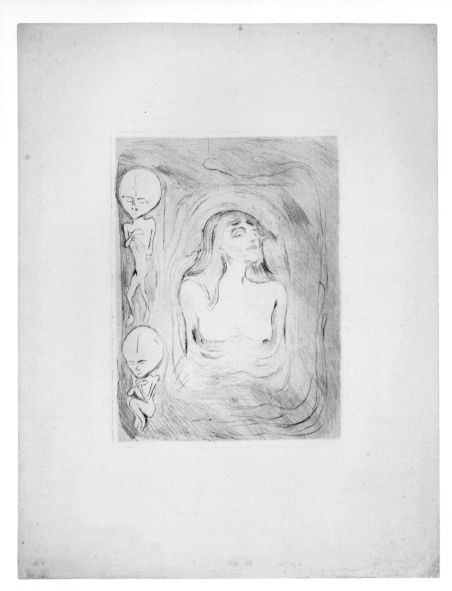

Madonna 1894
Drypoint and burnisher on copperplate, 360 × 262 mm
Munchmuseet, Oslo

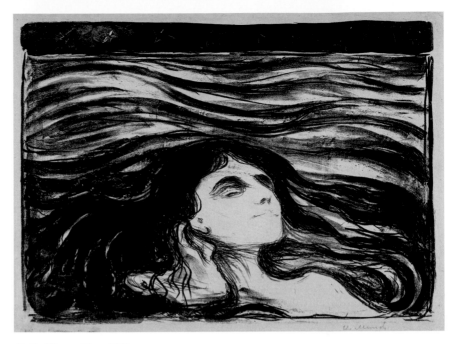

On the Waves of Love 1896
Lithographic crayon and tusche, 310 × 417 mm
Gundersen Collection, Oslo

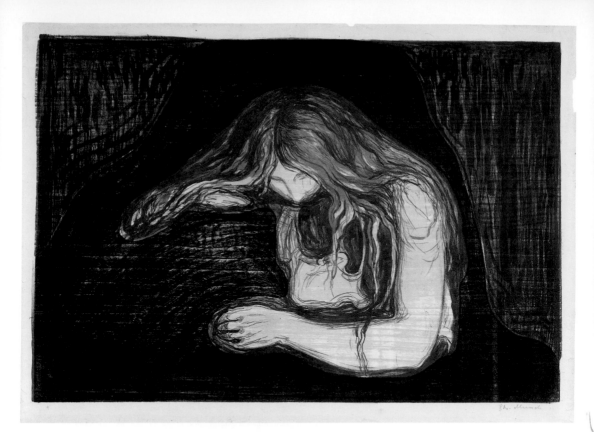

Vampire II 1895/1902
Lithographic crayon, tusche and scraper, 385 × 556 mm
Gundersen Collection, Oslo

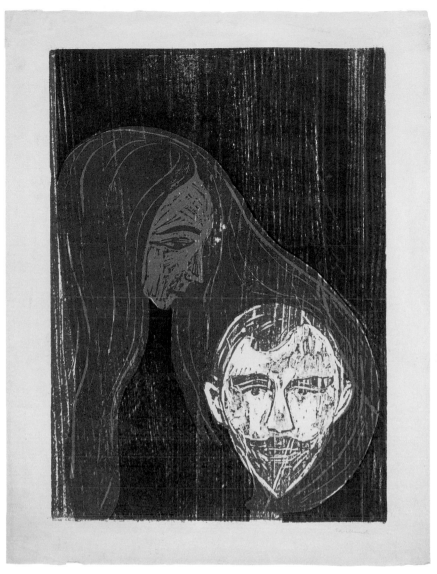

Man's Head in Woman's Hair 1896
Woodcut with gouges, chisel and fretsaw, 544 × 384 mm
Gundersen Collection, Oslo

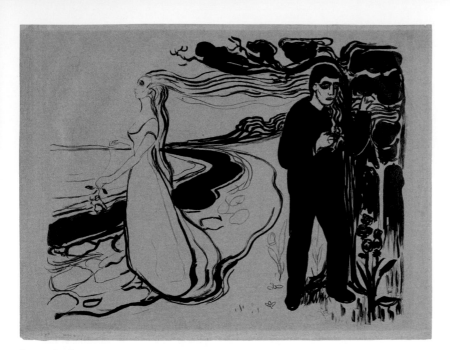

Separation I 1896
Lithographic crayon and tusche, 458 × 572 mm
Munchmuseet, Oslo

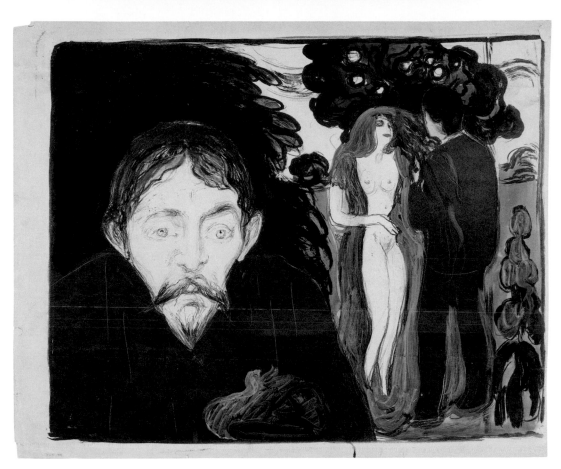

Jealousy II 1896
Lithographic crayon, tusche and scraper, 470 × 570 mm
Munchmuseet, Oslo

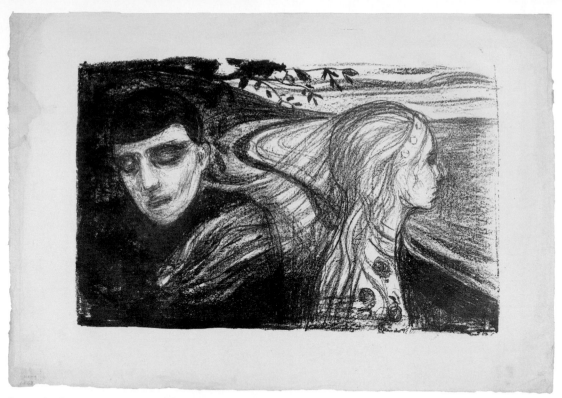

Separation II 1896
Lithographic crayon, 418 × 645 mm
Munchmuseet, Oslo

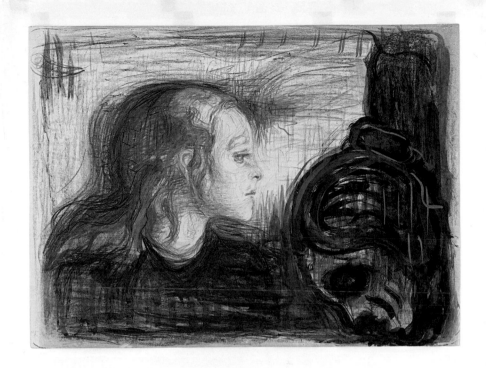

The Sick Child I 1896
Lithographic crayon, 432 × 573 mm
Munchmuseet, Oslo

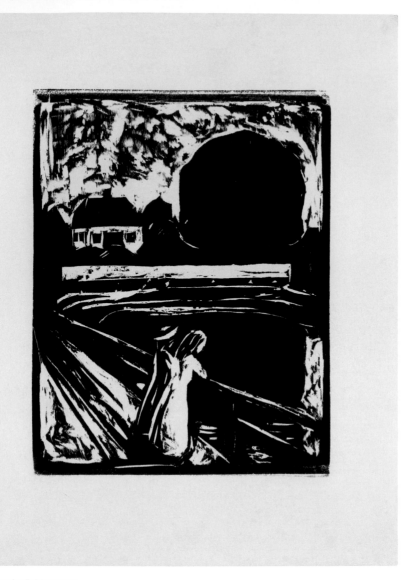

The Girls on the Bridge 1905
Woodcut with gouges and chisel, 268 × 204 mm
Munchmuseet, Oslo

Reuse and Mutation of the Motif

[...] but there was always progress, too, and they were never the same – I build one painting on the last.[1]

The Unique and the Multiple

Like many artists of the late 19th and early 20th century, Edvard Munch regularly created different variants of the same motif. Rather than a matter of purely formal issues, this was part of his thinking about the cyclical nature of his images. The elements reused from one work to the next should not be regarded as studies of motifs or as simple components of construction. Munch used these elements to assert a continuity between his works, regardless of their date of creation. Each work unavoidably led to the development of a new one, and Munch's reuse of motifs was a matter of mutation rather than repetition, since he could never exhaust them.

Munch produced a body of work with shifting boundaries, which interrogates the basic notions of finished and unfinished, unique and multiple. It is therefore difficult to describe some paintings or drawings as simple sketches, and the many reprises of his main motifs prevent any strict use of the singular to refer to an original work.

The reasons that led Munch to produce such a multiplicity of versions are themselves quite hard to identify. Depending on the motifs and mediums, experts are unsure whether to speak of artistic research or commercial strategy. Initially it seems Munch became interested in printmaking techniques because prints could be easily distributed and sold, giving his works greater visibility. Meanwhile some reprises of major works were commissioned, including the second version of *The Sick Child* (p. 125), which was painted at the request of Munch's patron Olaf Schou.

Concerning the artist's evocations of major events in his life, some have seen the repetition of motifs as 'memory work',[2] through which Munch was trying to regain the impression made on him by the event at the time when it occurred. This is one of the explanations often given for the different paintings and prints of *The Sick Child*, and the complex creative process leading up to the first painted version, which Munch endlessly scratched and partially repainted. The interpretation of this artistic act is ambivalent. Munch seems to have managed to recast his endlessly renewed encounter with painful memories by endowing it with a power of reparation. 'When I paint illness and misfortune it is on the contrary a healthy release. [...] In my art I have sought to explain to myself life and its meaning – I have also intended to help others to understand their own lives.'[3] Lastly, the variations of these paintings can ultimately be read as a way to keep hold of some of his major works, notably the paintings included in his magnum opus *The Frieze of Life,* as they were acquired by collectors.

The Girls on the Bridge

Among Munch's iconic motifs, the group of girls on a bridge offers a particularly good illustration of the gradual evolution from one work to the next. It appears in a great many paintings and prints from the late 1890s to the mid-1930s, in other words throughout almost all of the artist's career. Considering the paintings alone, there are more than ten based on this motif. These works are remarkable primarily for the largely unchanging nature of the structural elements of the composition. Munch slightly modified the elements of the background in different versions, but the main differences can be seen in the group of girls; they move around from one work to the next, as though the viewer were witnessing particular moments or pausing a visual flow. The first painting dates from 1901[4] and already features the key components of the series. The setting is easily identified: we see the wooden jetty of the port of Åsgårdstrand, a strong diagonal that structures the picture, and the Kiøsterud villa with its large lime tree in the garden. Three girls are leaning on the balustrade with their backs to the viewer, looking out over the water in which the landscape is partially reflected. The strange light that bathes the scene evokes the particular light of Scandinavian summer nights, creating strong shadows and chiaroscuro. But this is not an anecdotal depiction; Munch fills it with symbolic intent, notably through the colours of the girls' dresses, which are similar to those he had previously used in *Woman: Sphinx*[5] and *Red and White* (p. 138). In this way he turns the painting into an allegory of the transition from puberty to adulthood. All the later versions show great continuity in the construction of the composition, with only slight variations of the point of view and details of the buildings in the background. The group of girls is subject to more significant changes and sometimes one of the figures is shown facing the viewer. The composition of later examples, such as the painting of 1927 (p. 177), still remains the same in almost every respect.

The most notable change relates to the age of the girls themselves, who become a group of adult women, first seen in a painting of 1902.[6] In some versions, including ones painted in the years 1934–40 (p. 175), Munch adds a group of male silhouettes dressed in black. Here the strong contrast with the female figures in pale colours symbolises what the artist regarded as an almost irreconcilable antagonism between men and women.

Munch also placed great importance on the location of these scenes. The little port of Åsgårdstrand was a key place in his life from the late 1880s until his move to Ekely in 1916 and some of its most characteristic elements became motifs for studies in themselves. He was particularly interested in the Kiøsterud villa, the finest building in the village, and he depicts the spreading lime tree and garden wall in a painting of 1902–04 (p. 176). The artist imbued the places he inhabited with a particular symbolism;[7] however, it is interesting to note that in this painting the focus of his attention is not the house but the wall that he used to structure all his compositions depicting girls on the bridge. This use of a strong diagonal to define space is a key component in a great many of Munch's works, starting with *The Scream*.

In tandem with his approach to motifs, he also reused certain very characteristic types of composition from one work to the next. His diagonals bring the scene he depicts very close to the viewer, sometimes to the point of entirely blocking off the background space in order to heighten the dramatic dimension of his paintings. We can see this in *New Snow in the Avenue* (p. 179), a mysterious painting with an atmosphere of menace, characterised by its extreme simplification of forms, from the trees lining the road to the faceless, barely sketched silhouettes in the foreground. In *Children Playing in the Street in Åsgårdstrand* (p. 178) Munch reworks a very similar composition to that of *The Girls on the Bridge* to show a street in the village. The little girl in the foreground, staring at the viewer, conveys very little of the supposed innocence of childhood.

Munch and Printmaking

Munch made his first etchings and lithographs in Berlin, late in 1894. He soon became very skilled in both these difficult techniques, which endlessly provided him with new artistic inspiration. Printmaking became a vast area of exploration for him, and a vector of intense research into motifs.

The precise origins of Munch's interest in printmaking and his early uses of it are hard to retrace. His early prints seem to have arisen directly out of his contact with the literary circles in Berlin. The art critic Julius Meier-Graefe edited and actively contributed to the German magazine *Pan*, which published Munch's first album of etchings in June 1895. It seems certain that Munch initially regarded printmaking as a means to publicise his works more widely, in the hope of giving them greater visibility and increasing his sales. He was also curious about a technique that was little known and very little practised in Norway, and which he hoped to pioneer. Munch wrote in a letter: 'I must have money for my work which I believe may come to be of importance – at least, in initiating an art form that is not known at home, namely, the reproductive.'[8]

While this move to a reproducible medium offered undeniable commercial advantages, it crucially enabled Munch to use his capacities for invention in new formats, and he very quickly extended his printmaking practice. He began by mastering the traditional techniques of etching and drypoint in 1894 and printed his first lithographs in 1895. Lithography offers great freedom, but also brings many constraints linked to the bulk of the stones, so in 1896 Munch began making woodcuts. He found this technique highly conducive to his art, enabling him to develop an interplay between the different depths of relief and to use large, flat areas to render space. The woodcut *The Girls on the Bridge* (p. 168) of 1905 is a particularly representative example of this.

Munch also gave his prints a prominent place in his various exhibitions, presenting them in parallel to the paintings of *The Frieze of Life* in the exhibitions at the Berlin Secession in 1902 and Leipzig in 1903, both of which were particularly important to him. However, he

soon cast off traditional techniques and introduced his own singular artistic practices. Often he retouched his prints directly in gouache and watercolour, sometimes even adding entire motifs. In doing this he was seeking to offset the difficulties of colour printing and simplifying the process so that he did not have to create multiple plates. Three prints of *The Girls on the Bridge*, all dating from 1918, offer a glimpse of Munch's experiments in this field. We can immediately see that, even so long after his early experiments, he was still using conventional methods: one of the lithographs (p. 182) was printed using three zinc plates coloured in green, blue and red; another (p. 181) was printed from an engraved wood block inked in black, after which Munch added colours using watercolour. The third plate (p. 180) is the result of an unusual process, since he began by printing the blue ground from the woodblock and then added the colours using three zinc plates coloured green, red and yellow.

Munch used every element available to him without respect for the traditional techniques, increasingly simplifying the creation of his prints and probably also researching textural effects. Although he seems to have particularly liked wood engraving, he never totally abandoned any one technique in favour of another, and his work includes late examples of drypoint and lithography. Lithography in particular offered him the possibility of very quick, spontaneous expression, similar to drawing. The print *On the Bridge* (p. 183) has a very energetic air, due to rapidly drawn sketch-like elements. The face of the woman seen from the front is so schematic as to be almost grotesque. It certainly recalls the grimacing, ghostly faces of *The Scream* and *Evening on Karl Johan*. A drypoint of 1907, *Young Women on the Beach II* (p. 174), shows the same speed of execution, but creates a very different atmosphere imbued with melancholy. Here Munch also includes several of his recurrent motifs: the shore at Åsgårdstrand, the moon reflected in the sea and a group of young women, one of whom stands apart from the others, recalling the female figure of the *Separation* series.

It is undoubtedly in the motif of *The Kiss* that we find the most eloquent expression of Munch's ability to move fluidly from one medium to the next, which he maintained throughout his career. The image of an embracing couple first appeared in a drawing of 1889–90[9] and went on to increase in depth and evocative power. The earliest versions of both paintings[10] and graphic versions of this motif show the lovers in a studio or apartment, by a window looking on to a street. One drawing of 1894–95 (p. 184) appears to be a sketch for a drypoint (p. 185) of unusual compositional structure, in which Munch skilfully exploits the textural differences between the grey and black areas. Then, in a series of woodcuts, he focuses exclusively on the couple, using all his capacities of visual invention to create a background to highlight the fusion of the two figures and heighten the tension of the moment.

For this he adopted the technical ruse of cutting his plates into pieces corresponding to the component elements of his compositions. This 'jigsaw puzzle'

approach[11] enabled him to ink the pieces of wood differently and to obtain colour prints without having to engrave multiple plates. Devised to simplify his printing process, this approach also gave Munch far greater compositional freedom.[12] He most likely got the idea from the Danish artist Jens Ferdinand Willumsen, who used a very similar technique to print some of his lithographs and described it in the catalogue for his solo exhibition in Kristiania in 1892.[13]

The Kiss I (p. 186) clearly reuses the composition of its contemporary painting (p. 128). The couple are outlined with light incisions in the plate, inked entirely in black, where we can still see the motif of the window and curtain on the left of the image. The composition is enlivened by a series of scratches in parallel to the wood grain, which are more or less pronounced in the different states. Munch vigorously deepens the relief in The Kiss II (p. 187) and surrounds the couple with a set of sinuous lines reminiscent of the undulations of the sky in The Scream and Angst, and also of the shadow around the couple in Vampire II. This motif creates the illusion of a kind of vibration pulsing through the work and seeming to irradiate the figures. In some versions of The Kiss III (p. 190), curves are replaced by the delicate, elegant use of the wood veins, bestowing great aesthetic value on the material aspect of the technique. Lastly, in some prints of The Kiss IV (p. 191), Munch completely isolates the couple and sets up a contrast with the velvet texture of the paper.

Towards the end of his life, Munch produced new engravings of The Kiss, showing the lovers in a primitive landscape of mountains and water. These works, entitled Kiss in the Field (p. 188), renew the motif by giving it unexpected depth and mystery. The undulating waves combine with the lines and knots of the wood, making the couple almost invisible against the background. This insertion of the figures into a landscape is reminiscent of the painting Vampire in the Forest (p. 148). In these late reworkings, Munch transforms the lovers into allegories of Adam and Eve, isolated within primordial nature.

1 Draft letter to Axel Romdahl N 3359. Munchmuseet. Cited in Lampe 2011–12a, p. 36.
2 On this, see Lampe 2011–12b.
3 Note N 46, 1930–34. Munchmuseet.
4 The Girls on the Bridge, 1901, oil on canvas, 136 × 125 cm (Nasjonalmuseet, Oslo, Woll M 483).
5 Woman. Sphinx, 1894, oil on canvas, 72 × 100 cm (Munchmuseet, Woll M 361).
6 Women on the Bridge, 1902, oil on canvas, 184 × 205 cm (KODE Bergen, Woll M 541).
7 On this, see Flaatten 2013a.
8 Letter to Valborg Fredrikke Hammer N 1721, September 1896. Munchmuseet. Cited in Bartrum 2019.
9 Adieu (Kiss), 1889–90, pencil, 271 × 207 mm (Munchmuseet).
10 See for example Kiss by the Window, 1891, oil on canvas, 72 × 64.5 cm (Munchmuseet, Woll M 257).
1 See Clarke 2009.
1 The different pieces of wood can clearly be seen in the plates that have been preserved, such as that of The Kiss III.
13 See Clarke 2009.

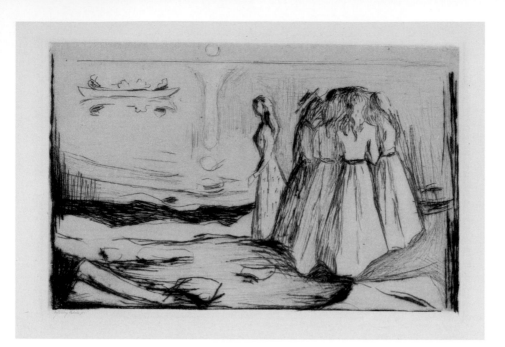

Young Women on the Beach II 1907
Drypoint on copperplate, 11 × 171 mm
Munchmuseet, Oslo

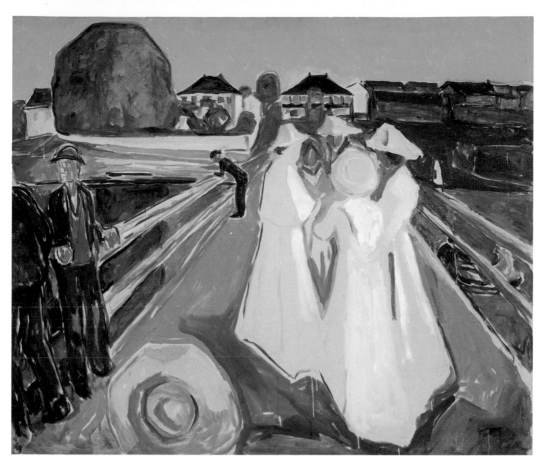

The Ladies on the Bridge 1934–40
Oil on canvas, 10 × 129 cm
Munchmuseet, Oslo

Trees and Garden Wall in Åsgårdstrand 1902–04
Oil on canvas, 99 × 103.5 cm
Musée d'Orsay, Paris

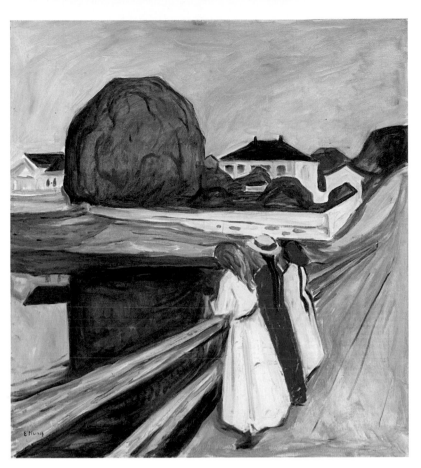

The Girls on the Bridge 1927
Oil on canvas, 100 × 90 cm
Munchmuseet, Oslo

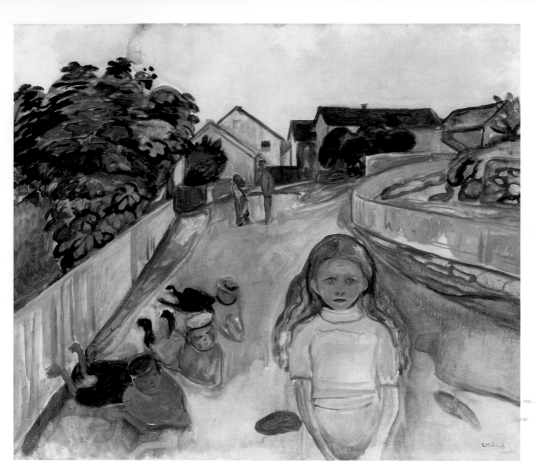

Children Playing in the Street in Åsgårdstrand 1901–03
Oil on canvas, 74.6 × 89.2 cm
KODE, Bergen (Rasmus Meyer Collection)

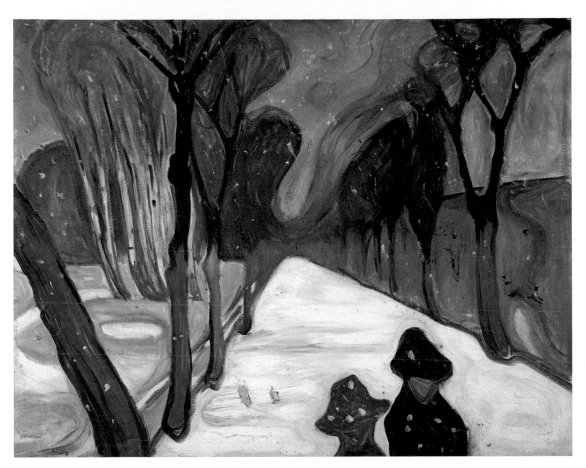

New Snow in the Avenue 1906
Oil on canvas, 80 × 100 cm
Munchmuseet, Oslo

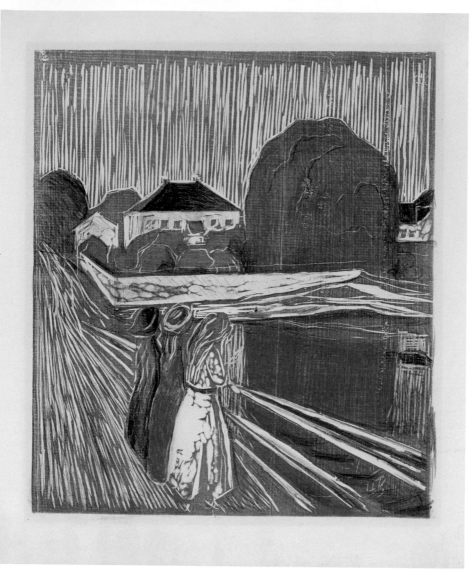

The Girls on the Bridge 1918
Woodcut with gouges, combination print, 498 × 432 mm
Munchmuseet, Oslo

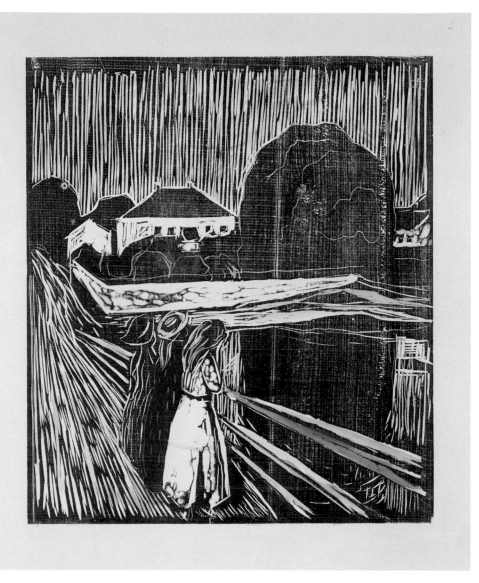

The Girls on the Bridge 1918
Woodcut with gouges, combination print, 496 × 430 mm
Munchmuseet, Oslo

Reuse and Mutation of the Motif

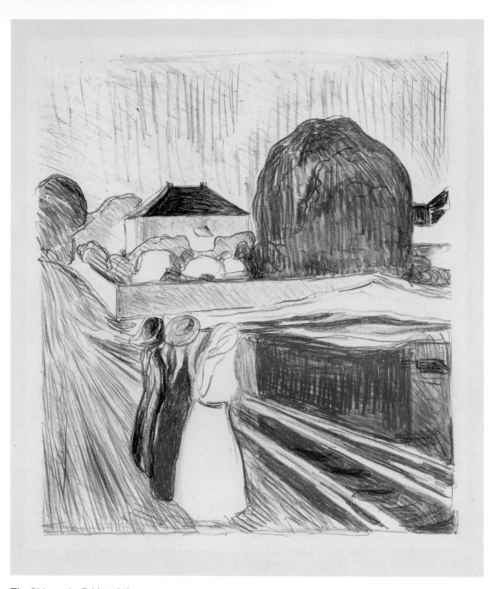

The Girls on the Bridge 1918
Lithographic crayon, 494 × 422 mm
Munchmuseet, Oslo

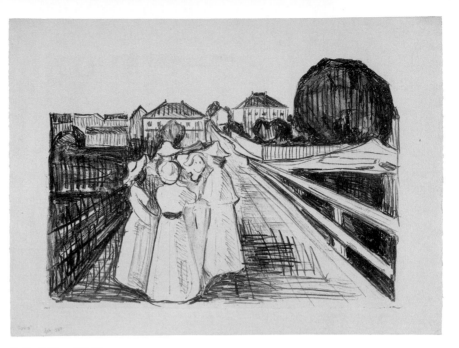

On the Bridge 1912–13
Lithographic crayon, 376 × 528 mm
Munchmuseet, Oslo

The Kiss 1894–95
Brush and crayon, 605 × 390 mm
Munchmuseet, Oslo

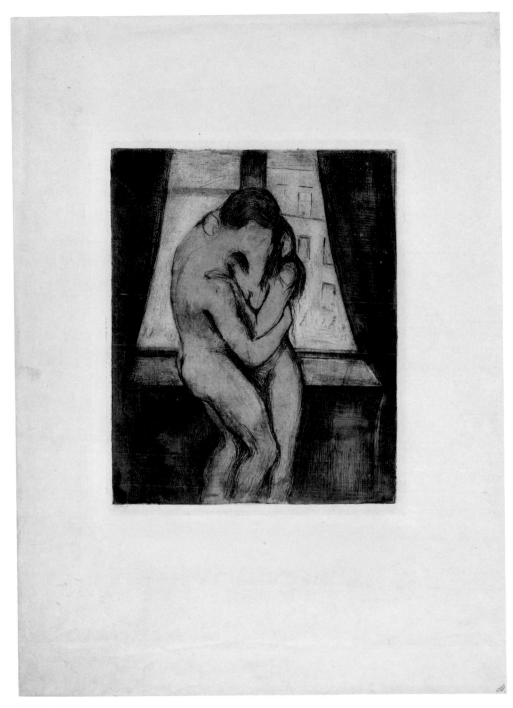

The Kiss 1895
Line etching, open bite, drypoint and
burnisher on copperplate, 330 × 262 mm
Munchmuseet, Oslo

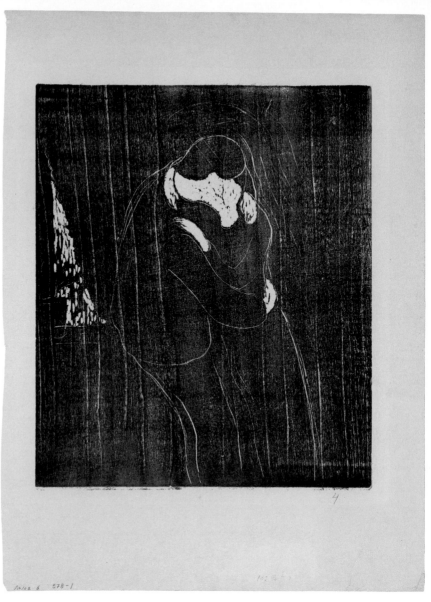

The Kiss I 1897
Woodcut with gouges and fretsaw, 453 × 377 mm
Munchmuseet, Oslo

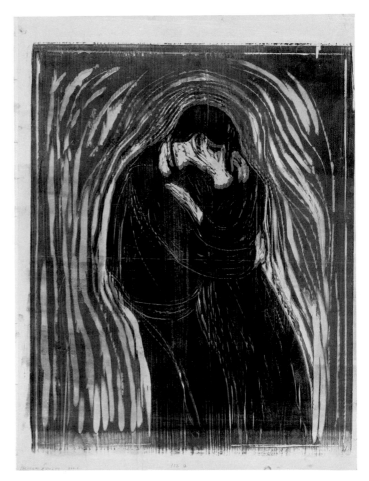

The Kiss II 1897
Woodcut with gouges, 590 × 460 mm
Munchmuseet, Oslo

Kiss in the Field 1943
Woodcut with gouges, 404 × 490 mm
Munchmuseet, Oslo

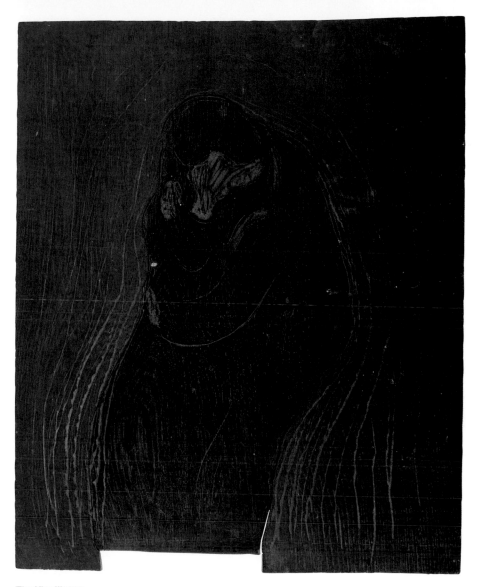

The Kiss III 1898
Teak woodblock, 504 × 405 × 6 mm
Munchmuseet, Oslo

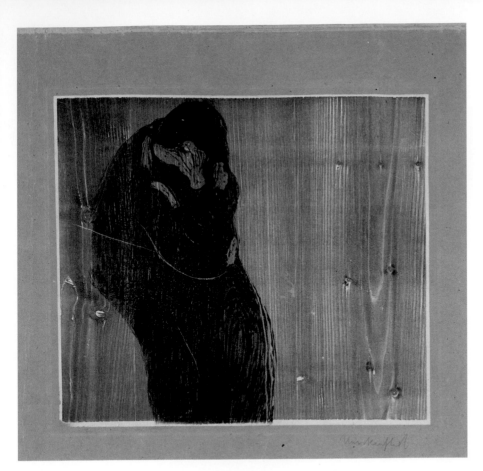

The Kiss III 1898
Woodcut with gouges and fretsaw, 403 × 458 mm
Munchmuseet, Oslo

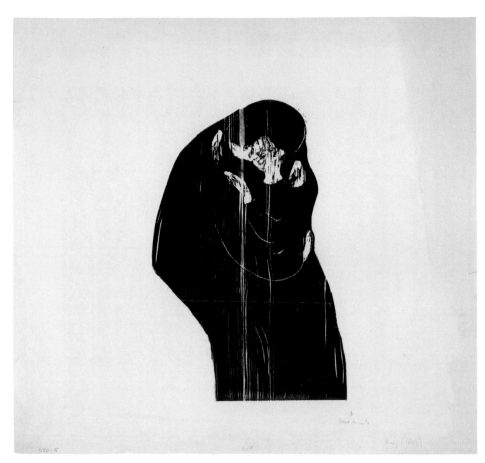

The Kiss IV 1902
Woodcut with gouges and fretsaw, 393 × 229 mm
Munchmuseet, Oslo

Munch and the Grand Decorations

It was I, with the Reinhardt frieze thirty years ago, and the Aula and the Freia frieze, who launched modern decorative art.[1]

In the early 20th century Edvard Munch began to work on large decorative projects, for both private commissions and public competitions. His interest is understandable, since such projects are particularly well suited to the cyclical aspect of his art. For Munch, the development of an iconography featuring disparate, yet necessarily interdependent elements, came naturally in the years when he was also putting together the first presentations of his major cycle *The Frieze of Life*.[2] Rather than isolating work on his various decorative projects, Munch integrated them into the development of his ideas, reusing themes and motifs that were already present in his artistic vocabulary. This approach once again demonstrates the singular nature of Munch's artistic process; he regarded his decorative work as part of his overall oeuvre, even though this sometimes led him into conflict with his patron's original wishes.

The Linde Frieze

Munch's solo exhibition of December 1892 in Berlin caused an unprecedented scandal and was widely reported in the press at the time as 'the Munch affair',[3] bringing him widespread fame in German intellectual and artistic circles. After this he spent long periods in Germany and received many commissions from private patrons, notably for portraits. In 1902 he met Dr Max Linde, a Lübeck-based ophthalmologist and great collector of contemporary art, and the two became friends.

A few months after they met, Linde published a book entitled *Edvard Munch und die Kunst der Zukunft* (Edvard Munch and the Art of the Future).[4] During the year 1903 he commissioned Munch to create around ten panels for the bedroom of his sons, whose portrait Munch had painted a few months before.[5] Discussions for this project seem to have taken place around the end of 1903, as shown by a letter of December 1903 from Linde to Munch, in which he provides the precise dimensions of the works to be created.[6] The artist designed pictures directly inspired by his ongoing artistic explorations, in several of which he reused certain motifs taken from *The Frieze of Life* or linked to representations of love. For example, he painted a new version of *The Dance of Life* and depicted pairs of lovers in the painting *Kissing Couples in the Park* (p. 201). The subjects of other paintings were more symbolic or directly linked to nature, such as *Girls Watering Flowers* (p. 198), *Summer in the Park* (p. 200) and *Trees by the Beach* (p. 199). All the works feature great formal simplification and broad, rapid brushwork that give them a strong air of spontaneity. The paintings were installed in Linde's house in late 1904, but Linde quickly had them taken down again, on the grounds that their subjects were inappropriate for a children's

bedroom, and also that their resolutely modern, partly experimental style did not sit well with the classical architecture of the opulent Linde family home. As Munch himself admitted following a site visit, their effect 'was just like ... a bomb'.[7] Linde returned the works to Munch, without criticising their intrinsic aesthetic qualities and seeking to cover the artist's expenses.[8] The failure of this commission did not cause any kind of rupture between the two men, who remained close friends for the rest of their lives. In 1904 Munch painted a large portrait of Max Linde.[9]

The Reinhardt Frieze

The mixed experience of the Linde frieze did not undermine Munch's interest in creating decorative works and, in 1906, due to his previous experience in the theatre world and notably his links with Strindberg, he received another major commission.

In 1905 the German theatre director Max Reinhardt was appointed head of the Deutsches Theater in Berlin and a few months later, in 1906, bought the building. He converted an adjoining hall that could hold an audience of just over 300, known as the 'Kammerspiele', which he wanted to open with a production of Ibsen's *Ghosts*. Reinhardt approached Munch for set designs (p. 220). From the account by Reinhardt's adviser Arthur Kahane,[10] we know that the discussions between Reinhardt and Munch led to a much larger commission since, in July 1906, Munch was also asked to design a frieze to decorate the foyer of the Kammerspiele. This new project proved to be particularly important for Munch, since it was his first experience of creating decorations for a public building. Unfortunately, we do not know the precise number of paintings commissioned, but there are around ten which can be directly linked to this frieze.[11] Munch focused his designs on the theme of love, describing his project briefly in a letter to his aunt Karen: 'The subject is inspired by the beach opposite my house in Åsgårdstrand – Men and women on a summer night.'[12] The various paintings show some of the central motifs that Munch had developed since the 1890s, including the kiss, the dance on the beach and girls on the bridge.[13] Others expressly recall his motifs for the Linde frieze, such as fruit picking.[14] In all of them the Åsgårdstrand shoreline is easily identifiable. The canvases were painted in distemper, a technique that enables quick work with very little retouching and is common in theatre backdrops. So in using this technique and its matt colours to create a gentle atmosphere of melancholy, Munch was also highlighting the identity of the place. The painting *Two Human Beings: The Lonely Ones* (p. 203) is particularly representative. Munch created the first version of the motif in a painting of 1892,[15] which was sadly destroyed in 1901. He painted another version in 1905[16] and also created a great many graphic variations. The version from the Reinhardt frieze is characterised by its very sober composition and the extreme simplification of the landscape and silhouettes. Attention is focused on the void surrounding and separating the two figures.

The man's pose with his drooping shoulders and slightly lowered head, walking behind and seemingly unable to reach his companion, encapsulates the powerfully sad and despairing atmosphere of the scene.

The paintings were installed in the Kammerspiele in the autumn of 1907, but because they were very high on the wall and almost certainly inadequately lit, they did not have the intended visibility. So they were taken down in 1912, when the theatre was being redesigned, and Reinhardt decided to sell them, with Munch's agreement. They were bought by the art historian Cornelius Gurlitt, who then sold some of them to Paul Cassirer in 1914.

The Aula

Munch's masterpiece of monumental decoration is undeniably the project for the centenary of the university in Kristiania. The international prominence of the competition, the jury's many hesitations and the strong publicity given to his works by Munch himself gave far greater prominence to a project that was already of great symbolic importance for the young nation of Norway.

In 1909 the university's new rector Waldemar Brøgger launched a competition for eleven paintings to decorate the new great festival hall for the university's centenary in 1911. The building, which was then under construction, was of major political significance for the Norwegians. In their eyes the university offered the finest embodiment of their country's cultural and political independence following the dissolution of the union between Norway and Sweden in 1905.

When he applied to enter the competition in May 1909, Munch was at a turning point in his career. He was very well known in Germany and France due to the sensation caused by his solo shows. In his personal life, he had just suffered a period of acute depression and had spent several months in the clinic of Dr Jacobson in Copenhagen. He returned to Norway well aware of what was at stake and determined to establish his position as a major artist on the international stage. Munch did not immediately have the success he hoped for and had to wait several months before his request to participate in the competition was accepted. In the spring of 1910, four artists were selected to present their projects to the final jury: Gerhard Munthe, Eilif Peterssen, Emanuel Vigeland and Edvard Munch. Faced with fundamentally different proposals, the jury made a surprising decision. Munch was the only artist selected, but his works were not accepted. The jury recognised the superiority of his proposals, but partially rejected their radical nature.[17] In his initial project Munch had included *The Human Mountain* (p. 206), a scene of extreme symbolism featuring intertwining bodies rising up towards the sky. This image can only really be understood in the light of another of Munch's proposals, the motif *Towards the Light* (p. 207), which shows a male figure facing the rising sun. Here Munch reworked his Symbolist refrain of perpetual regeneration to show the gradual elevation of the human race until the advent of a New Man, illuminated by the light of knowledge. The power

of the message could not, however, conceal the highly provocative, and indeed morbid nature of the proposal, which was resolutely rejected by the jury.

So Munch pursued his work focusing on the three major motifs *Alma Mater*, *History* (p. 204) and *The Sun* (p. 208). *Alma Mater* and *History* were conceived as pendants and refer at once to classical mythology and to profoundly Norwegian ideas and identity. *Alma Mater*, the wet nurse, shows a female figure with a baby at her breast. She is surrounded by small, naked children who might have been bathing and are exploring the landscape. *History* shows an old man teaching a boy in a rocky landscape.

The two main figures, both seated in the centre of the compositions, thus embody two key ideas: the mother country who provides profane nourishment and the setting for the coming generations, and the patriarch who provides intellectual nourishment and passes on knowledge. The landscapes in which these scenes take place also have symbolic importance, showing the two topographies typical for Norway. *History* evokes the ocean shoreline of jagged rocks, while the gentler contours of the inland hills and fjords appear in *Alma Mater*.[18]

The Sun occupies the central place in the decoration, as a counterpoint to the other two paintings. In this strongly Symbolist and almost non-figurative composition, Munch depicts the regenerative power of light, hope dawning with the new day, and the pure, dazzling light of knowledge.[19] The expressive power of this motif carries and supports the entire iconography of Munch's proposal, while providing an iconic image founding a new aesthetic.

The jury recognised the power of Munch's artistic language, but the great modernity of his designs made them hesitate. One of them, the new director of Nasjonalgalleriet, Jens Thiis, was a strong supporter of Munch's art and told him how to influence the other jury members. At the suggestion of Thiis, Munch staged a public exhibition of some of his sketches at Dioramalokalet in Kristiania in March 1910, which was exactly when the jury were meeting to name the winner of the competition. The exhibition had some success and the Norwegian public began to support Munch's project. He reused the strategy several times, even showing his many sketches in various European cities, notably Berlin in November 1913, at the Herbst-Ausstellung. The success of these exhibitions with the critics and public alike finally persuaded the jury, who accepted Munch's proposals on 29 May 1914.[20] The decorations were officially unveiled on 19 September 1916.

The Aula project had a particular significance for Munch, whose international reputation was at stake. He was constantly preoccupied with the development of his ideas and produced a considerable number of sketches during the competition. He pursued this work even after the paintings were finally installed in the Aula and unveiled in 1916, and continued to paint smaller versions of them into the early 1930s (p. 205).

Bathers

Alongside his work on major decorative projects, in the late 1900s and early 1910s Munch created several paintings showing bathers in Warnemünde (p. 197), a coastal resort on the Baltic Sea, where he stayed regularly from the summer of 1907. Rather than a true cycle, these works represent Munch's thinking about monumental works, in terms of both format and the way the figures are portrayed. The paintings are a real celebration of the bathers' bodies, which fill the entire space of the canvas, surrounded by bright sunlight. In Munch's art this apotheosis of the body can also be understood as the artistic transposition of the vitalism found in the thought of Nietzsche and Bergson. These bathers' bodies have their pendant in Munch's portraits of workers, which assert an equally powerful vision of the male body, but in the context of labour.[21]

1 Draft letter to Oslo Arbeidersamfund (Oslo Workers' Society) N 3668, 6 September 1938. Munchmuseet.
2 It was in 1902, at the exhibition of the Berlin Secession, that Munch had the idea of presenting his works as a cycle; see my essay 'The Frieze of Life' in this book.
3 See Krisch & Börsch-Supan 1997.
4 Linde 1902.
5 *Dr Linde's Four Sons*, 1903, oil on canvas, 144 × 199.5 cm (Museum für Kunst und Kulturgeschichte der Hansestadt Lübeck, Museum Behnhaus).
6 Letter from Max Linde to Munch K 2784, 2 December 1903. Munchmuseet. The letter includes a plan with indications of formats and dimensions for seven panels.
7 Letter to Ludvig Ravensberg N 2819, 9 December 1904. Munchmuseet.
8 Letter from Max Linde to Munch K 2806, 5 April 1905. Munchmuseet.
9 *Portrait of Dr Max Linde*, 1904, oil on canvas, 226.5 × 101.5 cm (Stiftung Moritzburg, Kunstmuseum des Landes Sachsen-Anhalt).
10 On this, see exh. cat. Oslo 2013, p. 164, and Lampe 2011–12b, p. 12.
11 See Woll 2008, Vol. II, pp. 714–729. All the works that can be linked to this frieze have a height of 90 cm.
12 Letter to Karen Bjølstad N 932, 26 December 1907. Munchmuseet.
13 See in particular *The Kiss on the Beach*, 1906–07, 90 × 155 cm (Neue Nationalgalerie, Berlin); *Dance on the Beach*, 1906–07, 90 × 403 cm (private collection); *Young Women on the Beach*, 1906–07, 90 × 148 cm (Hamburger Kunsthalle).
14 See *Young Women Picking Fruit*, 1906–07, 89.5 × 70 cm, Neue Nationalgalerie, Berlin.
15 *Two Human Beings: The Lonely Ones*, 1892, oil on canvas, unknown dimensions, destroyed in an explosion on a ship on 9 December 1901.
16 *Two Human Beings: The Lonely Ones*, 1905, oil on canvas, 80 × 10 cm (private collection).
17 On the overall organisation of the competition and Munch's different proposals, see Berman 1989 and Pettersen 2008, pp. 829–851.
18 Flaatten 2013b.
19 See also Patricia Berman's essay 'Munch's Aula and the Theatre of *The Sun*' in this book.
20 The building itself had been opened in June 1912, with gilded hangings installed in place of the future paintings. For a complete chronology of the creation of the project and Munch's action to obtain the jury's acceptance, see Berman 1989.
21 See for example *Workers in Snow*, 1909–10, distemper on unprimed canvas, 210 × 135 cm (Munchmuseet).

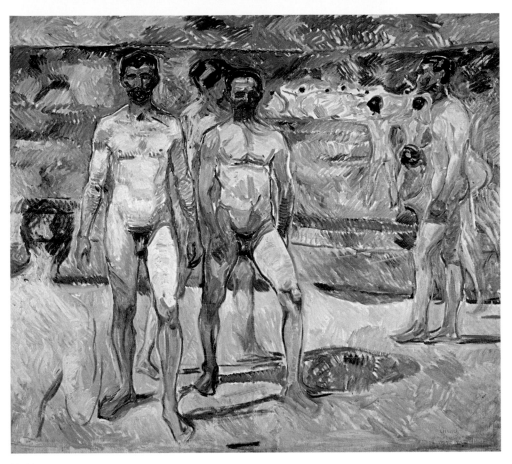

Bathing Men 1907–08
Oil on canvas, 206 × 227 cm
Ateneum, Finnish National Gallery, Helsinki (Antell Collection)

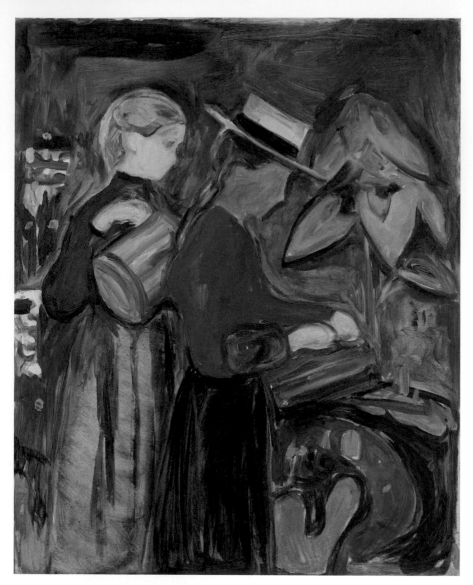

Girls Watering Flowers (The Linde Frieze) 1904
Oil on canvas, 99.5 × 80 cm
Munchmuseet, Oslo

Trees by the Beach (The Linde Frieze) 1904
Oil on canvas, 93 × 167 cm
Munchmuseet, Oslo

Summer in the Park (The Linde Frieze) 1904
Oil on canvas, 91 × 172 cm
Munchmuseet, Oslo

Kissing Couples in the Park (The Linde Frieze) 1904
Oil on canvas, 91 × 170.5 cm
Munchmuseet, Oslo

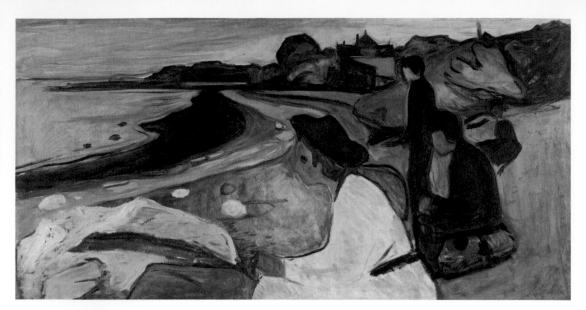

Young People on the Beach (The Linde Frieze) 1904
Oil on canvas, 90 × 174 cm
Munchmuseet, Oslo

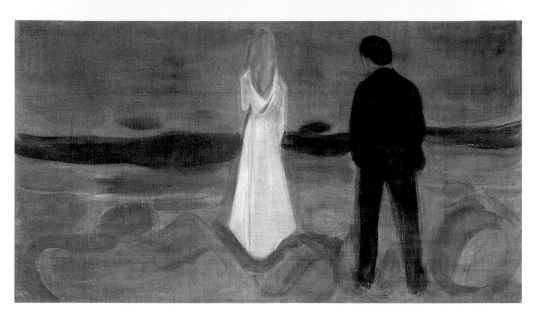

Two Human Beings: The Lonely Ones (The Reinhardt Frieze) 1906–07
Tempera on unprimed canvas, 89.5 × 159.5 cm
Museum Folkwang, Essen

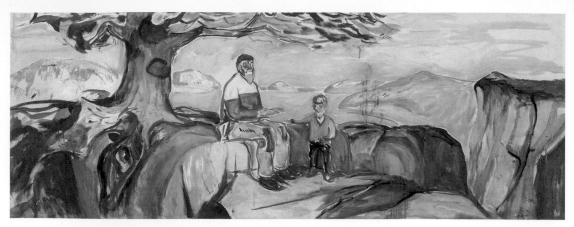

History 1914
Oil on canvas, 89 × 200 cm
Munchmuseet, Oslo (Rolf Stenersen Collection)

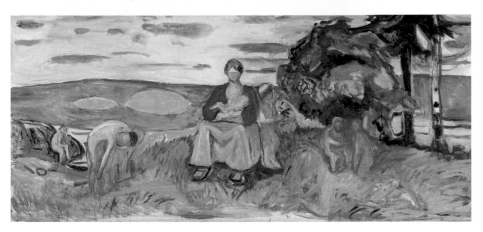

Alma Mater 1929
Oil on canvas, 91 × 198 cm
Munchmuseet, Oslo

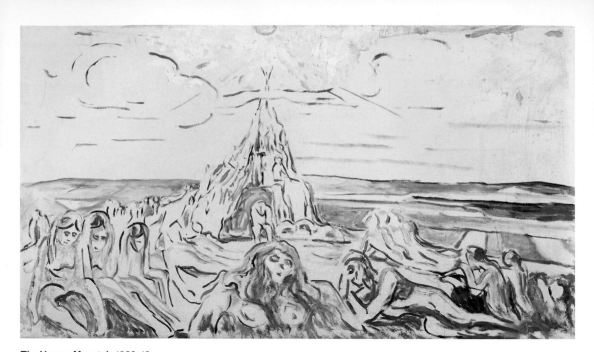

The Human Mountain 1909–10
Oil on canvas, 70 × 125 cm
Munchmuseet, Oslo

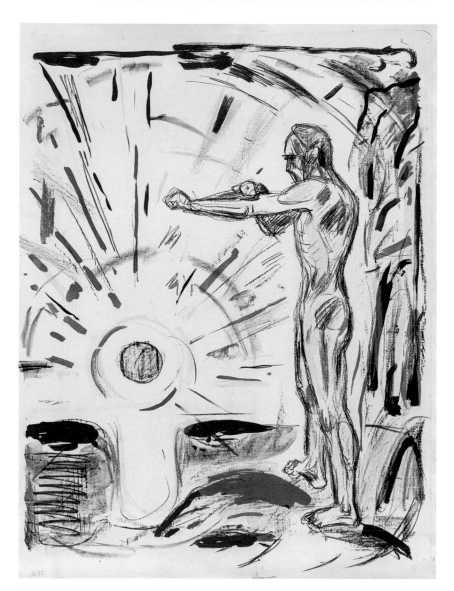

Towards the Light 1914
Lithographic crayon, 905 × 730 mm
Munchmuseet, Oslo

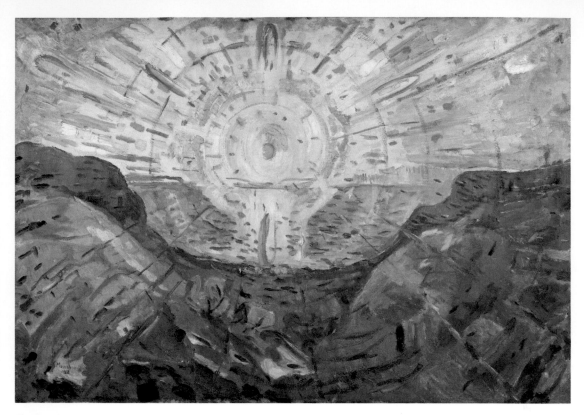

The Sun 1912
Oil on canvas, 123 × 176.5 cm
Munchmuseet, Oslo

Mise-en-scène and Introspection

I do not believe in art which has not been forced into being by a man's compulsion to open his heart. All art like music must be created with one's lifeblood – Art is one's lifeblood.[1]

In the late 19th century, and particularly in France, the avant-gardes of art and literature joined forces and shared ideas, notably around the Symbolist movement. Painters began working on theatre designs, one example being the fruitful collaboration between the young Nabi painters and Aurélien Lugné-Poë's Théâtre de l'Œuvre in Paris. Edvard Munch was no exception and, during his periods in France and Germany between the 1890s and late 1900s, he often created work for the theatre world. His intense collaboration with the German theatre director Max Reinhardt was among his most formative experiences and had an immediate effect on his art, greatly enhancing the attention he paid to the construction of pictorial space. More generally, Munch's strong interest in the modern theatre, and notably in the work of Henrik Ibsen and August Strindberg, provided him with a constant source of inspiration, as the writings of his contemporaries offered him motifs and emotions that enabled him to express the fluctuations of his own inner world.

Early Theatrical Collaborations

Munch and Lugné-Poë met in Stockholm in the autumn of 1894, through Ibsen's French translator Maurice Prozor. Lugné-Poë, who had developed an early interest in Nordic theatre, and had already produced several plays by Scandinavian authors since the opening of the Théâtre de l'Œuvre in 1893, was on a tour of Northern European cities with his troupe to present their work. Two years later, when Munch was living in Paris, Lugné-Poë took the opportunity to ask the artist to create the illustrated programme for Ibsen's play *Peer Gynt*, which was to be staged in late 1896 (p. 224). Lugné-Poë wanted to respond to Ibsen's criticisms[2] that the Théâtre de l'Œuvre's staging of his plays was too heavily Symbolist, and saw collaboration with a Norwegian artist as a way to find a more appropriate tone that would be closer to the play's original meaning.[3] Rather than portraying Peer Gynt himself on the programme, Munch depicted the character's mother Åse and young fiancée Solveig. Åse's face, seen in the foreground and turned towards the viewer, betrays a deep sadness that contrasts with the figure of young Solveig, whose attention is on the mountain landscape, looking for her man's return. This juxtaposition of two female figures respectively embodying resignation and hope recurs in many later graphic variations in the motif of *Women on the Beach*.

In 1897 Lugné-Poë asked Munch to illustrate the programme for another of Ibsen's plays, *John Gabriel Borkman* (p. 224). Here again, Munch did not choose to portray the main character, but placed a portrait of Ibsen in the foreground. With his frown, wild hair and piercing eyes, the playwright has an intimidating air, his face

emerging from deep chiaroscuro, lit by the beams from a lighthouse in the background in a clear symbol of artistic genius.

For Munch this portrait of Ibsen became a kind of iconographic model, variants of which he used in the painting *Henrik Ibsen at the Grand Café*[4] and in several graphic versions (p. 225). In these images the lighthouse is replaced by an evocation of the Grand Café's location in Karl Johan Street. The Grand Café was known as Ibsen's favourite place in Kristiania and Munch was a regular visitor there in his younger years, but he never dared approach the writer, whom he deeply admired. Relations between the two men were never more than distant. However, on a few occasions Ibsen showed interest in Munch's work, notably visiting his exhibition at Blomqvist in Kristiania in the autumn of 1895.

Munch had already attempted a writer's portrait, having made several lithographs of his friend August Strindberg in 1896 (p. 234). The two had become very close since Munch's time in Berlin in 1893 and the literary meetings at the café Zum schwarzen Ferkel (The Black Piglet). However, their respective emotional states led them to fall out somewhat during the year 1896. Strindberg, who was going through a severe personal crisis and about to embark on his second divorce, published a review in the form of a prose poem in *La Revue blanche*, giving a rather ambivalent assessment of Munch's solo exhibition at Samuel Bing's Maison de l'Art Nouveau in Paris.[5] Probably in response to this piece of debatable intent, Munch misspelled his friend's name, turning it into a derogatory pun.[6]

The portrait of Strindberg is very similar to the lithographic self-portrait Munch made the previous year (p. 233). Both adopt the same compositional approach, with the face standing out against the background in a strong contrast of black and white, and the use of graphic elements to frame the composition and give it a metaphorical, even morbid depth.[7] Here again, Munch introduces a dissonant note into his own name, by inverting the letter 'N'. This detail reinforces his general thoughts on the fleeting nature of life, conveyed through the skeletal arm, and adds an interrogation of identity.

The episode of 1896 did not mark the end of the friendship between Munch and Strindberg. In 1898, Munch agreed to contribute to a special issue of the German journal *Quickborn*,[8] featuring a number of pieces by Strindberg in celebration of his 50th birthday. Munch created the motif of *Blossom of Pain* for the occasion, initially in black and white (p. 222) and later in many coloured versions. This image can be interpreted in two ways: it uses the myth of Narcissus, in which the flower is born out of the death of the mythological hero, and also has a Symbolist dimension in the cycle of life already seen in *Metabolism*, in which creation arises out of decay. Munch brings about a symbiosis of these influences to portray the artist who metaphorically spills his blood for his art. The same idea can be seen in other lithographs of the late 1890s, such as *Self-Portrait with Lyre* (p. 223), in which the artist's body conveys intense

physical pain, and even more literally in *Harpy* (p. 227), where a chimera is about to seize his wasted corpse.[9]

One other literary experiment by Munch is known. In 1896 he contributed to publisher Alfred Piat's plans for an illustrated edition of Baudelaire's *Les Fleurs du Mal*.[10] Munch produced three drawings, for the poems 'Le Baiser', 'Le Mort Joyeux' (p. 226) and 'Une Charogne', but the project was left unfinished following the publisher's death.

Reinhardt and Ibsen

A few years after these early experiments with illustration, Munch was approached by the theatre director Max Reinhardt, with whom he began a very productive collaboration. In 1905, Reinhardt had been appointed head of the Deutsches Theater in Berlin and a few months later, in 1906, bought the building. He converted an adjoining hall that could hold an audience of just over 300, known as the 'Kammerspiele', which he wanted to open with a production of Ibsen's *Ghosts*, and asked Munch to design elements of the set (p. 220). Reinhardt wanted to use this space to develop a new type of theatre enabling a far more direct and intimate relationship with the audience. The rows of seats were only separated from the stage by a single step and everything was designed to ensure the audience was immersed in the action on stage. The sets were very important, since they had to assist the inclusion of the audience and be as realistic as possible. Munch made many studies of the bourgeois interior in which the play is set and also provided 'mood studies' (*Stimmungs-skizzen*) intended to help the actors become imbued with the emotions of their characters.[11] Munch engaged wholeheartedly in this project and moved back to Berlin in order to attend daily rehearsals. The script resonated with him very strongly, and he linked this drama of heredity and family secrets to certain traumatic events of his own life. The large black armchair downstage in his set is often seen as an evocation of the chair in the paintings of *The Sick Child*.[12]

Reinhardt's staging and Munch's sets were unanimously praised by reviewers. So the two men renewed their collaboration for another of Ibsen's plays, *Hedda Gabler*, the tragic story of a romantic young woman who is disappointed by a conventional marriage and becomes a prisoner of disillusionment. In his set designs for this play (p. 221), Munch's depiction draws an evident parallel with Tulla Larsen. His Hedda Gabler has the long silhouette and features of his former lover. In 1907 he was still deeply affected by their complex, sometimes brutal relationship and by their violent separation. For him, the figure of Hedda/Tulla thus becomes the symbol of a woman at once attractive and dangerous.

Hedda Gabler was not enthusiastically received by the critics. Undoubtedly disappointed by the cool response in the press and exhausted by long months of intense work for the Kammerspiele, Munch did not continue his collaboration with the theatre world.

The Green Room

These experiences with theatre did, however, immediately leave a deep mark on Munch's works. His vision of the construction of space was undeniably transformed, enabling him to bring ever greater dramatic intensity to the scenes he depicted. In this regard the painting *The Death of Marat* (p. 216) is exemplary. The choice of subject seems surprising in Munch's work, from which historical scenes are largely absent. Here he is interested in violence and murder committed by a woman, and again transposes a portrayal of Tulla Larsen onto the figure of Charlotte Corday, who symbolically kills the artist. This conflation is made even clearer by the detail of the blood stains on the sheet, which are concentrated around the man's drooping hand. In the course of the row that led to their separation in 1902, Munch was accidentally shot with a revolver. Part of one finger on his left hand was damaged and he long remained traumatised by this painful episode.[13] He returned to the theme of *The Death of Marat* in several paintings. In the version presented here, he emphasises the contrasting flesh tones of the two figures and the hieratic nature of their poses. These elements give the scene an icy atmosphere, heightened by the violence and speed of the brushwork. The tight framing and minimalist décor of the scene give the figures a monumental air, making their relationship to the viewer all the more powerful.

Munch pursued his expressions of anger and bitterness over his former relationship in a series of six very similar paintings entitled *The Green Room*.[14] All are set in a small, windowless room where the space is dominated by the pattern on the wallpaper. They show disturbing, unhealthy images of a woman and a couple. In *Jealousy* (p. 217) and *The Murderess* (p. 218), the foreground is occupied by a table top that obstructs our view of the space and seems to extend out of the painting and towards the viewer. This very considered compositional approach stems directly from the theatrical ideas of Reinhardt and intimist theatre, in which the stage was always constructed as a closed room with one missing wall.[15]

Munch continued to adopt this particular approach to space in the different versions of *Weeping Woman* (p. 219) created in the years 1907–09, which show the same atmosphere of suffocation due to the wallpaper and furniture that clutter the entire room. The very tight framing focuses on a female figure whose pose conveys deep affliction.

The Self-Portraits

The influence of the theatre in Munch's work is not confined to the treatment of space as a stage. He keenly admired the plays of his contemporaries, and in addition to formal approaches, drew on them for the subjects of his works. Some themes from Ibsen's plays, such as loneliness or the impossibility of life as a couple, directly resonated with Munch's own concerns. This is reflected in some of his self-portraits, where he portrays himself in

the pose of John Gabriel Borkman, Ibsen's character who has remained shut away in his room for years, a prisoner to obsessive thoughts.[16] This identification long persisted in Munch's mind and reflected his own experience, as he led a fairly isolated life after moving to Ekely in 1916. It finds literal expression in the self-portraits from the 1920s, such as *The Artist and his Model* (pp. 228–229), where Munch explores his relation to time by portraying his ageing self with a young female model, and *Sleepless Night: Self-Portrait in Inner Turmoil* (p. 215), which gives palpable expression to the psychological tension to which the artist was still subject.

However, Munch's practice of self-portraiture is not solely linked to his relationship with the theatre. From the start of his career, he often worked in this genre, both to externalise his ideas and doubts and to mark the different stages of his life. These portraits, which often have an allegorical dimension, also express his keen awareness of the inevitability of death. Shortly after his dramatic break with Tulla Larsen, he depicted himself in *Self-Portrait in Hell* (p. 235), a literal transposition of the emotional pain he was suffering at the time. Constructed in the same way as *Self-Portrait with Cigarette* (p. 124), the young artist's head and torso are seen against a nebulous coloured background. However, the effect produced here is radically different and reveals Munch's profound vulnerability. This fragility is also expressed in the series *Self-Portrait After the Spanish Flu* (p. 230). While some have doubted that Munch really was infected with the flu,[17] he shows himself physically depleted and explicitly refers to this event that generated great anxiety across Europe in the period immediately after the First World War. In *The Night Wanderer* (p. 231), he seems to lean towards the viewer, with the worried expression and sunken eyes of a ghost. Seen as a portrait of the artist at an advanced age, this painting was long thought to date to the late 1930s. In fact, it was painted around 1923–24, once again illustrating the constant preoccupation with death in Munch's work.

1 Note N 29, 1890–92. Munchmuseet.
2 See Aitken 1991–92, pp. 222–236.
3 See Coppel 2019, pp. 97–126.
4 *Henrik Ibsen at the Grand Café*, 1898, oil on canvas, 70 × 96 cm (private collection).
5 Strindberg 1896, p. 525.
6 Munch spelled Strindberg's name as Stindberg. The Norwegian word *stind* can be translated as 'full of oneself'; see Coppel 2019.
7 The portrait of Strindberg includes the same foetus motif as various graphic versions of *Madonna*. The skeleton's arm at the bottom of the image gives the lithographic self-portrait of 1895 the significance of a memento mori.
8 For this he was approached by Strindberg's German translator Emil Schering.
9 See also Ingrid Junillon's essay 'Munch and the Symbolist Theatre' in this book.
10 On this, see Junillon 2009, pp. 179–193.
11 Junillon 2009, pp. 10–143.
12 See Lampe 2011–12.
13 *On the Operating Table*, 1902–03, oil on canvas, 109 × 149 cm (Munchmuseet).
14 See Eggum 1977.
15 See Eggum 1977 and Lampe 2011–12.
16 On this, see Junillon 2009, pp. 235–256.
17 See Berman 2016 and Steihaug 2013.

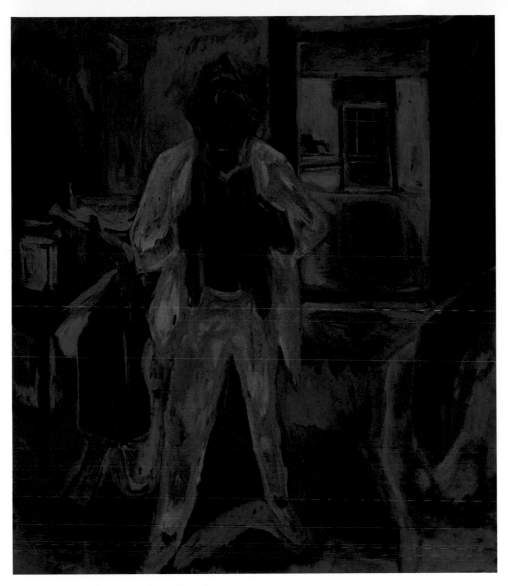

Sleepless Night: Self-Portrait in Inner Turmoil 1920
Oil on canvas, 150 × 129 cm
Munchmuseet, Oslo

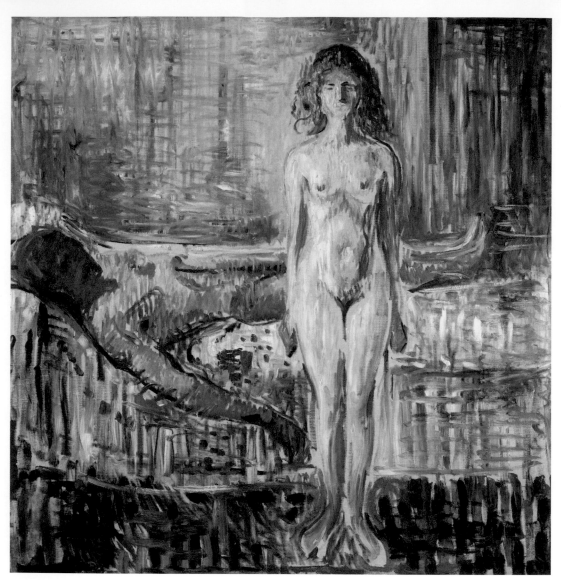

The Death of Marat 1907
Oil on canvas, 153 × 149 cm
Munchmuseet, Oslo

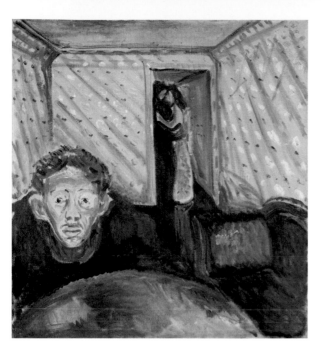

Jealousy 1907
Oil on canvas, 89 × 82.5 cm
Munchmuseet, Oslo

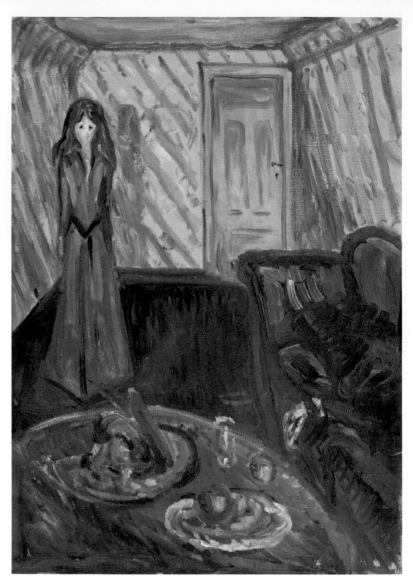

The Murderess 1907
Oil on canvas, 89 × 63 cm
Munchmuseet, Oslo

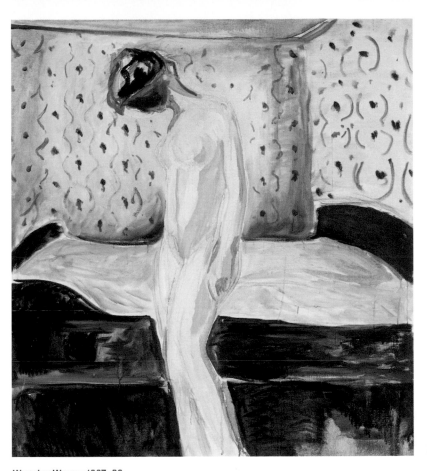

Weeping Woman 1907–09
Oil and crayon on canvas, 10.5 × 99 cm
Munchmuseet, Oslo

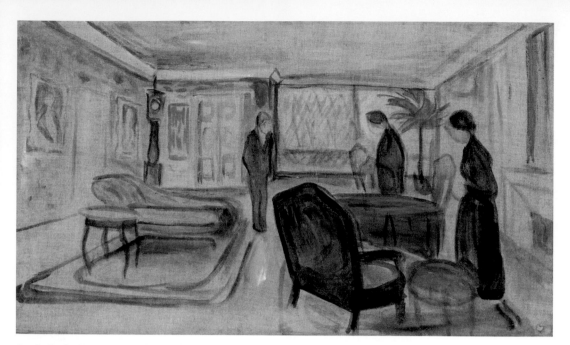

Set design for Henrik Ibsen's *Ghosts* 1906
Tempera on unprimed canvas, 60 × 102 cm
Munchmuseet, Oslo

Hedda Gabler 1906–07
Crayon and watercolour, 660 × 487 mm
Munchmuseet, Oslo

Mise-en-scène and Introspection

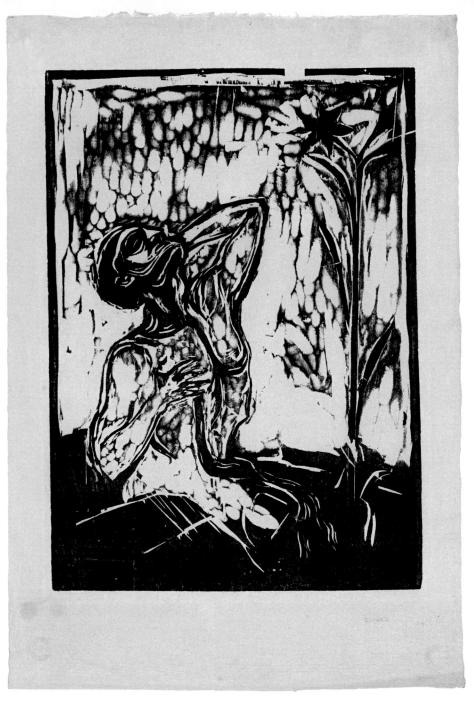

Blossom of Pain 1898
Woodcut with gouges, 460 × 326 mm
Munchmuseet, Oslo

Self-Portrait with Lyre 1897
Gouache and pencil, 635 × 480 mm
Munchmuseet, Oslo

Theatre programme for Henrik Ibsen's *Peer Gynt* 1896
Lithographic crayon, 249 × 298 mm
Munchmuseet, Oslo

Theatre programme for Henrik Ibsen's *John Gabriel Borkman* 1897
Lithographic crayon, 207 × 319 mm
Munchmuseet, Oslo

Henrik Ibsen at the Grand Café 1902
Lithographic crayon, 434 × 600 mm
Munchmuseet, Oslo

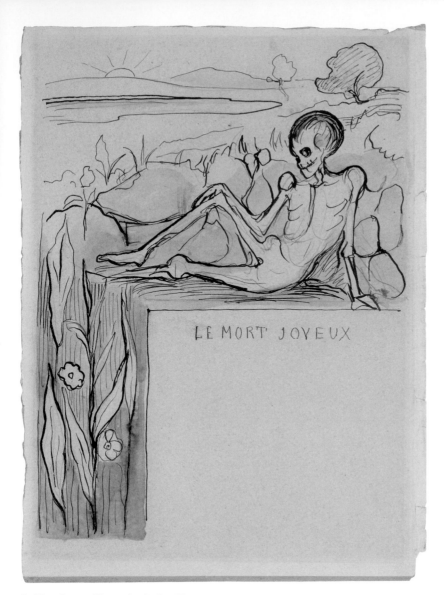

Le Mort Joyeux: Illustration for *Les Fleurs du Mal* 1896
Pen, pencil and wash, 280 × 205 mm
Munchmuseet, Oslo

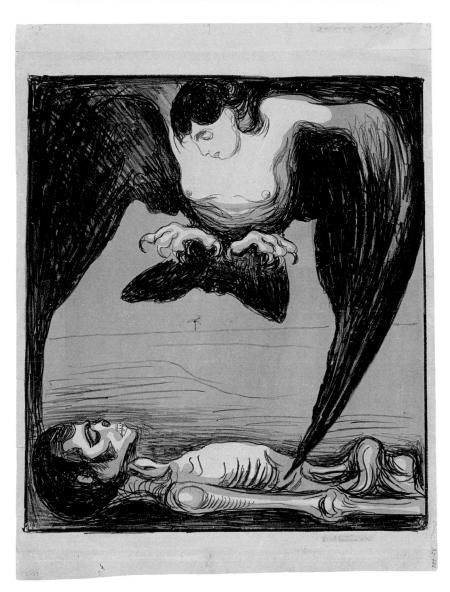

Harpy 1899
Lithographic crayon, 365 × 320 mm
Munchmuseet, Oslo

Mise-en-scène and Introspection

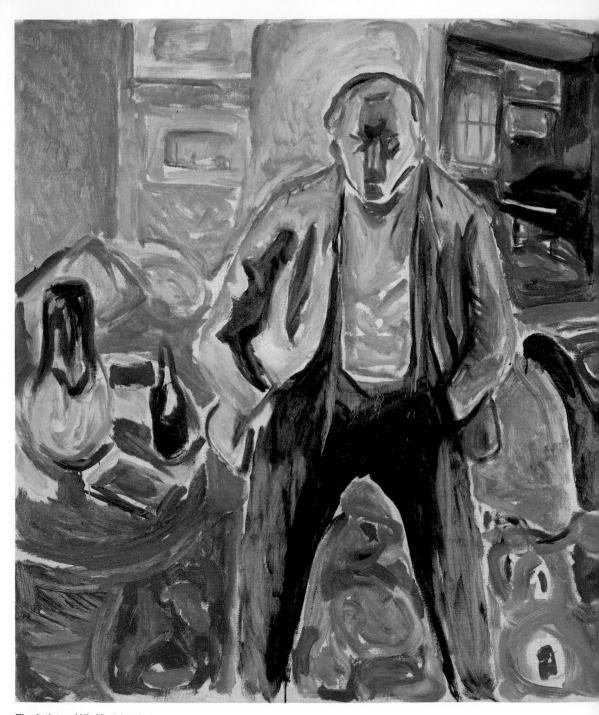

The Artist and His Model 1919–21
Oil on canvas, 120.5 × 200 cm
Munchmuseet, Oslo

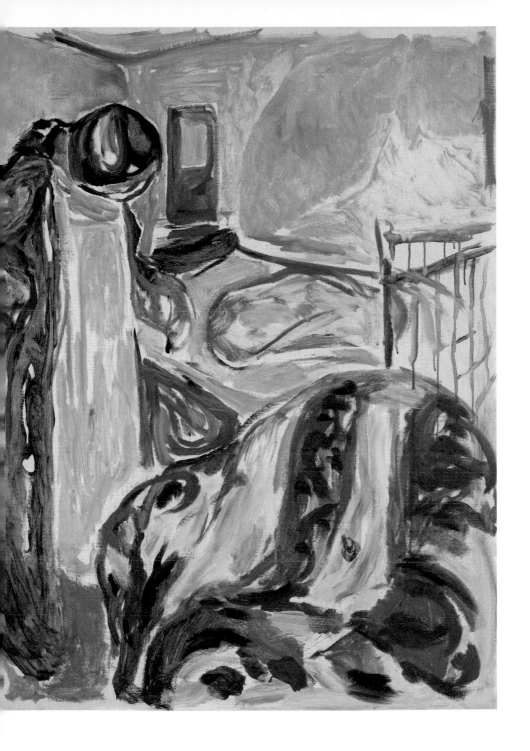

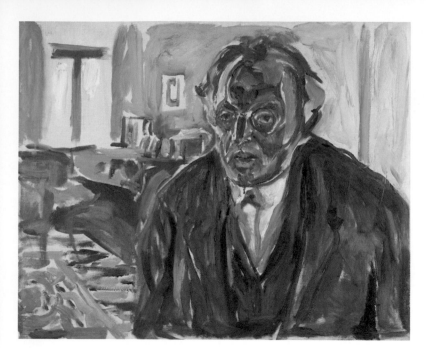

Self-Portrait After the Spanish Flu 1919
Oil on canvas, 59 × 73 cm
Munchmuseet, Oslo

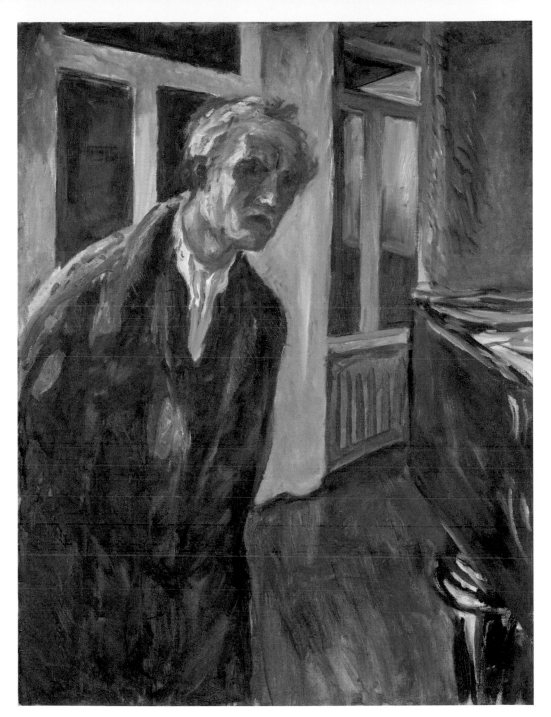

Self-Portrait: The Night Wanderer 1923–24
Oil on canvas, 90 × 68 cm
Munchmuseet, Oslo

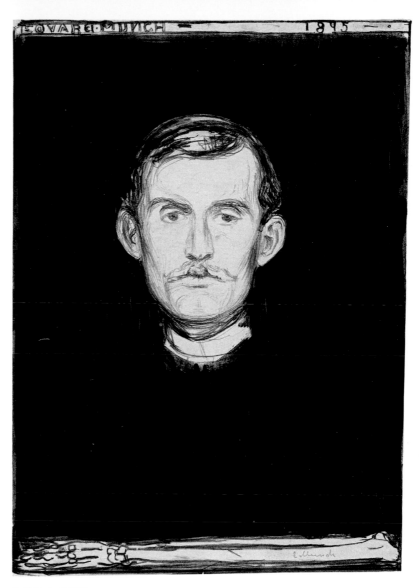

Self-Portrait 1895
Lithographic crayon, tusche and scraper, 467 × 320 mm
Gundersen Collection, Oslo

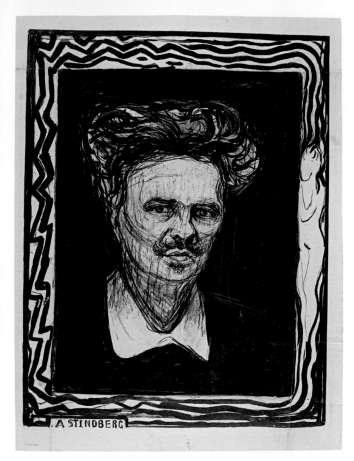

August Strindberg 1896
Lithographic crayon, tusche and scraper, 600 × 460 mm
Munchmuseet, Oslo

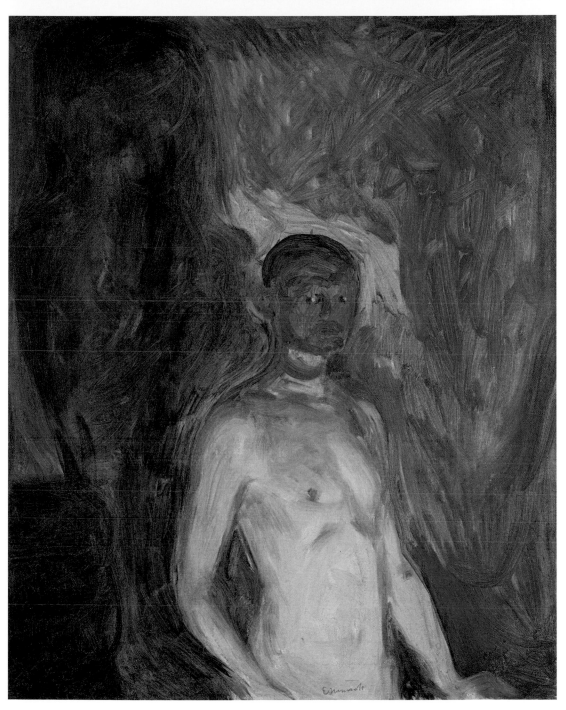

Self-Portrait in Hell 1903
Oil on canvas, 82 × 66 cm
Munchmuseet, Oslo

Mise-en-scène and Introspection

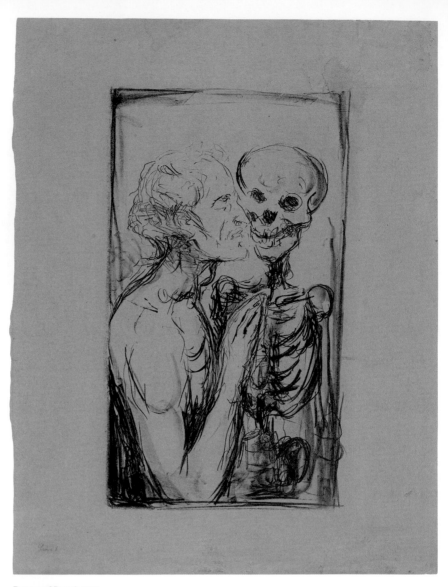

Dance of Death 1915
Lithographic crayon, 500 × 285 mm
Munchmuseet, Oslo

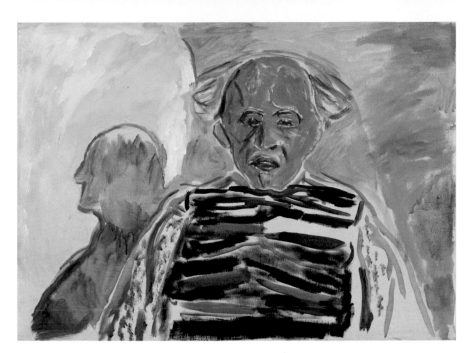

Self-Portrait 1940–43
Oil on canvas, 57.5 × 78.5 cm
Munchmuseet, Oslo

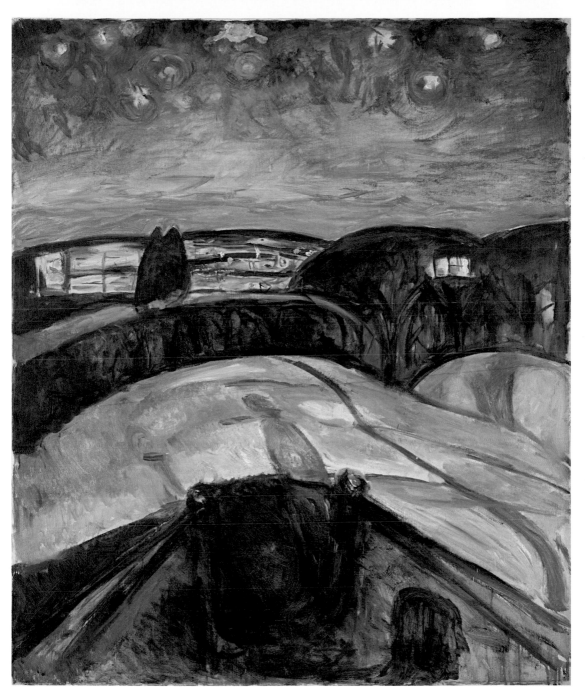

Starry Night 1922–24
Oil on canvas, 120.5 × 100 cm
Munchmuseet, Oslo

Mise-en-scène and Introspection

Reference

Chronology

by Estelle Bégué

– **What is time?**

– **A mere second between the heartbeats –** [1]

1863

Birth of Edvard Munch in Løten (Norway) on 12 December. His father is Christian Munch, an army doctor; his mother is Laura Cathrine *née* Bjølstad.

1868

Munch's mother dies from tuberculosis on 29 December. His maternal aunt Karen Bjølstad takes on the task of raising the family. She is an amateur painter and teaches Edvard to draw.

1877

Edvard's older sister Sophie dies of tuberculosis on 9 November, aged 15.

1879

Munch starts to study architecture at the technical school in Kristiania.[2]

1880

In December Munch enrols at the Royal College of Drawing in Kristiania, where his teachers notably include the sculptor Julius Middelthun.

1882

Munch rents his first studio on Stortings Plass, Kristiania. It is located in the Pultosten building, where the painters Christian Krohg and Frits Thaulow also work.

1883

Munch takes part in his first group exhibitions, the Norwegian Exhibition of Industry and Art, June–October, and the Autumn Exhibition, both in Kristiania.

1884

Munch again exhibits at the Kristiania Autumn Exhibition, where Frits Thaulow's brother-in-law Paul Gauguin also shows several paintings. Munch meets the writer Hans Jæger and has his first contact with the Kristiania Bohemians.

1885

In May financial assistance from Frits Thaulow enables Munch to make his first trip to Paris, where he visits the Louvre. He exhibits a portrait of his younger sister Inger at the Universal Exhibition in Antwerp. In early summer he embarks on a passionate relationship with Milly Thaulow, a supporter of the Norwegian feminist movement and Frits Thaulow's sister-in-law. In December

Hans Jæger publishes his novel *From the Kristiania Bohemians* in which he gives an unvarnished portrayal of young people who have rejected traditional morality. Jæger is sentenced to 60 days in prison.

1886

Munch shows four paintings at the Kristiania Autumn Exhibition, including *The Sick Child* (Nasjonalmuseet), which causes an uproar. Jæger and Krohg publicly support him. Munch's younger sister Laura, aged 20, who suffers from serious, chronic depression, is interned in a psychiatric hospital where she will remain on and off for the rest of her life.

1889

In April Munch opens his first solo exhibition in Kristiania at Studenter Samfundet (the students' association). He shows 63 paintings and 47 drawings, including a portrait of Hans Jæger. In the autumn Munch moves to Paris and is based mainly in France until 1892, making frequent trips to Norway and Denmark. His father's death in November leaves him grief-stricken. In December he moves to Saint-Cloud, where he begins writing what becomes the Saint-Cloud Manifesto.

1890

Munch exhibits 10 paintings at the Kristiania Autumn Exhibition. Shortly after the exhibition, several of his paintings are destroyed in a fire.

1892

In September Munch has another solo exhibition at Tostrupgården in Kristiania. In October he has his first exhibition in Berlin, at the Verein Berliner Künstler, on the initiative of the painter Eilert Adelsteen Normann. Munch's work is considered deeply shocking by the Berlin public and the exhibition has to close after one week. Nevertheless, he manages to show his paintings in Düsseldorf and Cologne. The exhibition then reopens in Berlin before moving to Breslau, Dresden and Munich.

1893

Munch is living in Berlin, where he attends literary meetings at the café Zum schwarzen Ferkel (The Black Piglet). There he rubs shoulders with the writers and dramatists Stanislaw Przybyszewski and August Strindberg and the art critic

Julius Meier-Graefe. In December he holds an exhibition of 50 paintings at a gallery in Unter den Linden, where he presents the series *Die Liebe* (Love), including the first version of *The Scream* (1893, Nasjonalmuseet).

1894

Munch makes his first etchings and lithographs. In the summer Stanislaw Przybyszewski publishes *Das Werk des Edvard Munch* in Germany. This is the first book on Munch's work and also contains essays by the art critics Julius Meier-Graefe, Franz Servaes and Willy Pastor. Towards the end of the year Munch meets Harry Graf Kessler, who becomes one of his patrons.

1895

In March Munch exhibits with Akseli Gallen-Kallela at the Ugo Barroccio gallery in Unter den Linden. Munch presents 14 paintings on love, including *Puberty*. In December his younger brother Andreas dies of pneumonia at the age of thirty.

1896

In April Munch exhibits for the first time at the Salon des Indépendants in Paris. In June his work is shown at Samuel Bing's Maison de l'Art Nouveau. In the same year Munch designs the programmes for Henrik Ibsen's plays *Peer Gynt* and *John Gabriel Borkman* for the Théâtre de l'Œuvre, and starts working on illustrations for Baudelaire's *Les Fleurs du Mal*, but the project is left unfinished.

1898

In June Munch buys a house in the village of Åsgårdstrand, on the Oslo fjord, where he has regularly spent time since the summer of 1889. He publishes several illustrations for pieces by Strindberg in a special issue of the German journal *Quickborn*. In the summer Munch meets Tulla Larsen, with whom he begins a turbulent love affair that lasts for nearly four years.

1899

In the autumn Munch enters the Kornhaug Sanatorium in Gudbrandsdalen, Norway, where he remains until March 1900, receiving treatment for recurrent lung problems and alcoholism.

1901

June–October, Munch's work is shown at the Internationalen Kunstausstellung at the Glaspalast, Munich. In the autumn he shows a very wide selection of works – 72 paintings, including *Angst* and around 30 prints – at Hollændergården, Kristiania.

1902

In spring Munch exhibits a group of 22 paintings at the Berlin Secession, which he entitles a 'Presentation of a Sequence of Pictures from Life'. This is the first exhibition of *The Frieze of Life*. Munch buys his first Kodak camera. In September his relationship with Tulla Larsen ends very violently. Munch's left hand is injured in their final row.

1903

In March Munch presents his *Frieze of Life* at the gallery of P.H. Beyer & Sohn in Leipzig. Later in March he spends time in Paris, where he sees the English violinist Eva Mudocci. In November he joins the Société des Artistes Indépendants.

1904

Munch signs an exclusive three-year deal for the rights to sell his prints in Germany with the publisher Bruno Cassirer. Munch's patron Dr Max Linde commissions the painter to design decorations for his children's nursery. Linde rejects the proposed paintings, but continues to support Munch.

1906

Theatre director Max Reinhardt commissions Munch to create sets for Ibsen's plays *Ghosts* and *Hedda Gabler*, and a frieze for the foyer of the 'Kammerspiele' at the Deutsches Theater, Berlin.

1907

Munch takes part in further exhibitions at the Paul Cassirer gallery and the Berlin Secession. For the first time he spends the summer and autumn in Warnemünde on the Baltic coast. The German judge Gustav Schiefler, a major art collector and patron of Munch, publishes the first catalogue raisonné of the artist's graphic works.

1908

In the autumn Munch suffers a serious mental breakdown and asks to be taken into Dr Jacobson's clinic in Copenhagen, where he remains until spring 1909. He continues to paint throughout this period nevertheless. In the same year he is made a Knight of the Royal Norwegian Order of St Olav.

1909

Munch stages a large retrospective exhibition of his work at the Blomqvist gallery in Kristiania and then in Bergen. The Norwegian industrialist Rasmus Meyer buys a large number of works and Jens Thiis, director of Nasjonalgalleriet in Oslo, buys five major works, including *Puberty* and *The Day After*. In May Munch rents a house in Kragerø, on the Oslo fjord. He begins work on his entry for the competition to decorate the festival hall (the Aula) at the University of Kristiania.

1910

In April Munch has an exhibition at Dioramalokalet in Kristiania, where he presents his sketches for the Aula decorations to the public. In November he buys a house in Hvitsten, on the Oslo fjord.

1911

In April Munch holds another major solo exhibition at Dioramalokalet, where he shows over 100 paintings and 170 prints.

1912

In May–September Munch takes part in the Sonderbund exhibition in Cologne, where an entire room is devoted to his work. He shows 32 paintings. In December he exhibits for the first time in the USA, sending six paintings to the Exhibition of Contemporary Scandinavian Art at the American Art Galleries, New York.

1913

Munch exhibits eight prints at the Armory Show, New York.

1914

On 29 May, after several rejections and modifications, Munch's plans for the Aula decorations are finally accepted. He takes part in the exhibition of Norwegian art staged by Christian Krohg as part of the celebrations marking the centenary of the Norwegian Constitution.

1915

Munch sends nine paintings and around 60 prints to the World's Fair in San Francisco.

1916

Munch buys Ekely, a property on the outskirts of Kristiania, where he lives until his death. The decorations for the Aula are finally completed and are unveiled on 19 September.

1917

Bruno Cassirer publishes the first biography of Munch, written by the German art historian and collector Curt Glaser.

1918

In February Munch has a major exhibition at the Blomqvist gallery, Kristiania, featuring nearly 60 paintings, notably including new versions of the paintings of *The Frieze of Life*. In October, also at the Blomqvist gallery, Munch devotes an exhibition to *The Frieze of Life*, in which he shows the original paintings alongside later versions. He publishes *Livs-frisen*, a booklet in which he explains his artistic vision.

1919

Munch contracts flu and depicts his illness in several self-portraits. In November the Bourgeois Galleries, New York, stage the first retrospective of Munch's work in the USA; 57 of his prints are exhibited.

1920

The poet Arnulf Øverland writes the first monograph on Munch in Norwegian.

1921

In April Munch shows 34 paintings and 90 prints at the Paul Cassirer gallery, Berlin. Munch starts work on decorations for the canteen of the Freia chocolate factory in Kristiania, using motifs created for the Linde frieze.

1922

In June the Kunsthaus Zürich mounts Munch's first solo exhibition in Switzerland, comprising 73 paintings and 433 prints.

1924

The city of Bergen opens a museum showing the Rasmus Meyer Collection to the public. The works were given to the city council in 1917, shortly after Meyer's death, and include a great many important paintings by Munch.

1926

Munch turns once again to photography, taking many snapshots at Ekely in the following years. His sister Laura dies at the end of the year.

1927

The national galleries in Berlin and Oslo host major Munch retrospectives. He also exhibits at the Carnegie International, Pittsburgh.

1930

Munch suffers from a disease of the eyes that makes him practically blind for several months.

1931

In May Munch's aunt Karen dies at the age of 92.

1933

Jens Thiis and Pola Gauguin, son of Paul Gauguin, each publish a biography of Munch. In celebration of his 70th birthday, Munch is elevated to Grand Cross of the Order of St Olav.

1936

In October Munch has his first major solo exhibition in London, at the London Gallery.

1937

In Germany the Nazis confiscate 80 works by Munch from German museums and several private collectors on the grounds of their supposedly 'degenerate' nature.

1939

Many of Munch's works confiscated by the Nazis are sold at auction in Oslo at the Harald Holst Halvorsen Gallery and at the Hotel Bristol, including two paintings seized from the Gemäldegalerie in Dresden, *The Sick Child* (1907, Tate Modern) and *Life* (1910, Oslo City Hall).

1940

On 9 April the German army invades Oslo. Munch refuses to have any contact with the occupiers. On 18 April he signs a will in which he bequeaths all his property, including all the works in his studio and his manuscripts, to the City of Oslo.

1944

Munch dies at Ekely on the afternoon of 23 January at the age of 80.

1 Note N 533, undated. Munchmuseet.
2 In 1624, on the order of King Christian IV of Denmark and Norway, the city of Oslo was renamed 'Christiania'. From 1877 the spelling 'Kristiania' was often preferred and became the official version of the name in 1897. The city returned to its original name Oslo in 1925.

List of Artworks
exhibited at the Musée d'Orsay

For more detailed information about
the works, see the catalogues raisonnés
listed in the Selected Bibliography.

Paintings

p. 119 **Hans Jæger** 1889
Oil on canvas, 109 × 84 cm
Nasjonalmuseet, Oslo
NG.M.00485 (Woll M 174)

p. 120 **Evening** 1888
Oil on canvas, 75 × 100.5 cm
Museo Thyssen-Bornemisza, Madrid
1967.7 (Woll M 163)

p. 121 **Summer Night:
Inger on the Beach** 1889
Oil on canvas, 126.5 × 161.5 cm
KODE, Bergen (Rasmus Meyer Collection)
RMS.M.00240 (Woll M 182)

p. 123 **Inger in Black and Violet** 1892
Oil on canvas, 172.5 × 122.5 cm
Nasjonalmuseet, Oslo
NG.M.00499 (Woll M 294)

p. 124 **Self-Portrait with Cigarette**
1895
Oil on canvas, 10.5 × 85.5 cm
Nasjonalmuseet, Oslo
NG.M.00470 (Woll M 382)

p. 125 **The Sick Child** 1896
Oil on canvas, 121.5 × 10.5 cm
Göteborgs Konstmuseum,
Gothenburg
GKM.0975 (Woll M 392)

p. 126 **Puberty** 1894–95
Oil on canvas, 151.5 × 10 cm
Nasjonalmuseet, Oslo
NG.M.00807 (Woll M 347)

p. 127 **Sick Mood at Sunset:
Despair** 1892
Oil on canvas, 92 × 67 cm
Thielska Galleriet, Stockholm
TG.286 (Woll M 264)

p. 129 **The Kiss** 1897
Oil on canvas, 99 × 81 cm
Munchmuseet, Oslo
MM.M.00059 (Woll M 401)

p. 135 **Dance on the Beach** 1899–1900
Oil on canvas, 99 × 96 cm
National Gallery Prague
O.3349 (Woll M 460)

p. 136 **Vampire** 1895
Oil on canvas, 91 × 109 cm
Munchmuseet, Oslo
MM.M.00679 (Woll M 377)

p. 137 **Melancholy** 1894–96
Oil on canvas, 81 × 100.5 cm

KODE, Bergen (Rasmus Meyer Collection)
RMS.M.00249 (Woll M 360)

p. 138 **Red and White** 1899–1900
Oil on canvas, 93.5 × 129.5 cm
Munchmuseet, Oslo
MM.M.00460 (Woll M 463)

p. 139 **Evening on Karl Johan** 1892
Oil on unprimed canvas, 84.5 × 121 cm
KODE, Bergen (Rasmus Meyer Collection)
RMS.M.00245 (Woll M 290)

p. 144 **By the Deathbed** 1895
Oil and tempera on unprimed canvas
90 × 120.5 cm
KODE, Bergen (Rasmus Meyer Collection)
RMS.M.00251 (Woll M 376)

p. 147 **Metabolism:
Life and Death** 1898–9
Oil on canvas, 172.5 × 142 cm
Munchmuseet, Oslo
MM.M.00419 (Woll M 428)

p. 148 **Vampire in the Forest**
1924–25
Oil on canvas, 200 × 138 cm
Munchmuseet, Oslo
MM.M.00374 (Woll M 1508)

p. 150–151 **Dance on the Beach
(The Linde Frieze)** 1904
Oil on canvas, 90 × 316 cm
Munchmuseet, Oslo
MM.M.00719 (Woll M 614)

p. 152 **Death Struggle** 1919
Oil on canvas, 174 × 230 cm
Munchmuseet, Oslo
MM.M.00002 (Woll M 131)

p. 175 **The Ladies on the Bridge**
1934–40
Oil on canvas, 10 × 129 cm
Munchmuseet, Oslo
MM.M.00030 (Woll M 1721)

p. 176 **Trees and Garden Wall
in Åsgårdstrand** (1902–04)
Oil on canvas, 99 × 103.5 cm
Musée d'Orsay, Paris
RF.1986.58 (Woll M 537)

p. 177 **The Girls on the Bridge** 1927
Oil on canvas, 100 × 90 cm
Munchmuseet, Oslo
MM.M.00490 (Woll M 1632)

p. 178 **Children Playing in the Street
in Åsgårdstrand** 1901–03
Oil on canvas, 74.6 × 89.2 cm
KODE, Bergen (Rasmus
Meyer Collection)
RMS.M.00258 (Woll M 491)

p. 179 **New Snow in the Avenue** 1906
Oil on canvas, 80 × 100 cm

Munchmuseet, Oslo
MM.M.00288 (Woll M 676)

p. 197 **Bathing Men** 1907–08
Oil on canvas, 206 × 227 cm
Ateneum, Finnish National Gallery,
Helsinki (Antell Collection)
A.II.908 (Woll M 766)

p. 198 **Girls Watering Flowers
(The Linde Frieze)** 1904
Oil on canvas, 99.5 × 80 cm
Munchmuseet, Oslo
MM.M.00054 (Woll M 612)

p. 199 **Trees by the Beach
(The Linde Frieze)** 1904
Oil on canvas, 93 × 167 cm
Munchmuseet, Oslo
MM.M.00014 (Woll M 609)

p. 200 **Summer in the Park
(The Linde Frieze)** 1904
Oil on canvas, 91 × 172 cm
Munchmuseet, Oslo
MM.M.00013 (Woll M 607)

p. 201 **Kissing Couples in the Park
(The Linde Frieze)** 1904
Oil on canvas, 91 × 170.5 cm
Munchmuseet, Oslo
MM.M.00695 (Woll M 610)

p. 202 **Young People on the Beach
(The Linde Frieze)** 1904
Oil on canvas, 90 × 174 cm
Munchmuseet, Oslo
MM.M.00035 (Woll M 608)

p. 203 **Two Human Beings:
The Lonely Ones (The Reinhardt
Frieze)** 1906–07
Tempera on unprimed canvas
89.5 × 159.5 cm
Museum Folkwang, Essen
G.358 (Woll M 735)

p. 204 **History** 1914
Oil on canvas, 89 × 200 cm
Munchmuseet, Oslo
(Rolf Stenersen Collection)
RES.A.00315 (Woll M 1099)

p. 205 **Alma Mater** 1929
Oil on canvas, 91 × 198 cm
Munchmuseet, Oslo
MM.M.00783 (Woll M 1660)

p. 206 **The Human Mountain**
1909–10
Oil on canvas, 70 × 125 cm
Munchmuseet, Oslo
MM.M.00441 (Woll M 912)

p. 208 **The Sun** 1912
Oil on canvas, 123 × 176.5 cm
Munchmuseet, Oslo
MM.M.00822 (Woll M 1019)

p. 215 **Sleepless Night:
Self-Portrait in Inner
Turmoil** 1920
Oil on canvas, 150 × 129 cm
Munchmuseet, Oslo
MM.M.00076 (Woll M 1383)

p. 216 **The Death of Marat** 1907
Oil on canvas, 153 × 149 cm
Munchmuseet, Oslo
MM.M.00004 (Woll M 768)

p. 217 **Jealousy** 1907
Oil on canvas, 89 × 82.5 cm
Munchmuseet, Oslo
MM.M.00573 (Woll M 783)

p. 218 **The Murderess** 1907
Oil on canvas, 89 × 63 cm
Munchmuseet, Oslo
MM.M.00588 (Woll M 786)

p. 219 **Weeping Woman** 1907–09
Oil and crayon on canvas,
10.5 × 99 cm
Munchmuseet, Oslo
MM.M.00081 (Woll M 777)

p. 220 **Set design for Henrik
Ibsen's** *Ghosts* 1906
Tempera on unprimed canvas
60 × 102 cm
Munchmuseet, Oslo
MM.M.00984 (Woll M 699)

p. 228–229 **The Artist
and His Model** 1919–21
Oil on canvas, 120.5 × 200 cm
Munchmuseet, Oslo
MM.M.00723 (Woll M 1331)

p. 230 **Self-Portrait After
the Spanish Flu** 1919
Oil on canvas, 59 × 73 cm
Munchmuseet, Oslo
MM.M.00069 (Woll M 1297)

p. 231 **Self-Portrait: The Night
Wanderer** 1923–24
Oil on canvas, 90 × 68 cm
Munchmuseet, Oslo
MM.M.00589 (Woll M 1462)

p. 235 **Self-Portrait in Hell** 1903
Oil on canvas, 82 × 66 cm
Munchmuseet, Oslo
MM.M.00591 (Woll M 555)

p. 237 **Self-Portrait** 1940–43
Oil on canvas, 57.5 × 78.5 cm
Munchmuseet, Oslo
MM.M.0061 (Woll M 1752)

p. 239 **Starry Night** 1922–24
Oil on canvas, 120.5 × 100 cm
Munchmuseet, Oslo
MM.M.00032 (Woll M 1452)

Drawings

p. 15 **Outline sketch for** *The Frieze of
Life*, **including** *Metabolism, The Kiss,
Anxiety* **and other works** 1917–24
Crayon and watercolour, 431 × 628 mm
Munchmuseet, Oslo
MM.T.0241

p. 141 **Head of** *The Scream* **with
Raised Arms** c. 1898
Crayon and tusche, 380 × 476 mm
KODE, Bergen (Rasmus Meyer Collection)
RMS.M.0815

p. 146 **Metabolism: Life and Death**
1898–1903
Crayon and watercolour, 810 × 555 mm
Munchmuseet, Oslo
MM.T.00413

p. 184 **The Kiss** 1894–95
Brush and crayon, 605 × 390 mm
Munchmuseet, Oslo
MM.T.00421–recto

p. 221 **Hedda Gabler** 1906–07
Crayon and watercolour, 660 × 487 mm
Munchmuseet, Oslo
MM.T.01584

p. 223 **Self-Portrait with Lyre** 1897
Gouache and pencil, 635 × 480 mm
Munchmuseet, Oslo
MM.T.02460

p. 226 **Le Mort Joyeux: Illustration
for** *Les Fleurs du Mal* 1896
Pen, pencil and wash, 280 × 205 mm
Munchmuseet, Oslo
MM.T.00402

Not illustrated
Outline sketch for *The Frieze of Life*
1902–03
Crayon, 10 × 164 mm
Munchmuseet, Oslo
MM.T.00133–21–verso

Prints

p. 140 **Angst** 1896
Woodcut with gouges and chisel
455 × 375 mm
Gundersen Collection, Oslo (Woll G 93)

p. 143 **The Scream** 1895
Lithographic crayon and tusche
445 × 254 mm
Gundersen Collection, Oslo (Woll G 38)

p. 145 **By the Deathbed** 1896
Lithographic crayon, tusche and scraper
418 × 510 mm
Munchmuseet, Oslo
MM.G.00214–08 (Woll G 64)

p. 154 **The Alley** 1895
Lithographic crayon and tusche
427 × 266 mm
Munchmuseet, Oslo
MM.G.00197–21 (Woll G 43)

p. 155 **The Hands** 1895
Lithographic crayon and tusche
484 × 290 mm
Munchmuseet, Oslo
MM.G.00196–04 (Woll G 42)

p. 156 **Salome** 1903
Lithographic crayon and scraper
395 × 305 mm
Munchmuseet, Oslo
MM.G.00256–01 (Woll G 245)

p. 157 **The Brooch: Eva Mudocci** 1903
Lithographic crayon, tusche and scraper
597 × 460 mm
Munchmuseet, Oslo
MM.G.00255–23 (Woll G 244)

p. 158 **Woman with Red Hair
and Green Eyes: The Sin** 1902
Lithographic crayon, tusche and scraper
698 × 402 mm
Gundersen Collection, Oslo (Woll G 198)

p. 159 **Madonna** 1895/1902
Lithographic crayon, tusche and scraper
595 × 440 mm
Gundersen Collection, Oslo (Woll G 39)

p. 160 **Madonna** 1894
Drypoint and burnisher on copperplate
360 × 262 mm
Munchmuseet, Oslo
MM.G.00015–03 (Woll G 1)

p. 161 **On the Waves of Love** 1896
Lithographic crayon and tusche
310 × 417 mm
Gundersen Collection, Oslo (Woll G 81)

p. 162 **Vampire II** 1895/1902
Lithographic crayon, tusche and scraper
385 × 556 mm
Gundersen Collection, Oslo (Woll G 41)

p. 163 **Man's Head in Woman's Hair** 1896
Woodcut with gouges, chisel and fretsaw
544 × 384 mm
Gundersen Collection, Oslo (Woll G 89)

p. 164 **Separation I** 1896
Lithographic crayon and tusche
458 × 572 mm
Munchmuseet, Oslo
MM.G.00209–07 (Woll G 77)

p. 165 **Jealousy II** 1896
Lithographic crayon, tusche and scraper
470 × 570 mm
Munchmuseet, Oslo
MM.G.00202–10 (Woll G 69)

p. 166 **Separation II** 1896
Lithographic crayon, 418 × 645 mm
Munchmuseet, Oslo
MM.G.00210-08 (Woll G 78)

p. 167 **The Sick Child I** 1896
Lithographic crayon, 432 × 573 mm
Munchmuseet, Oslo
MM.G.00203a-05 (Woll G 72)

p. 168 **The Girls on the Bridge** 1905
Woodcut with gouges and chisel
268 × 204 mm
Munchmuseet, Oslo
MM.G.00615-01 (Woll G 271)

p. 174 **Young Women on the Beach II** 1907
Drypoint on copperplate, 11 × 171 mm
Munchmuseet, Oslo
MM.G.00124-08 (Woll G 292)

p. 180 **The Girls on the Bridge** 1918
Woodcut with gouges,
combination print
Munchmuseet, Oslo
MM.G.00647-12 (Woll G 629)

p. 181 **The Girls on the Bridge** 1918
Woodcut with gouges, combination print
496 × 430 mm
Munchmuseet, Oslo
MM.G.00647-1 (Woll G 628)

p. 182 **The Girls on the Bridge** 1918
Lithographic crayon, 494 × 422 mm
498 × 432 mm
Munchmuseet, Oslo
Inv. no, MM.G.00647-03 (Woll G 628)

p. 183 **On the Bridge** 1912-13
Lithographic crayon, 376 × 528 mm
Munchmuseet, Oslo
MM.G.00360-02 (Woll G 416)

p. 185 **The Kiss** 1895
Line etching, open bite, drypoint
and burnisher on copperplate,
330 × 262 mm
Munchmuseet, Oslo
MM.G.00021-08 (Woll G 23)

p. 186 **The Kiss I** 1897
Woodcut with gouges and fretsaw
453 × 377 mm
Munchmuseet, Oslo
MM.G.00578-02 (Woll G 14)

p. 187 **The Kiss II** 1897
Woodcut with gouges, 590 × 460 mm
Munchmuseet, Oslo
MM.G.00577-01 (Woll G 15)

p. 188 **Kiss in the Field** 1943
Woodcut with gouges, 404 × 490 mm
Munchmuseet, Oslo
MM.G.00707-01 (Woll G 746)

p. 189 **The Kiss III** 1898
Teak woodblock, 504 × 405 × 6 mm
Munchmuseet, Oslo
MM.P.00335 (Woll G 124)

p. 190 **The Kiss III** 1898
Woodcut with gouges and fretsaw
403 × 458 mm
Munchmuseet, Oslo
MM.G.00579-09 (Woll G 124)

p. 191 **The Kiss IV** 1902
Woodcut with gouges and fretsaw
393 × 229 mm
Munchmuseet, Oslo
MM.G.00580-20 (Woll G 204)

p. 207 **Towards the Light** 1914
Lithographic crayon, 905 × 730 mm
Munchmuseet, Oslo
MM.G.00565-77 (Woll G 485)

p. 222 **Blossom of Pain** 1898
Woodcut with gouges, 460 × 326 mm
Munchmuseet, Oslo
MM.G.00586-01 (Woll G 130)

p. 224 **Theatre programme
for Henrik Ibsen's** *Peer Gynt* 1896
Lithographic crayon, 249 × 298 mm
Munchmuseet, Oslo
MM.G.00216-10 (Woll G 82)

p. 224 **Theatre programme
for Henrik Ibsen's** *John Gabriel
Dorkman* 1897
Lithographic crayon, 207 × 319 mm
Munchmuseet, Oslo
MM.G.00721-02 (Woll G 108)

p. 225 **Henrik Ibsen at the Grand
Café** 1902
Lithographic crayon, 434 × 600 mm
Munchmuseet, Oslo
MM.G.00244-04 (Woll G 200)

p. 227 **Harpy** 1899
Lithographic crayon, 365 × 320 mm
Munchmuseet, Oslo
MM.G.00239-28 (Woll G 145)

p. 233 **Self-Portrait** 1895
Lithographic crayon, tusche
and scraper, 467 × 320 mm
Gundersen Collection, Oslo
(Woll G 37)

p. 234 **August Strindberg** 1896
Lithographic crayon, tusche and
scraper, 600 × 460 mm
Munchmuseet, Oslo
MM.G.00219a-04 (Woll G 66)

p. 236 **Dance of Death** 1915
Lithographic crayon, 500 × 285 mm
Munchmuseet, Oslo
MM.G.00381-20 (Woll G 509)

Selected Bibliography

Catalogues raisonnés

Woll 2008: Woll, Gerd, *Edvard Munch: Samlede malerier I–IV*. Oslo, Cappelen Damm, 2008. (English edition: *Edvard Munch: Complete Paintings I–IV*. London, Thames & Hudson, 2009.)

Woll 2012: Woll, Gerd, *Edvard Munch: Samlede grafiske verk*. Oslo, Orfeus Publishing, 2012. (English edition: *Edvard Munch: The Complete Graphic Works*. London, Philip Wilson Publishers, 2012.)

Edvard Munch's drawings: https://munch.emuseum.com/en

Edvard Munch's writings (texts and correspondence)

Edvard Munch's writings: https://emunch.no

Munch 1908–09: Munch, Edvard, *Alpha & Omega*. Oslo, Munchmuseet, 1981.

Munch 1911: Munch, Edvard, *Konkurransen om den kunstneriske utsmykning av Universitetets nye Festsal*. Kristiania, 1911.

Munch 1918: Munch, Edvard, 'Livs-frisen' (The Frieze of Life), in *Edvard Munch*. Kristiania, Blomqvists Kunstutstilling, 1918.

Munch 1918–19: Munch, Edvard, *Livs-frisen*. Kristiania, Blomqvist, 1918–19.

Munch 1919: Munch, Edvard, *Livs-frisen*, 1919.

Munch 1928: Munch, Edvard, 'Grand Café', in *Kruset*, 1928.

Munch 1929: Munch, Edvard, *Livs-frisens tilblivelse* (The Origins of *The Frieze of Life*). Oslo, 1929.

Munch 2011: Munch, Edvard, *Écrits*, ed. Jérôme Poggi. Dijon, Les Presses du réel, 2011.

Munch 2018: Munch, Edvard, *Like a Ghost I Leave You: Quotes by Edvard Munch*. Oslo, Munchmuseet, 2018.

Munch & Schiefler 1987: Munch, Edvard, & Schiefler, Gustav, *Briefwechsel*, Vol. I: *1902–1914*, ed. Arne Eggum. Hamburg, Verein für Hamburgische Geschichte, 1987. Vol II: *1915–1935/43*, 1990.

Tøjner 2001: Tøjner, Poul Erik, *Munch: In His Own Words*. Munich, Prestel, 2001.

Munch 2021: *Kunskabens Træ på godt og ondt* (The Tree of Knowledge of Good and Evil). Oslo, MUNCH, 2021. (Facisimile edition of Edvard Munch's portfolio including booklet written by Nora Cecilie Nerdrum).

General publications

Monographs published in Edvard Munch's lifetime

Glaser 1922: Glaser, Curt, *Edvard Munch*. Berlin, Bruno Cassirer, 1922.

Linde 1902: Linde, Max, *Edvard Munch und die Kunst der Zukunft*. Berlin, Friedrich Gottheiner, 1902.

Przybyszewski 1894: Przybyszewski, Stanislaw (ed.), *Das Werk des Edvard Munch. Vier Beiträge* (with contributions by Franz Servaes, Julius Meier-Graefe & Willy Pastor). Berlin, Fischer, 1894.

Thiis 1933: Thiis, Jens, *Edvard Munch og hans samtid. Slekten, livet og kunsten*. Oslo, Gyldendal, 1933.

Monographs published after Edvard Munch's death

Berman & Anker 2011: Berman, Patricia G., & Anker, Peder (eds.), *Edvard Munchs Aulamalerier. Fra kontroversielt prosjekt til nasjonalskatt*. Oslo, Messel, 2011.

Bruteig 2004: Bruteig, Magne, *Munch: Dessins*. Paris, Citadelles & Mazenod, 2004. (English edition: *Munch: Drawings*. Ghent, Tijdsbeeld & Pièce Montée, 2004.)

Bruteig & Zondag 2022: Bruteig, Magne, & Zondag, Morten, *Edvard Munch: The Graphic Works and The Gundersen Collection*. Oslo, J.M. Stenersen, 2022.

Cordulack 2002: Cordulack, Shelley Wood, *Edvard Munch and the Physiology of Symbolism*. Madison (WI), Fairleigh Dickinson University Press, 2002.

Eggum 1982: Eggum, Arno, *Der Linde-Fries. Edvard Munch und sein erster deutscher Mäzen, Dr. Max Linde*. Lübeck, Senat der Hansestadt Lübeck, Amt für Kultur, 1982.

Eggum 1983: Eggum, Arne, *Edvard Munch: Peintures, esquisses, études*. Paris, Berggruen, 1983. (English edition: *Paintings, Sketches and Studies*. Oslo, J.M. Stenersen, 1984.)

Eggum 1989: Eggum, Arne, *Munch and Photography*. New Haven (CT), Yale University Press, 1989.

Eggum 2000: Eggum, Arne, '*The Frieze of Life' from Painting to Graphic Art*. Oslo, J.M. Stenersen, 2000.

Flaatten 2013b: Flaatten, Hans-Martin Frydenberg, *Sunrise in Kragerø: The Story of Edvard Munch's Life at Skrubben 1909–1915*. Oslo, Sem & Stenersen, 2013.

Flaatten 2016: Flaatten, Hans-Martin Frydenberg, *Edvard Munch: Høysommer i Hvitsten. Hans kunstnerliv på Nedre Ramme 1910–1944*. Vestby, Vestby kommune, 2016.

Glaser 2008: Glaser, Curt, *Une visite à Edvard Munch* (1927). Paris, L'Échoppe, 2008.

Heller 1973: Heller, Reinhold, *Edvard Munch, 'The Scream'*. New York, Viking Press, 1973.

Heller 1984: Heller, Reinhold, *Munch: His Life and Work*. Chicago (IL), University of Chicago Press, 1984.

Høifødt 2010: Høifødt, Frank, *Kunsten, kvinnen og en ladd revolver. Edvard Munch anno 1900*. Oslo, Forlaget Press, 2010.

Junillon 2009: Junillon, Ingrid, *Edvard Munch face à Henrik Ibsen. Impressions d'un lecteur*. Leuven, Peeters, 2009.

Knausgaard 2019: Knausgaard, Karl Ove, *So Much Longing in so Little Space: The Art of Edvard Munch*. London, Penguin, 2019.

Krisch & Börsch-Supan 1997: Krisch, Monika, & Börsch-Supan, Helmut, *Die Munch-Affäre: Rehabilitierung der Zeitungskritik. Eine Analyse ästhetischer und kulturpolitischer Beurteilungskriterien in der Kunstberichterstattung der Berliner Tagespresse zu Munchs Ausstellung 1892*. Mahlow bei Berlin, Tenea, 1997.

Mørstad 2006: Mørstad, Erik (ed.), *Edvard Munch: An Anthology*. Oslo, Unipub/Oslo Academic Press, 2006.

Næss 2011: Næss, Atle, *Munch. Les couleurs de la névrose*. Paris, Hazan, 2011 (Norwegian edition: *Munch. En biografi*. Oslo, Gyldendal, 2004).

Øverås 2022: Øverås, Tor Eystein (ed.), *Edvard Munch Infinite*. Oslo, MUNCH, 2022.

Smith 1983: Smith, John Boulton, *Frederick Delius and Edvard Munch: Their Friendship and Their Correspondence*. Rickmansworth, Triad Press, 1983.

Stenersen 1969: Stenersen, Rolf, *Edvard Munch: Close-up of a Genius*. Oslo, Gyldendal, 1969.

Templeton 2008: Templeton, Joan, *Munch's Ibsen: A Painter's Visions of a Playwright*. Seattle (WA), University of Washington Press / Copenhagen, Museum Tusculanum Press, 2008.

Ustvedt 2020: Ustvedt, Øystein, *Edvard Munch: An Inner Life*. London, Thames & Hudson, 2020.

Other general publications

Berman & Utley 2008: Berman, Patricia G., & Utley, Gertje, *A Fine Regard: Essays in Honor of Kirk Varnedoe*. London, Ashgate Press, 2008.

Bliksrud & Rasmussen 2002: Bliksrud, Liv, & Rasmussen, Tarald, *Norsk idéhistorie*, Vol. IV: *Vitenskapens utfordringer (1850–1920)*. Oslo, Aschehoug, 2002.

Bölsche 1900: Bölsche, Wilhelm, *Ernst Haeckel, ein Lebensbild*. Leipzig, Hermann Seemann Nachfolger, 1900.

Brauer 2022: Brauer, Fae (ed.), *Vitalist Modernism: Art, Science, Energy and Creative Evolution*. London, Routledge, 2022.

Dauthendey 1933: Dauthendey, Max, *Ein Herz im Lärm der Welt. Briefe an Freunde*. Munich, Albert Langen/Georg Müller, 1933.

Dietrichson 1911: Dietrichson, Lorentz, *Konkurransen om den kunstneriske utsmykning av Universitetets nye festsal*. Kristiania, A.W. Brøggers Boktrykkeri, 1911.

Dobler 1892: Dobler, K.G., *Ein neues Weltall. Begründet durch die Erfindung des 'Kometograph' und durch eine vergleichende Astro-Embryologie*. Leipzig, Wilhelm Friedrich, 1892.

Fialek 2007: Fialek, Marek, *Die Berliner Künstlerbohème aus dem 'Schwarzen Ferkel'*. Hamburg, Verlag Dr. Kovac, 2007.

Flammarion 1900: Flammarion, Camille, *L'Inconnu: The Unknown*. New York, Harper & Brothers, 1900.

Friedrich 2011: Friedrich, Caspar David, *En contemplant une collection de peintures*. Paris, José Corti, 2011.

Haeckel 1895: Haeckel, Ernst, *Monism as Connecting Religion and Science: The Confession of Faith of a Man of Science* (English transl. by J. Gilchrist). London, Adam & Charles Black, 1895.

Johnson & Ogawa 2005: Johnson, Deborah J., & Ogawa, David (eds.), *Seeing and Beyond: Essays in Eighteenth- to Twenty-First-Century Art in Honor of Kermit S. Champa*. New York, Peter Lang, 2005.

Kierkegaard 2008: Kierkegaard, Søren, *La Reprise*. Paris, Garnier Flammarion, 2008.

Kyllingstad & Rørvik 2011: Kyllingstad, Jon Røyne, & Rørvik, Thor Inge, *Universitetet i Oslo (1811–2011)*, Vol. II, *1870–1911: Vitenskapenes universitet*. Oslo, Unipub, 2011.

Losco-Lena 2010: Losco-Lena, Mireille, *La Scène symboliste (1890–1896). Pour un théâtre spectral*. Grenoble, ELLUG, 2010.

Pechstein 1960: Pechstein, Max, *Erinnerungen*. Wiesbaden, Limes, 1960.

Rasmussen 1943: Rasmussen, Rudolf, *Salong og foyer. Minner, meninger, fantasier om livet på scene og podium*. Oslo, Gyldendal, 1943.

Slagstad 2008a: Slagstad, Rune, *(Sporten). En idéhistorisk studie*. Oslo, Pax, 2008.

Strindberg 2010: Strindberg, August, *Samlade Verk*, Vol. 35: *Naturvetenskapliga skrifter I*, eds. Per Stam & Elisabeth Bladh. Stockholm, Norstedts, 2010.

Uddgren & Dauthendey 1893: Uddgren, Gustaf, & Dauthendey, Max, *Verdensaltet. Det nye sublime i Kunsten*. Copenhagen, Graebes Bogtrykkeri, 1893.

Articles and reviews

Articles and reviews published in Edvard Munch's lifetime

Bölsche 1893: Bölsche, Wilhelm, 'Naturwissenschaftlicher Unterricht in den Schulen'. *Freie Bühne*, No. 4, 1893.

Haeckel 1892: Haeckel, Ernst, 'Der Monismus als Band zwischen Religion und Wissenschaft', talk given on 9 October 1892 at Altenburg. Published in *Altenburger Zeitung* on 19 October 1892 and in *Freie Bühne*, No. 11, 1892, with the title 'Die Weltanschauung der monistischen Wissenschaft', and subsequently in a book published by Emil Strauss, Bonn, 1893.

Natanson 1895: Natanson, Thadée, 'Correspondance de Kristiania: M. Edvard Munch'. *La Revue blanche*, Vol. 9, No. 60, November 1895. Geneva, Slatkine Reprints, 1968, p. 477.

Quillard 1891: Quillard, Paul, 'De l'inutilité absolue de la mise en scène exacte'. *Revue d'art dramatique*, 1 May 1891, Vol. 22, pp. 181–183.

Strindberg 1896: Strindberg, August, 'L'exposition d'Edvard Munch'. *La Revue blanche*, Vol. 10, June 1896. Geneva, Slatkine Reprints, 1968, pp. 525–526.

Articles and reviews published after Edvard Munch's death

Aitken 1991–92: Aitken, Geneviève, 'Edvard Munch et la scène française'. In exh. cat. Paris–Oslo–Frankfurt 1991–92, pp. 224–230.

Andersen 2011: Andersen, Per Thomas, 'Edvard Munch and the Literary Fragment'. In exh. cat. Oslo 2011, pp. 157–166.

Anger 2005: Anger, Jenny, 'Modernism at Home: The Private *Gesamtkunstwerk*'. In Johnson & Ogawa 2005, pp. 211–239.

Bartrum 2019: Bartrum, Giulia, 'Munch and the World of Printmaking'. In exh. cat. London 2019, pp. 59–95.

Berman 1993a: Berman, Patricia G., 'Body and Body Politic in Edvard Munch's *Bathing Men*'. In Adler & Pointon 1993.

Berman 2003: Berman, Patricia G., 'Making Family Values: Narratives of Kinship and Peasant Life in Norwegian Nationalism'. In Facos & Hirsh 2003, pp. 207–228.

Berman 2006: Berman, Patricia G., '*Mens sana in corpore sano*: Munchs vitale kropper' (Munch's Vital Bodies). In exh. cat. Oslo 2006, pp. 44–60.

Berman 2008a: Berman, Patricia G., 'Dionysus with Tan Lines: Edvard Munch's Discursive Skin'. In Berman & Utley 2008, pp. 68–85.

Berman 2008b: Berman, Patricia G., 'The Many Lives of Edvard Munch'. In Woll 2008, Vol. IV.

Berman 2011: Berman, Patricia G., 'Strategisk modernitet: Munch og Universitetet'. In Berman & Anker 2011, pp. 47–70.

Berman 2011–12: Berman, Patricia G., 'From Munch's Laboratory'. In exh. cat. Oslo 2011–12, pp. 41–71.

Berman 2013: Berman, Patricia G., 'The Monumental Artist in Public: The Artist as Monument'. In exh. cat. Oslo 2013.

Berman 2016: Berman, Patricia G., 'Self-Portraits "as" Expressionist Embodiments'. In exh. cat. New York 2016, pp. 81–93.

Berman 2017–18: Berman, Patricia G., 'The Business of Being Edvard Munch'. In exh. cat. San Francisco–New York–Oslo 2017–18, pp. 45–57.

Berman 2022: Berman, Patricia G., 'Edvard Munch and the Vitalized Bodies of Natural Science'. In Brauer 2022.

Boe 1960: Boe, Roy A., 'Edvard Munch's Murals for the University of Oslo'. *The Art Quarterly*, Vol. 23, No. 3, 1960, pp. 233–246.

Bøe 2011: Bøe, Hilde, 'Edvard Munch's Written Language and Handwriting'. In exh. cat. Oslo 2011, pp. 21–32.

Brain 2010: Brain, Robert, 'How Edvard Munch and August Strindberg Contracted Protoplasmania: Memory, Synesthesia, and the Vibratory Organism in Fin-de-Siècle Europe'. *Interdisciplinary Science Reviews*, Vol. 35, No. 1, March 2010.

Clarke 2009: Clarke, Jay A., 'The Matrix and the Market: Exploring Munch's Prints'. In exh. cat. Chicago 2009, pp. 113–155.

Coppel 2019: Coppel, Stephen, 'Munch and the Theatre in Paris'. In exh. cat. London 2019, pp. 97–126.

Dybvik 2011a: Dybvik, Hilde, 'Edvard Munchs skriftspråkstil – eller språklige forvirring': https://emunch.no/ART_norskStil.xhtml

Dybvik 2011b: Dybvik, Hilde, 'Edvard Munch and His Literary Voice'. In exh. cat. Oslo 2011, pp. 143–155.

Eggum 1977: Eggum, Arne, 'The Green Room'. In exh. cat. Stockholm 1977, pp. 82–102.

Eggum 1991–92a: Eggum, Arne, 'Le naturalisme français, l'impressionnisme et le jeune Munch'. In exh. cat. Paris–Oslo–Frankfurt 1991–92, pp. 32–61.

Eggum 1991–92b: Eggum, Arne, 'Importance des deux séjours de Munch en France en 1891–1892'. In exh. cat. Paris–Oslo–Frankfurt 1991–92, pp. 106–116.

Eggum 1991–92c: Eggum, Arne, 'Munch tente de conquérir Paris (1896–1900)'. In exh. cat. Paris–Oslo–Frankfurt 1991–92, pp. 188–221.

Flaatten 2013a: Flaatten, Hans-Martin Frydenberg, 'Town, Fjord and Landscape: Munch's Search for the Soul of a Place'. In exh. cat. Oslo 2013, pp. 88–101.

Friedman 2011: Friedman, Robert Marc, 'Et forjættende symbol: Aulaen, Universitetet og Folket'. In Berman & Anker 2011, pp. 25–45.

Gluchowska 2013: Gluchowska, Lidia, 'Munch, Przybyszewski and *The Scream*'. *Kunst og Kultur*, No. 4, 2013, pp. 182–193.

Godet 2005: Godet, Armen, 'L'Oeuvre cosmopolite, un répertoire universel'. In exh. cat. Paris 2005.

Guleng 2008–09: Guleng, Mai Britt, 'Exhibition Strategy and Artistic Individuality: Edvard Munch's Critics in 1892'. In exh. cat. Oslo 2008–09.

Guleng 2011: Guleng, Mai Britt, 'Edvard Munch – The Narrator'. In exh. cat. Oslo 2011, pp. 219–236.

Guleng 2011–12: Guleng, Mai Britt, 'Repetition in the Writings of Edvard Munch'. In exh. cat. Paris–Frankfurt–London 2011–12, pp. 153–157.

Guleng 2013: Guleng, Mai Britt, 'The Narratives of The Frieze of Life. Edvard Munch's Picture Series'. In exh. cat. Oslo 2013, pp. 128–139.

Hauptmann 1947: Hauptmann, Ivo, 'Edvard Munch. Erinnerungen an den norwegischen Künstler'. *Die Zeit*, March 1947.

Heller 2017: Heller, Reinhold, 'Edvard Munch as Photographed for His 75th Birthday, 1938: Strategies in Defense of a Legacy'. *Kunst og Kultur*, March 2017, pp. 35–47.

Henderson 2002: Henderson, Linda Dalrymple, 'Vibratory Modernism: Boccioni, Kupka, and the Ether of Space'. In Clarke & Henderson 2002.

Johansen 2011–12: Johansen, Bjørn V., 'The University's Aula: Temple of Knowledge and Culture. Room for a Whole Nation'. In exh. cat. Oslo 2011–12, pp. 207–221.

Junillon 2017: Junillon, Ingrid, 'Le Cri de Munch: "sensations détraquées" ou empathie phonographique?'. In Morisson 2017, pp. 73–84.

Körber 2006: Körber, Lill-Ann, 'Munch and Men: Work, Nation and Reproduction in Edvard Munch's Later Works'. In Mørstad 2006, pp. 163–178.

Lampe 2011–12a: Lampe, Angela, 'Reworkings'. In exh. cat. Paris–Frankfurt–London 2011–12 (pp. 29–39 in English edition, London 2012).

Lampe 2011–12b: Lampe, Angela, 'Munch and Max Reinhardt's Modern Stage'. In exh. cat. Paris–Frankfurt–London 2011–12 (pp. 109–118 in English edition, London 2012).

Lathe 1983: Lathe, Carla, 'Edvard Munch's Dramatic Images (1892–1909)'.

Journal of the Warburg and Courtauld Institutes, Vol. 46, No. 1, 1983, pp. 191–206.

Ohlsen 2013: Ohlsen, Nils, 'Edvard Munch's Visual Rhetoric, Seen Through Selected Interiors'. In exh. cat. Oslo 2013, pp. 196–207.

Pettersen 2008: Pettersen, Petra, 'Munch's Aula Paintings'. In Woll 2008, Vol. III (pp. 829–851 in English edition, London, 2009).

Pettersen 2011–12: Pettersen, Petra, 'Edvard Munch's Triumph: The Decoration Drafts in "Half Size"'. In exh. cat. Oslo 2011–12, pp. 257–269.

Ravensberg 1946: Ravensberg, Ludvig O., 'Edvard Munch på nært hold'. In Schreiner 1946.

Rioual 2017: Rioual, Quentin, 'Maeterlinck et Munch: transnationalité et convergence des arts'. *Textyles* (online), Nos. 50–51, 2017, pp. 259–273.

Rognerud 2011: Rognerud, Hilde M.J., 'Zarathustra-Nietzsche med vinger. Edvard Munch maler samtidens motefilosof'. *Kunst og Kultur*, No. 3, 2011, pp. 146–159.

Rousseau 2003–04: Rousseau, Pascal, '"L'oeil solaire". Une généalogie impressionniste de l'abstraction'. In exh. cat. Paris 2003–04, pp. 123–139.

Rousseau 2011–12: Rousseau, Pascal, 'Radiation: Metabolising the "new rays"', In exh. cat. Paris–Frankfurt–London 2011–12 (pp. 161–169 in English edition, London 2012).

Shiff 2010: Shiff, Richard, 'Vibrations'. In exh. cat. Paris 2010.

Slagstad 2008b: Slagstad, Rune, 'Munchs kropp'. In Slagstad 2008a, pp. 417–456.

Sørensen 2006: Sørensen, Gunnar, 'Vitalismens år'. In exh. cat. Oslo 2006.

Steihaug 2013: Steihaug, Jon-Ove, 'Edvard Munch's Performative Self-Portraits'. In exh. cat. Oslo 2013, pp. 12–23.

Thue 2011: Thue, Sivert, '*The City of Free Love*. A Dramatic Settling of Accounts with the Kristiania Bohemia'. In exh. cat. Oslo 2011, pp. 123–131.

Welsh-Ovcharov 2016–17: Welsh-Ovcharov, Bogomila, 'Cosmic Visions: In Search of the Axis Mundi'. In exh. cat. Toronto 2016–17.

Woll 2008–09: Woll, Gerd, 'Use and Re-use in Munch's Earliest Paintings'. In exh. cat. Oslo 2008–09, pp. 85–103.

Yarborough 2006: Yarborough, Tina, 'Public Confrontations and Shifting Allegiances: Edvard Munch and the Art of Exhibition'. In exh. cat. New York 2006, pp. 65–77.

Academic writings

Adler & Pointon 1993: Adler, Kathleen, & Pointon, Marcia (eds.), *The Body Imaged: The Human Form and Visual Culture since the Renaissance*.

Cambridge, Cambridge University Press, 1993.

Berman 1989: Berman, Patricia G., *Monumentality and Historicism in Edvard Munch's University of Oslo Festival Hall Paintings*, unpublished PhD dissertation. New York University, 1989.

Chéroux 1993: Chéroux, Clément, *Edvard Munch à Aasgaardstrand. Points de vue*, thesis. École Nationale Supérieure de la Photographie, Arles, 1993.

Clarke & Henderson 2002: Clarke, Bruce, & Henderson, Linda Dalrymple (eds.), *From Energy to Information: Representation in Science and Technology, Art, and Literature*. Stanford (CA), Stanford University Press, 2002.

Dittmann 1982: Dittmann, Reidar, *Eros and Psyche: Strindberg and Munch in the 1890s*. Ann Arbor (MI), UMI Research Press, 1982.

Endresen 2015: Endresen, Signe, *Serial Experiments: Close-Readings of Edvard Munch's 'Det grønne værelset' (1907)*, unpublished PhD dissertation. University of Oslo, 2015.

Facos & Hirsh 2003: Facos, Michelle, & Hirsh, Sharon (eds.), *Art, Culture and National Identity in Fin-de-Siècle Europe*. Cambridge, Cambridge University Press, 2003.

Gamwell 2002: Gamwell, Lynn, *Exploring the Invisible: Art, Science, and the Spiritual*. Princeton (NJ), Princeton University Press, 2002.

Hedin 2012: Hedin, Gry, *Skrig, sult og frugtbarhed. Darwins fortællinger og metoder som katalysator for værker af J.P. Jacobsen, Knut Hamsun, Edvard Munch og August Strindberg*, PhD dissertation. University of Copenhagen, 2012.

Heller 1968: Heller, Reinhold, *Edvard Munch's 'Life Frieze': Its Beginnings and Origins*, unpublished PhD dissertation. University of Indiana at Bloomington, 1968.

Junillon 2001: Junillon, Ingrid, *Le Théâtre d'Henrik Ibsen dans l'oeuvre d'Edvard Munch. Scénographie, 'illustration' et variations graphiques*, thesis. Université Lumière, Lyon, 2001.

Kittelsen 2014: Kittelsen, Elin, *Edvard Munchs upubliserte roman. Problemer og perspektiver*, Master's thesis. Department of Literature, University of Oslo, 2014.

Koss 2010: Koss, Juliet, *Modernism after Wagner*. Minneapolis (MN), University of Minnesota Press, 2010.

Morisson 2017: Morisson, Valérie (ed.), *Le Cri dans les arts et la littérature*. Dijon, Éditions Universitaires de Dijon, 2017.

Silverman 1989: Silverman, Debora, *Art Nouveau in Fin-de-Siècle France: Politics, Psychology, and Style.* Berkeley (CA), University of California Press, 1989.

Volle 2012: Volle, Wenche, *Munchs Rom*, unpublished PhD dissertation. Oslo School of Architecture and Design, 2012.

Vollsnes 2011: Vollsnes, Arvid O., *Universitetets aula. Glimt fra et 100-årig mangfoldig musikkliv.* Department of Musicology, University of Oslo, 2011.

Woloshyn 2017: Woloshyn, Tania Anne, *Soaking up the Rays: Light Therapy and Visual Culture in Britain (c. 1890–1940).* Manchester, Manchester University Press, 2017.

Yarborough 1995: Yarborough, Tina, *Exhibition Strategies and Wartime Politics in the Art and Career of Edvard Munch (1914–1921),* unpublished PhD dissertation. University of Chicago, 1995.

Exhibition catalogues

London 2019: *Edvard Munch: Love and Angst* (British Museum). London, Thames & Hudson, 2019.

Oslo 2018: *With Eyes Closed: Gauguin and Munch* (Munchmuseet). Oslo, Munchmuseet/Uten tittel, 2018.

San Francisco–New York–Oslo 2017–18: *Edvard Munch: Between the Clock and the Bed* (SF Museum of Modern Art; Metropolitan Museum of Art; Munchmuseet). New Haven (CT), Yale University Press, 2017.

Oslo 2017: *Towards the Forest: Knausgaard on Munch* (Munchmuseet). Oslo, Munchmuseet, 2017.

Toronto 2016–17: *Mystical Landscapes: From Vincent Van Gogh to Emily Carr* (Toronto Art Gallery). Munich, DelMonico Books/Prestel, 2016.

New York 2016: *Munch and Expressionism* (Neue Galerie). New York, Prestel, 2016.

Madrid 2015–16: *Edvard Munch. Arquetipos* (Museo Thyssen-Bornemisza). Madrid, Museo Thyssen-Bornemisza, 2015.

Vienna 2015–16: *Edvard Munch: Love, Death and Loneliness* (Albertina Museum). Vienna, Albertina Museum, 2015.

Oslo–Amsterdam 2015–16: *Munch – Van Gogh* (Munchmuseet; Van Gogh Museum). Brussels, Mercatorfonds, 2015.

Oslo 2013–14: *Edvard Munch: Works on Paper* (Munchmuseet). Oslo, Munchmuseet/Brussels, Mercatorfonds, 2013.

Oslo 2013: *Edvard Munch (1863–1944)*, exhibition *Munch 150* (Munchmuseet

& Nasjonalgalleriet). Oslo, Munchmuseet & Nasjonalmuseet, Oslo / Milan, Skira, 2013.

Paris–Frankfurt–London 2011–12: *Edvard Munch, l'oeil moderne* (Centre Pompidou; Schirn Kunsthalle; Tate Modern). Paris, Centre Pompidou, 2011. (English edition: *Edvard Munch: The Modern Eye.* London, Tate Publishing, 2012.)

Oslo 2011–12: *Munch's Laboratory: The Path to the Aula* (Munchmuseet). Oslo, Munchmuseet/Unipub, 2011.

Oslo 2011: *eMunch.no: Text and Image* (Munchmuseet). Oslo, Munchmuseet/Unipub, 2011.

Paris 2010: *Edvard Munch ou l''Anti-Cri'* (Pinacothèque de Paris). Paris, Pinacothèque de Paris, 2010.

Chicago 2009: *Becoming Edvard Munch: Influence, Anxiety and Myth* (Art Institute). New Haven (CT), Yale University Press, 2009.

Oslo 2008–09: *Munch Becoming 'Munch': Artistic Strategies (1880–1892)* (Munchmuseet). Oslo, Munchmuseet/Labyrinth Press, 2008.

Oslo 2008: *Edvard Munch in the National Museum* (Nasjonalmuseet). Oslo, Nasjonalmuseet, Oslo, 2008.

Tokyo–Kobe 2007–08: *Edvard Munch: The Decorative Projects* (National Museum of Western Art; Hyogo Prefectural Museum of Art). Tokyo, Tokyo Shimbun, 2007.

New York 2006: *Edvard Munch: The Modern Life of the Soul* (Museum of Modern Art). New York, Museum of Modern Art, 2006.

Oslo 2006: *Livskraft. Vitalismen som kunstnerisk impuls (1900–1930)* (Munchmuseet). Oslo, Munchmuseet/Labyrinth Press, 2006.

Paris 2005: *Le Théâtre de l'Œuvre (1893–1900). Naissance du théâtre moderne* (Musée d'Orsay). Paris, Musée d'Orsay / Milan, Cinq Continents, 2005.

Stockholm–Oslo–London 2005: *Munch by Himself* (Moderna Museet; Munchmuseet; Royal Academy of Arts). London, Royal Academy Books, 2005.

Brussels–Oslo 2004–05: *Munch. Dessins* (Musée d'Ixelles; Munchmuseet). Paris, Citadelles & Mazenod, 2004. (English edition: *Munch: Drawings*. Ghent, Tijdsbeeld & Pièce Montée, 2004.)

Paris 2003–04: *Aux origines de l'abstraction (1800–1914)* (Musée d'Orsay). Paris, Réunion des musées nationaux, 2003.

Vienna 2003: *Edvard Munch: Theme and Variation* (Albertina Museum). Ostfildern-Ruit, Hatje Cantz, 2003.

Atlanta 2002: *After 'The Scream': The Late Paintings of Edvard Munch* (High Museum of Art). Atlanta (GA),

High Museum of Art / New Haven (CT), Yale University Press, 2001.

Lillehammer 1993: *Edvard Munch: Monumental Projects (1909–1930)* (Lillehammer Bys Malerisamling). Lillehammer, Lillehammer Bys Malerisamling, 1993.

London 1992–93: *Edvard Munch, 'The Frieze of Life'* (National Gallery). London, National Gallery Publications, 1992.

Paris–Oslo–Frankfurt 1991–92: *Munch et la France* (Musée d'Orsay; Munchmuseet; Schirn Kunsthalle). Paris, Réunion des Musées Nationaux, 1991. (Norwegian edition: *Munch og Frankrike.* Oslo, Munchmuseet/Labyrinth Press, 1992.)

Washington 1978–79: *Edvard Munch: Symbols and Images* (National Gallery of Art). Washington DC, National Gallery of Art, 1978.

Berlin 1978: *Edvard Munch. Der 'Lebensfries' für Max Reinhardts Kammerspiele* (Nationalgalerie). Berlin, Nationalgalerie, 1978.

Stockholm 1977: *Edvard Munch (1863–1944)* (Liljevalchs Konsthall & Kulturhuset). Stockholm, Liljevalchs Konsthall, 1977.

Photo Credits

Ateneum, Finnish National Gallery,
Helsinki (Jaakko Holm): p. 197.

Arbeiderbevegelsens Arkiv og Bibliotek,
Oslo: p. 88.

Bibliothèque Nationale de France, Paris:
p. 88.

Göteborgs Konstmuseum, Gothenburg
(Hossein Shatlou): p. 125.

Gundersen Collection, Oslo (Thomas
Widerberg): pp. 140, 143, 158, 162, 163, 233;
(Morten Henden Aamot): pp. 159, 161.

Hamburger Kunsthalle / bpk
(Elke Walford): p. 25.

KODE, Bergen (Dag Fosse): pp. 49, 80, 121,
137, 139, 141, 144, 178.

MUNCH, Oslo (Halvor Bjørngård & Ove
Kvavik): pp. 3, 15, 16, 26, 35, 39, 46, 51, 54,
57, 61, 62, 77, 92, 95, 97, 102, 106, 109, 129,
136, 138, 145–148, 150–152, 154–157, 160,
164–168, 174, 175, 177, 179–191, 198–202,
204–208, 215–231, 234–237, 239.

Museu Thyssen-Bornemisza, Madrid:
p. 120.

Museum Folkwang, Essen (Artothek):
p. 203.

National Gallery Prague: p. 135.

Nasjonalbiblioteket, Oslo: p. 91.

Nasjonalmuseet, Oslo (Børre Høstland):
pp. 22, 67, 73, 79, 105, 119, 123, 124, 126.

National Gallery of Art, Washington DC:
p. 74.

Norsk Folkemuseum, Oslo: p. 41.

Réunion des Musées Nationaux -
Grand Palais / Musée d'Orsay
(Hervé Lewandowski): Paris: p. 176.

Thielska Galleriet, Stockholm
 Per Myrehed): p. 127.

First published by MUNCH to accompany the exhibition *Edvard Munch. A Poem of Life, Love and Death* at Musée d'Orsay 20 September 2022–20 January 2023.

This book is a redesigned and slightly abbreviated English-language edition of Musée d'Orsay's exhibition catalogue edited by Claire Bernardi with the collaboration of Estelle Bégué.

Translation of essays by Estelle Bégué, Claire Bernardi, Ingrid Junillon and Pierre Wat from French: Trista Selous Art history adviser on essays translated from French: Emil Leth Meilvang

Translation of essays by Hilde Bøe, Trine Otte Bak Nielsen and Øystein Ustvedt from Norwegian: Rob Young / MUNCH

On the cover: *Towards the Light* (1914)

Published originally under the title *Edvard Munch. Un poème de vie, d'amour et de mort.*
© Établissement public du musée d'Orsay et de l'Orangerie - Valéry Giscard d'Estaing, Paris 2022

© Réunion des musées nationaux - Grand Palais, Paris 2022

© 2022 MUNCH, Oslo
www.munchmuseet.no

This edition first published in the United Kingdom in 2023 by Thames & Hudson Ltd, 181A High Holborn, London WC1V 7QX

This edition first published in the United States of America in 2023 by Thames & Hudson Inc., 500 Fifth Avenue, New York, New York 10110

British Library Cataloguing-in-Publication Data
A catalogue record for this book is available from the British Library

Library of Congress Catalog Card Number 2023939313

ISBN: 978-0-500-02674-8

Printed and bound in China by C&C Offset Printing Co. Ltd

MIX
Paper | Supporting responsible forestry
FSC® C008047

Be the first to know about our new releases, exclusive content and author events by visiting
thamesandhudson.com
thamesandhudsonusa.com
thamesandhudson.com.au

MUNCH thanks its sponsors and supporters: